D0559470

S. GIEDION

architecture
you
and
me

The diary of a development

Harvard University Press
1958 Cambridge, Massachusetts

Printed in the United States of America
Library of Congress Catalog Card Number 58–6578

FOREWORD

This book is not based upon organized research. Books concerned with research into past events have to be planned and written consistently from beginning to end to clarify relationships between events and developments. No such method is possible in the case of this book.

When one is standing in the midst of an evolving period, only a few signs can occasionally be traced or noted. Only later, by checking backward, can one judge whether truly constituent facts had been recognized or where the argument had gone astray.

This book cannot be more than a diary of a development insofar as architecture is concerned—the diary of a contemporary observer. The development forms and reforms as new problems appear on the horizon.

Evidences are set forth of the tragic conflict between the general public and the really creative artists, architects, and planners that has existed for more than a century. Some indications are then given of the ways in which this conflict is becoming resolved, or healed: some means by which the rifts can be spanned.

In the realm of the architect, as in that of the painter, much has changed during the last decades. Creative spirits among the painters have attained a certain influence, and the outlook for both architecture and town planning has undoubtedly improved since the last century, when, as snails destroy a fresh green sprout, the smear of the press and the attitude of the public destroyed any new architectonic beginning.

But let us not deceive ourselves! Despite all, the basic situation remains at a rather low level. The prolific scale-

less sprawl of urban growth and the banal architecture of rebuilt inner areas bequeath a heavy burden to posterity. There are few glimpses of light; in general there are only further chaos and stillborn buildings.

Biological, social, and economic considerations have been sufficiently stressed. Here we shall lay the main emphasis upon a greatly undervalued factor: the direct influence of aesthetic values upon the shaping of reality. This is far greater than is generally realized. The statement, "I like this and I don't like that," is in many cases, perhaps in most, more decisive than first costs. Today's problem is to bridge the fatal gulf between the greatly developed powers of thinking and greatly retarded powers of feeling of those in authority, no matter to what category they may belong. Once this link has been established, the search naturally follows for the most creative designers. Here, in the field of the sciences just as much as in architecture and town planning, it is only those gifted with imagination who can find solutions to the problems facing us today.

Architecture, You and Me was first published in German as vol. 18 of the Rowohlts Deutsche Enzyklopaedie under the title *Architektur und Gemeinschaft* (Hamburg, 1956) and our thanks are due to the Rowohlt publishing house for their permission to bring out this enlarged version of the book in English. Most of the material first appeared in the form of articles, and a list of the sources is provided at the end. Occasionally the liberty has been taken of making cuts or insertions. *Marginalia* providing continuity have been added between certain sections. The revision of English texts and translation of material from German or French has been done by Jaqueline Tyrwhitt.

CONTENTS

Part 1.

ON THE RULING TASTE

page 2 Do We Need Artists? 1937
 6 Art as the Key to Reality 1937
 10 *Marginalia*
 11 The Tragic Conflict 1936, 1955

Part 2.

ON MONUMENTALITY

22 *Marginalia*
25 The Need for a New Monumentality 1944
40 On Monumentality and Color, by Fernand Léger 1943
48 Nine Points on Monumentality 1943
52 Some Words on Fernand Léger 1955
56 *Marginalia*
57 On the Space-Emanating Power of Contemporary Sculpture 1949

Part 3.

ON THE COOPERATION
OF ARCHITECT, PAINTER, AND SCULPTOR

64 *Marginalia*
67 On the Force of Aesthetic Values 1947
70 *Marginalia*
72 Architects' Attitudes Toward Aesthetics 1947
79 Architects and Politics: an East-West Discussion 1949
91 *Marginalia*
93 Aesthetics and the Human Habitat 1953

Part 4.

ON THE FORMATION
OF THE ARCHITECT

100 *Marginalia*
102 On the Education of the Architect 1947
105 *Marginalia*
106 History and the Architect 1955

Part 5.

ON THE RENEWAL
OF THE HUMAN HABITAT

122 *Marginalia*
125 The Humanization of Urban Life 1951, 1952
138 The New Regionalism 1954

Part 6.

ON THE DEMAND FOR IMAGINATION

154 *Marginalia*
157 Social Imagination 1954, 1956
178 Spatial Imagination 1954, 1956

202 Finale

207 Developments in Urban Design since 1850
213 Acknowledgments
215 Index of Names
220 Subject Index

viii

Part 1

ON THE RULING TASTE

Do We Need Artists?

Art as the Key to Reality

The Tragic Conflict

DO WE NEED ARTISTS?

A widespread opinion

Life today has become so rich in means of expression that art has more or less lost its earlier purpose; it has become absorbed into life itself. Movies, photography, radio, television—the whole gamut of modern civilization—has taken its place. So what is the use of artists?

With a few exceptions, a serious artist can no longer make a living from his art. Either he has to be a salesman on the side, or he needs far-reaching patronage. The great patron of former times has become half a dozen smaller ones. It cannot be denied that the artist of today usually lives a dog's life; and, in doing so, he conforms to another widely held opinion, that an artist has to starve to be creative! (This ethical alibi is today falser than ever.)

Another opinion

We certainly do not recommend a return to a primitive way of life. We love modern civilization. It is one of the few honest expressions of our being today. It is a part of us. But it is not the whole.

A long time ago man lost the key to the inner meaning of technics, of traffic, of the daily round of his life. His inner feelings became disassociated from these, because art—official art—lost all contact with the life that has grown out from this civilization.

No civilization can develop without those high notes that we call art.

Art? Feeling?

Means of expression are needed with no other apparent purpose than to serve as containers for our feelings. Every-

2

one needs some outlet for his feelings. The outlet can be a frown, a sigh, or a voluptuous gasp.

The frown is no help, since it does not banish the feelings. They remain. They accumulate. So each man longs for an environment that is the symbol or mirror of his inner desires. Everyone longs for a prolonged satisfaction of these inner desires—some more ardently, others more contentedly. There is no political platform and no community movement that has not some such symbol.

There are also pseudo-symbols. These always arise when the true situation, for reasons of convenience, is concealed behind a false façade.

The history of the nineteenth century is a history of pseudo-symbols.

The consequences are clear:

For those matters which arise newly from the innermost depths of a period, that are thrust aside in the daily round of life, man finds no inner assurance, no guiding voice. As a result mechanization becomes rampant and life brutalized.

The artist has lost contact with the public

That contact has been lost between the artist and the general public needs no discussion. But it is another matter to ask whose fault this is.

The artist has it thrown up to him that his vocabulary of forms is no longer generally understandable. Whose fault is this? The artist's or the public's?

When this statement is made it usually means that contact became lost when artists turned away from naturalistic representations.

A slight historical correction

It is possible to establish quite accurately just when contact ceased to exist between the artist and the general public. When? With the dissolution of the craftsmen's

3

guilds, with the *proclamation de la liberté du travail* on March 17, 1791. The abolition of all legal restraints upon the choice of a trade left everyone free to select whatever profession he pleased. Simultaneously with this (seemingly) creative freedom the artist lost his former natural contact with the community.

Industrial development and artistic detriment occurred simultaneously.

In the field of art itself a rift now developed.

Artists had to face the question: how shall I secure for myself the greatest possible sales?

The consequence: an art was born that catered to the public, more shameless than anything previously known in history.

This was the art of the Salons, of the academies of art, of the gold medals, of the Prix de Rome, of officialdom. The general public—in the most general sense of this term, whether rich or poor—swallowed it whole. Middle-income groups raised their tone by hanging engravings on their walls, made by skillful craftsmen; noblemen, industrialists and financiers had the originals, for which they paid their favorites as much as a thousand francs per square centimeter.

This was art, according to the critics appointed by the general public, who could see nothing and who had no wish to see anything.

This monstrous apparatus, this art industry which took on veritable industrial dimensions, eventually proved itself to be of the utmost insignificance, though its poisonous and befuddling effect was of long endurance.

The voice of the majority, so loud that it drowned all others, proved utterly fallacious.

The general public lost contact with art

On the one hand there was this public art, produced on an enormous scale; on the other the work of half a dozen painters, upon whose shoulders lay all tasks of research and

4

invention. They knew—right through the entire century—that their position rendered all hope of success or approbation quite impossible. The right to have his work recognized, which is expected by every normal individual, was almost always denied to such artists—throughout the last century and even today. That these phenomena did not die out; that there continued to be men who were prepared to create their work at the cost of their lives, is part of the nature of heroism, which takes on different forms in different periods.

Outwardly these people lived their lives in creative isolation. For the moment, they were obliged to withdraw their work more and more from the popular taste of the general public, the critics, and the art collections. As a result, a type of artist evolved whose work was more and more that of a pioneer, of a research worker, of an inventor.

As the artist came to glance less and less in the direction of the public, he came nearer to the possibilities of making contact with those underlying sources that provide the nourishment for our period.

Do we need artists?

In a period in which the artist seems to have lost all rights and privileges, should we not say:

Artists can more easily exist without the general public than the general public without the artists! Why? Because mechanization runs amuck when there is no line of direction, and when feeling cannot find a suitable outlet.

This interchange between reality and the symbols of feeling is as delicately balanced as the influence of our unconscious upon our conscious behavior. The moment it is disturbed sound judgment disappears.

ART AS THE KEY TO REALITY

Why is our age so sick?

Every creative art has the task of creating its own approach to the world—its own key to the universe. Its task lies within the realm of irrationality: to give an expression to the emotional feeling of a period. When this is not done it is a sign that that period has lost contact with its own inner self.

Everyone knows the reason why our period cannot find its equilibrium.

It can neither control nor organize the possibilities that it has itself produced.

There is nothing more disturbing to the balance of our inner vigor than production which becomes an end in itself, and which has the power (through the means at its disposal) to develop indefinitely.

Inventions are important, since they are the means whereby these possibilities may find a final inner freedom. There is no other way by which we can ensure a higher standard of living for all.

The problem starts when inventions are put into production. The machine produces as much as man desires it should. The machine and its products confront something that can be interpreted in many different ways and yet never wholly grasped: Man! The operation starts with the producer, continues with the distributor, and ends (but not in every case) with the consumer. This depends upon the way in which, finally, the product reacts upon the general organization of society that we call its culture.

It has been shown that these consequences have always been undeterminable, socially, humanly, and in the domain of man's emotions. In a century and a half industrialization has created no new reality to encompass our life cycle.

6

Today, as then, the situation remains the same.

We have not been able to cope with the new reality. We have not mastered the social consequences any better than the human ones, for we have created a civilization which lacks any desire for tranquillity. We do not know how to adapt ourselves to this civilization, for our culture lacks an adequate balance between physical and mental tension.

In short, we have not found the key to reality, which lies hidden in our emotion. This is the matter which we must discuss here.

Art as a substitute

The rift between the newly created reality and emotional feeling started with the industrial revolution:

ungoverned machines—outcast feeling,
production as an end in itself—escape into romanticism.

This dichotomy explains the rise of the public art of the last century, which is still the standard of taste of the general public. The officially accepted art of the exhibitions, the academies, the press: the art that had real power and that came to govern the emotional world of the general public proved to be merely a drug, a narcotic.

No man can exist without emotion: he finds his expression for this where he can obtain it most easily. And what is more comfortable than to escape from the world, to shut one's eyes and make believe that one is living in an idyllic period? One need only thumb through the journals of 1830 to 1900 to see this in operation.

Today, a safe historical distance away, the public art of the nineteenth century quite often has the charm of a mask —half banal, half demoniac. It can be likened to some pleasant-tasting medicinal powder that gives the organism a momentary lift before the poison begins its fell work.

The consequence of this situation was that the greatest

7

painters of this period, the only ones whose work continues to survive today, were forced to capitulate to the situation and become doomed to unimportance.

Production as an end in itself and—in the domain of the emotions—escape into romanticism, go hand in hand throughout this period.

Art approaches life

Since Cubism assembled the possibilities created by the Impressionists up to the Fauves, and then found new ones, art has recovered its power to exert an immediate influence upon the present-day reality.

But this cannot come about at once.

This organically growing art works like a biological medicine, slowly and quietly, for it has to act on the organism from within.

This is the function pursued by Cubism, Constructivism, and all other movements which, unlike those of the last century, do not present realistic representations of the world and personal experiences.

To the eye of the naturalistically oriented observer the abstract forms or the organic fragments they create have no connection whatsoever with reality.

But it turns out that these paintings have the power to radiate a marvelous strength, so that even several decades later they are still effective and do not grow outdated.

These artists create not representations but symbols of the contemporary reality. This means that, by presenting us immediately with the very essence of a form, they suddenly give us the power of spatial penetration—to acquire a completely new approach to the world around us, the world which we ourselves have fashioned.

From tin can to iron construction, from the annual rings of a tree to the furthest form of life that the microscope can disclose, from organic movement to machine precision, from the stone age monolith to a tangle of wire cable in the

bed of a stream—wherever we look, this seemingly far-removed art has widened our experience.

It has taught us to find an approach to ourselves, and, thus, to create once again a unity between feeling and reality, which is essential for the start of any true culture.

It has shown us that what appear at first sight to be merely banal, nondescript, utilitarian objects can suddenly be transformed into vehicles of feeling, when their inner nature is expressed by a painter. It has shown us the links that exist between the machine and the organism and the machine. Thanks to these paintings the loathing of ugliness and banality has been removed from that reality which exists because of and as part of us. This is only the beginning, but it has opened the way for us to find anew the key both to ourselves and to cosmic forces.

Marginalia

Why was it that an art filled with the spirit of the period could not win through?

Why was it possible that, for over a century, the painters and sculptors who determined the emotional make-up of the masses made a pretense of having life, yet had no more of it than the doll Olympia in the "Tales of Hoffman"?

The pictures of the famous painters of that period now molder in the cellars of art galleries. Their names have become meaningless.

The whole production of the period had little connection with real art. Even so it should not be ignored. Within it lie the roots of that tragic rift between retarded emotional feeling and highly developed thinking which cuts through our period. Though the art of the ruling taste of the last century has now disappeared, its influence is still strong in the emotional standpoint of the general public, of both great and small administrators, of elected politicians, and of government officials. Each of these believes himself, because of his position, to be a competent art critic; in this way false idyls and sentimental images of the past century live today. It is still a favorite Sunday amusement to ridicule an art that has sprung from the heart of our period.

There are exceptions but the overwhelming mass of the public are still at the emotional level of the former ruling taste.

It is enough to glance at postwar reconstruction of damaged urban areas—from the bombed area around St. Paul's Cathedral in London, or Berlin, or the reconstruction of Stalingrad, to the tiny city of Saint-Dié. Everywhere we see mirrored the characteristics of the ruling taste: to erect sham façades before the realities of life.

THE TRAGIC CONFLICT

Do we need artists? Art as the key to reality. These phrases indicate the tragic conflict, the tragic rift, of the nineteenth century.

The nineteenth century witnessed a greater expansion of material goods than had ever been known before. Its thinking was concentrated upon obtaining a rational mastery over all the world. This approach, which had begun with the Renaissance, was now taken to extreme lengths, especially in connection with everything to do with technical development. In this field procedures have now been developed to such a degree that almost anything that is desired can be produced. Man needs only to press the button labeled research laboratory and the desired product will be delivered.

At the same time the nineteenth century lived in a fog of inarticulate feelings. It floundered between one extreme and another, reaching out blindly in all directions. It sought its release by escape into the past. It remained eternally uncertain, eternally doubtful, because it could not find the key to its inner self. Its emotions stumbled down false tracks leading toward substitute and second-rate values.

All this, caused by the particular predicament of the period, was well known before the middle of the century. The statement that only posterity can estimate the true values of a period is one of those thin excuses behind which we shelter to escape our responsibilities. It is of course true that to evaluate the real meaning of public opinion, as expressed in the daily press, it is necessary to regard it from some distance in time. But any person with real judgment can recognize the main predicaments of a period while in the midst of its problems, just as well as any later comer.

When Heinrich Heine, the German poet, paid his first visit to Paris in 1831, he wrote at length about the Salon of

that year, which had a special claim to interest as it immediately followed the revolution of 1830. Though it was packed with pictures depicting historic events, his estimate was "The art of today is in distasteful contrast to the actual scene."

But it was Charles Baudelaire, the French poet, who found the most tender spot when he published his booklet on the Salon of 1846. Here he placed his finger upon the evil that is inevitably bound up with eclecticism: doubt. "Doubt, which today is the principal cause of all morbid affections in the moral world, and whose ravages are now greater than ever before . . . Doubt begat Eclecticism." And a little later in his chapter, "On schools and journeymen," he says, "Doubt, or the absence of faith and of naïveté, is a vice peculiar to this age . . . Naïveté"— which is the capacity to approach things directly without intermediary—"is a divine privilege which almost all are without." [1]

No period is entirely without depth, and the nineteenth century too had its great artists, but the really great—those who never lost the gift of "naïveté"—were without influence at that time, their works unknown and inaccessible. The strength of the ruling taste overpowered them. But real art has one thing in common with the voice of conscience: both utter the truth which cannot, in the long run, be silenced. The art which at that time was heaped with glory and success is now stacked in heaps in the cellars of all museums and art galleries. It has become materially valueless. In its place hang masterpieces of these misunderstood artists—such as Edouard Manet—who suffered severely from lack of all appreciation in their lifetime, and sometimes even destroyed their work in consequence.

Therefore, between the highly developed powers of thinking of the nineteenth century and its debased powers of feeling—debased through the acceptance of substitute out-

[1] Charles Baudelaire, *The Mirror of Art*, trans. and ed. Jonathan Mayne (London, 1955), pp. 103, 124.

lets—a tragic rift opened ever wider. T. S. Eliot and others have recognized the same phenomenon among the poets who were then the darlings of the ruling taste. These too were unable to interlock thinking with feeling, which alone can prepare the way for an emotional absorption of mental achievement. Without this inner connection between methods of thinking and methods of feeling it is impossible to have a positive way of life or genuine culture.

In my introductory chapter to *Space, Time and Architecture* under the title, "History a part of life," I sought to express this disastrous conflict, as follows:

"We have behind us a period in which thinking and feeling were separated. This schism produced individuals whose inner development was uneven, who lacked inner equilibrium: split personalities. The split personality as a psychopathic case does not concern us here; we are speaking of the inner disharmony which is found in the structure of the normal personality of this period. . . . The real spirit of the age came out in these researches—in the realm of thinking, that is. But these achievements were regarded as emotionally neutral, as having no relation to the realm of feeling. Feeling could not keep up with the swift advances made in science and the techniques." [2]

In all periods there have been artists who have pleasantly satisfied certain instincts of the people—it was so in the times of Sophocles, Shakespeare, and Goethe. But the nineteenth-century situation is exceptional. We know of no other period in which genuine artists, those with sufficient imagination to distill the essence of the period and give it form, were, in such great measure, debarred from contact with the masses.

Franz Roh, in "Studies of History and the Theory of Cultural Misunderstandings," included in his book *Der verkannte Künstler* (The unappreciated artist), laid the cornerstone of a *Resonanzgeschichte* (history of the recep-

[2] Sigfried Giedion, *Space, Time and Architecture*, 3rd ed. (Cambridge Mass., 1954), p. 13.

13

tion of ideas) in which, among other things, he stressed the delay that occurs before the echo of the event reaches the public.[3]

But we still lack a badly needed history of the ruling taste of the nineteenth century. This would not be a history of the reception of the works of creative artists and their disastrous elimination, but rather a study of the ruling taste of the period and its immediate effect upon the contemporary scene.

Today it requires a certain courage to drag past favorites of the public from their forgotten graves. It is a somewhat ghostly undertaking as they can no longer stand the light of day. These forgotten works have little to do with art, but a very great deal to do with the psyche of the nineteenth century, and with the lack of instinct—the misguided instincts —which still plague us today.

I once thought that I myself would write such a history and started to assemble some preliminary material, at least to make a study of one typical example. The material for this was gathered during the summer of 1936 in the Bibliothèque Nationale in Paris. Then it was put aside, unused. In connection with an appointment in America it seemed to me more urgent to make some studies of the effect of mechanization upon our daily lives, which, through the power of the same ruling taste, was misused in a way somewhat similar to art. This I tried to do in *Mechanization Takes Command*.[4] Since that time my interests have become more concerned with the continuity of human experience through the ages than with the events of the period immediately preceding our own time.

Some fragments of this earlier material may help to clarify the picture for only through a careful study and documentation of a typical case can one gain insight into the degree to which the ruling taste paralyzed the capacity for

[3] Franz Roh, *Der verkannte Künstler* (Munich, 1948).
[4] S. Giedion, *Mechanization Takes Command* (New York, 1948).

14

judgment. A typical popular artist, who by 1830 had won the heart of the great public, was Ary Scheffer, a Dutch painter (1795–1857). Today his name is quite unknown, but at that time he bewitched great and small, rich and poor. It was Baudelaire's criticism of his work in the Salon of 1846 that brought him to my notice. During the summer of 1936 I did my best to understand the phenomenon of Ary Scheffer, and the following is a shorthand version of the situation which produced him.

Born 1795 in Dordrecht, in the then French Batavian Republic. Milieu: thoroughly imbued with literature and art. Father a portrait painter, mother a miniature painter: "at her knee the child learnt to read Goethe and Dante in their native tongues." An infant prodigy: when twelve years old Ary Scheffer exhibited a picture in Amsterdam which caused a sensation. In 1812 the family moved to Paris. The same year Scheffer made his debut in the Paris Salon with a picture of a religious subject. He entered the Paris atelier of the classicist Guérin, the most famous studio of the time. Fellow students were Géricault, Eugène Delacroix. Scheffer hesitates over the direction he should take, but soon finds it: sentimental genre pictures after the English style, such as "The Soldier's Widow" (1819), "Orphans at their Mother's Grave," and so on. "Who has not seen an engraving or a lithograph of The Soldier's Widow?" asks L. Vitet in his excellent work on Ary Scheffer.[5] Sales, success, countless commissions: soon he had a riding horse in the stable. He became drawing master to the family of the Duc d'Orléans, later to be King Louis Philippe. He made an unsuccessful attempt at historical pictures. The thirties marked the high point of his career. Literary representations of Gretchens and Mignons. The King of Belgium, Queen Victoria of England, the Queen of France, the banker Achille Fould, the railway king Péreire, Madame de Rothschild, the top aristocracy of England, France, and Poland, and—in the first rank—the Louvre Museum, whose officials were naturally

[5] L. Vitet, *Peintres modernes de la France: Ary Scheffer* (Paris, 1858).

15

also representatives of the ruling taste: all these were purchasers of originals or of copies of his work. Scheffer permitted many copies to be made in his atelier of the favorite pictures of his clients. In 1856 the Earl of Ellesmere paid 1100 guineas for a picture, and then found that he had received a copy. He was at once given permission to return it, but preferred to keep it. The middle classes hung lithographs or engravings in their parlors or bedrooms.

In the forties Scheffer leaned more and more toward religious themes. The technique was similar, as was the delight with which they were greeted. In 1846 he showed for the last time in the Paris Salon. Perhaps this was because he had a large enough private clientele; but perhaps it was because, in this year, the twenty-five-year-old Charles Baudelaire in his "Salon de 1846" and Gustave Planche in the *Revue des Deux Mondes* both saw his work for what it was. The subject was "St. Augustine and his Mother Monica" (fig. 4). Some found this picture more beautiful than a Raphael. Planche, one of the first to make art criticism his chief profession, was of a different opinion in his article in the *Revue des Deux Mondes*, and Baudelaire said saucily that the work of Ary Scheffer was for "those aesthetic ladies who revenge themselves on the curse of their sex by indulging in religious music." [6]

It was not the pictures that hung in exclusive mansions that had the greatest effect upon the representatives of the ruling taste. We had reached the period of mechanization. Around 1830 the mass production of illustrated journals started. From the start, and right on through the whole century, they were the servitors of the ruling taste. One need only thumb through the pages of the *Magasin Pittoresque*, which was started in 1831 at ten centimes a copy, or the *Illustrated London News* and *Illustration*, both of which were begun shortly after, or the German family journals of the second half of the century, to understand readily how it was that readers in all countries inevitably lost their judg-

[6] Baudelaire, *Mirror of Art*, p. 106.

ment of quality; all were nourished by the same emotional material.

Why should not subjects be selected from the work of great poets or from religious events? It all depends upon the way in which the subject is handled. The contemporary public found that Ary Scheffer's sentimental mistiness opened the floodgates of their emotional feelings. "Basically, the public does not appreciate either the line of Ingres nor the color of Delacroix" remarked Théophile Gautier in *Portraits Contemporains*.[7] As another author stated in 1867, the public liked "art and poetry that let them relax before misty images and daydreams." [8]

Hofstede de Groot, professor of theology at the University of Groningen, wrote a book on Ary Scheffer in 1870 in which he stated that he greatly preferred the work of Scheffer to the poems of Goethe. "He is, in comparison, both nobler and greater." His "Mignon" (fig. 2), a favorite picture of Queen Victoria, "does not, as in Goethe, merely long to return to her earthy abode. Scheffer's skillful paintbrush enables us to sense her yearnings for her celestial fatherland." [9]

A Polish Count Krasinski found that his ideal of Raphael was overshadowed by Ary Scheffer. By comparison, Raphael was a mere materialist.

Even the great skeptic and theological critic, Ernest Renan, devotes the final essay of his famous *Studies of Religious History* to the discussion of a religious picture by Ary Scheffer, "The Search for Christ," purchased by the Louvre. Renan speaks of him as this "eminent artist who has best sought in our times to find the way to the heart." [10]

The twenty-year-old Émile Zola came to Paris to establish himself as a writer. Although a few years later he was

[7] Théophile Gautier, *Portraits Contemporains* (Paris, 1874), p. 431.

[8] Julius Mayer, *Geschichte den Modern Französichen Malerei seit 1789* (Leipzig, 1867), p. 245.

[9] Hofstede de Groot, *Charakteristik Ary Scheffers* (1870).

[10] Ernest Renan, *Studies of Religious History* (London, 1893), p. 303.

to become a fearless defender of Édouard Manet, in 1860 he absorbed the current atmosphere of Paris and wrote to his boyhood's friend Paul Cézanne:

"I don't know if you knew Ary Scheffer, that painter of genius who died last year: in Paris it would be a crime to say you didn't, but in the provinces it can be put down to crass ignorance. Scheffer was a passionate lover of the ideal, all his types are pure and light—almost diaphanous. He was a poet in the full meaning of the word, scarcely ever painted reality, but kept to the most sublime and moving subjects." [11]

These examples indicate how far this emotional fog had penetrated into the lungs of all layers of society. There were very few observers who, like Baudelaire, could recognize the model of the ruling taste, and judge it even in 1846 as history has since judged it.

The poet Baudelaire was the only one to pass a final judgment upon his century: he alone recognized its Janus, two-way facing, face. In his chapter on eclecticism he writes of the truly great that "each of them has a banner to his crown and the words inscribed on that banner are clear for all the world to read. Not one of their number has doubts of his monarchy and it is in this unshakable conviction that their glory resides." Here Baudelaire was referring more to specialists than to Ingres, Delacroix, and Daumier, whom, in a highly perceptive manner, he excepts from the eclectics, of whom he says: "No matter how clever he may be, an eclectic is but a feeble man; for he is a man with . . . neither star nor compass . . . An eclectic is a ship which tries to sail before all winds at once." The nature of an eclectic is further elaborated: "Experiment with contradictory means, the encroachment of one art upon another, the importation of poetry, wit, and sentiment into painting—all these modern miseries are vices peculiar to the eclectics." [12]

[11] Émile Zola, *Correspondance, Lettres de jeunesse* (Paris, 1907), pp. 202–204.
[12] Baudelaire, *Mirror of Art*, pp. 103, 104.

And then Baudelaire starts his chapter entitled, "On Mr. Ary Scheffer and the apes of sentiment," with the words: "A disastrous example of this method—if an absence of method can be so called—is Mr. Ary Scheffer." Even earlier Baudelaire has described Scheffer as a painter who "befouls" his canvas. This is followed by a diatribe on the whole species which can be accepted for the entire century, and more:

"To make a deliberate point of looking for poetry during the conception of a picture is the surest means of not finding it . . . Poetry is the result of the art of painting itself; for it lies in the spectator's soul, and it is the mark of genius to awaken it there. Painting is only interesting in virtue of color and form." [13]

Again and again, throughout the century and later, traditional techniques and modes of expression were adopted in a vain attempt to discover a means of interpreting the essence of the period. Again and again it was quickly discovered that these methods failed. The period exhausted all possibilities to no result, because, eyes turned backward, it wandered always in circles, seeking escape in past history and self-deception. Again and again, as—twenty years after Baudelaire—an art historian expressed it, "the eel-smooth and mobile world of the present slips between the fingers." [14]

And what about architecture?

Architecture in general lay outside the realm of public interest. Buildings were there to provide shelter, and the architect became a decorator whose job it was to adorn them. In many interiors there is no lack of warmth and a subtle use of architectonic effects. But one must beware of taking everything too seriously, as has sometimes happened recently. A sedulously careful selection of buildings is necessary to bring out those values which are worthy of forming a part of the history of the development of architecture.

[13] Baudelaire, *Mirror of Art*, p. 105.
[14] Mayer, *Geschichte der Französichen Malerei*.

When taken as a whole, it is clear that the power of the ruling taste was so strong and dominant that its dictatorship completely inhibited the development of architectural imagination. In architecture, as with the art of the ruling taste "the eel-smooth and mobile world of the present slips between the fingers."

Part 2

ON MONUMENTALITY

The Need for a New Monumentality

On Monumentality and Color by Fernand Léger

Nine Points on Monumentality

Some Words on Fernand Léger

On the Space-Emanating Power of Contemporary Sculpture

Marginalia

One day in New York, in 1943, Fernand Léger the painter, José Luis Sert the architect and town planner (later to become Dean of the Graduate School of Design, Harvard University), and I met together. We discovered that each of us had been invited to write an article for a publication to be prepared by the American Abstract Artists. After discussion, we thought it would be more interesting if we all discussed the same topic, each approaching it from the point of view of his own field of activity: the painter, the architect, and the historian. We decided upon the subject, "A New Monumentality," and finally assembled our joint views under nine heads, which are here printed for the first time.

The publication of the American Abstract Artists never materialized. My contribution, entitled "The New Monumentality," appeared later, in the collection of papers, *New Architecture and City Planning*.[1]

Many friends whose opinion I value shook their heads at the use of so dangerous a term, and one to which the ruling taste had given so banal a meaning. They were right. It was certainly dangerous to revive a term that had become so debased. Lewis Mumford, in a *New Yorker* article, took up a defensive position. Despite these warnings, I lectured on this topic in many places in the United States, and also, later, on the other side of the Atlantic.

All of us are perfectly aware of the fact that monumentality is a dangerous thing, especially at a time when most people do not even grasp the most elementary requirements for a functional building. But we cannot close our eyes.

[1] *New Architecture and City Planning*, ed. Paul Zucker (New York, 1944), pp. 547–568.

Whether we want it or not, the problem of monumentality still lies before us as the task of the immediate future. All that could then be done was to point out some of the dangers and some of the possibilities.

Following a lecture in the Royal Institute of British Architects, London, on September 26, 1946, the *Architectural Review* (London) decided "to take the matter a stage further" and, in their issue of September 1948, some of the world's leading architects and architectural writers defined what monumentality meant to them, and where they thought it fitted into the twentieth-century architectural picture. Contributions came from Gregor Paulsson (Uppsala, Sweden), Henry-Russell Hitchcock (Smith College, United States), Sir William Holford (London), Walter Gropius (then at Harvard), Lucio Costa (Rio de Janeiro), Alfred Roth (Zurich), and myself. Lewis Mumford followed this up with an essay, "Monumentalism, Symbolism and Style," in the *Architectural Review*. One can willingly agree with Mumford's plaint: "Now we live in an age which has not merely abandoned a great many historic symbols, but has likewise made an effort to deflate the symbol itself by denying the values which it represents . . . Because we have dethroned symbolism, we are now left, momentarily, with but a single symbol of almost universal validity: that of the machine . . . What we are beginning to witness today is a reaction against this distorted picture of modern civilization."

"The monument," he adds, "is a declaration of love and admiration attached to the higher purposes men hold in common. . . . An age that has deflated its values and lost sight of its purposes will not produce convincing monuments." [2]

[2] Lewis Mumford, "Monumentalism, Symbolism and Style," *Architectural Review* (April 1949), p. 179.

This is certainly true for the monuments of the ruling taste, but is not just when speaking of the work of the creative artists of our time such as Brancusi, Antoine Pevsner, Hans Arp, Naum Gabo, Alberto Giacometti, or Picasso.

These all desire nothing more ardently than to see their work placed on the public streets, or squares, or in parks—in the midst of the people. Up to now, however, the administrators and leaders of the ruling taste have banished almost all their products to museums and to private collections, and kept them there behind bolts and bars.

THE NEED FOR A NEW MONUMENTALITY

Modern architecture had to take the hard way. Tradition had been mercilessly misused by the representatives of the ruling academic taste in all fields concerned with emotional expression.

The buildings of perennial power such as the Acropolis, the sensitive construction of Gothic cathedrals, the geometric phantasy of Renaissance churches, and the exquisite scale of eighteenth-century squares were all in existence.

But they could not help. For the moment they were dead. They had become temporarily frozen in the icy atmosphere created by those architects and their patrons who, in order to compensate for their own lack of expressive force, had misused eternal names by pilfering from history.

In this way the great monumental heritages of mankind became poisonous to everybody who touched them. Behind every great building of the past leered the faces of its misusers.

This was the period of pseudomonumentality. The greater part of the nineteenth century belongs to it. Its models of the past were not imbued, as in the Renaissance, with a strong artistic vision leading to new results. There was an undirected helplessness and, at the same time, a routine use of shapes from bygone periods. These were used indiscriminately everywhere, for any kind of building. Because they had lost their inner significance they had become devaluated; mere clichés without emotional justification. Clichés cannot be used by creative artists, only by professional eclectics. Thus the creative spirit had to be banished wherever public taste was being formed. Those obedient servants of the ruling taste have now devaluated and undermined the taste and the emotions of the public and brought about the extreme banalization which still exists today.

Periods which are dear to our memory, whose structures and work rose beyond their mere temporal existence, were aware that monumentality, because of its inherent character, can be employed but rarely, and then only for the highest purposes. In ancient Greece monumentality was used sparingly, and then only to serve the gods, or, to a certain extent, the life of the community. The masterly discrimination and discipline of the Greeks in this respect is one of the reasons for their lasting influence.

Contemporary architecture takes the hard way

Contemporary architecture had to take the hard way. As with painting and sculpture, it had to begin anew. It had to reconquer the most primitive things, as if nothing had ever been done before. It could not return to Greece, to Rome, or to the Baroque, to be comforted by their experience. In certain crises man must live in seclusion, to become aware of his own inner feelings and thoughts. This was the situation for all the arts around 1910.

Architects found traces of the undisguised expression of their period in structures far removed from monumental edifices. They found them in market halls, in factories, in the bold vaults of the great exhibition buildings, or in the only real monument of this period, the Eiffel Tower, 1889. There was no denying that these lacked the splendor of buildings of bygone periods, which had been nourished by handicraft and a long tradition. They were naked and rough, but they were honest. Nothing else could have served as the point of departure for a language of our time.

Three steps of contemporary architecture

Architecture is not concerned exclusively with construction.

First, architecture has to provide an adequate frame for man's intimate surroundings. Individual houses as well as

the urban community have to be planned from the human point of view. Modern architecture had to begin with the single cell, with the smallest unit, the low-cost dwelling, which to the last century had seemed beneath the talents and attention of the artist. The 1920's and 1930's saw a resurgence of research in this direction, for it seemed then senseless to push ahead before first trying to find new solutions for this task.

The main impetus lay in the fact that this problem also involved social and human orientation. But, looking back, we can see that an architecture which had to begin anew found here a problem where the utmost care had to be given to exact organization within the smallest space, and to the greatest economy of means. Of course, at the same time, houses were built for the middle or upper classes where, for the first time, a new space conception could be carried out. But it was housing for the lower-income classes that taught the architects the exactitude of planning which had been lost in the nineteenth century.

The second step: From a human point of view, and from the architectonic view as well, houses and blocks are not isolated units. They are incorporated in urban settlements and these are parts of a greater entity, the city. An architect who is not interested in the whole scope of planning, from the right height of a kitchen sink to the layout of a region, is not part of the contemporary building scene. From the single cell, to the neighborhood, the city, and the organization of the whole region is one direct sequence. Thus it can be said that the second phase of modern architecture was concentrated on urbanism.

The third step lies ahead. In view of what had happened in the last century and because of the way modern architecture had come into being, it is the most dangerous and the most difficult step. This is the reconquest of monumental expression.

People desire buildings that represent their social, ceremonial, and community life. They want these buildings to

be more than a functional fulfillment. They seek the expression of their aspirations in monumentality, for joy and for excitement.

In the United States, where modern architecture has had up to now (1944) a rather limited influence because it has been more or less confined to single-family dwellings, housing projects, factories, and office buildings, it may perhaps seem too early to speak about these problems. But things are moving fast. In countries where modern architecture has been recently called upon for solutions of museums, theatres, universities, churches, or concert halls, it has been forced to seek the monumental expression which lies beyond functional fulfillment. If it cannot meet this demand, the whole development will be in mortal danger of a new escape into academicism.

Monumentality—an eternal need

Monumentality springs from the eternal need of people to create symbols for their activities and for their fate or destiny, for their religious beliefs and for their social convictions.

Every period has the impulse to create symbols in the form of monuments, which, according to the Latin meaning are "things that remind," things to be transmitted to later generations. This demand for monumentality cannot, in the long run, be suppressed. It will find an outlet at all costs.

Pseudomonumentality

Our period is no exception. For the present it continues the habits of the last century and follows in the tracks of pseudomonumentality. No special political or economic system is to blame for this. No matter how different they may be in their political and economic orientations, whether the most progressive or the most reactionary, there is one

28

point where the governments of all countries meet: in their conception of monumentality.

Pseudomonumentality has nothing to do with Roman, Greek, or any other style or tradition. It came into being within the orbit of Napoleonic society which imitated the manner of a former ruling class. Napoleon represents the model that gave the nineteenth century its form: the self-made man who became inwardly uncertain.

The origin of pseudomonumental buildings can be found in the paper architecture and lifeless schemes that later became reality everywhere.

a. *Jean Nicolas L. Durand* (1760–1834): *Design for a Museum, 1801–1805.* A typical example of paper architecture. Durand's architectural propositions and teaching examples retain their influence in countless government offices. The formula is always the same: take a curtain of columns and place it before any structure, regardless of whether it serves any purpose or of whatever consequences may follow upon the decision.

A prototype is the scheme for a museum by J. N. L. Durand (1760–1834), illustrated in his lectures *Précis de leçons d'architecture* (1801–1805) which were many times translated and reprinted and were used by architects of every country (fig. a). His lectures are forgotten today, but the buildings which resulted from their study are still standing and new ones have been added in a continuous stream for 140 years. The recipe is always the same: take some curtains of columns and put them in front of any building, whatever its purpose and whatever the consequences.

One could compile an immense square of "monumental edifices" of the whole world, erected in recent years, from the Hall of German Art, 1937, at Munich (fig. 10) or the Mellon Institute, 1937, at Pittsburgh (fig. 11), to recent

museums in Washington, or similar buildings in Moscow.

The palace of the League of Nations at Geneva (finished 1935) is perhaps the most distinguished example of internationally brewed eclecticism. The moral cowardice reflected in its architecture seems to have an almost prophetic affinity to the failure of the League itself.

How can this be explained?

Those who govern and administer may be the most brilliant men in their fields, but in their emotional or artistic training, they reflect the average man of our period, plagued as he is by the rift between his methods of thinking and his methods of feeling. The thinking may be developed to a very high level, but the emotional background has not caught up with it. It is still imbued with the pseudo-ideals of the nineteenth century. Is it, then, any wonder that most official artistic judgments are disastrous, or that the decisions made for urban planning, monuments, and public

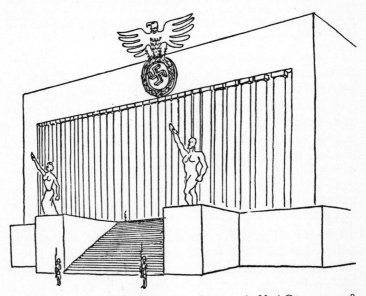

b. *Osbert Lancaster: "Monumental" architecture in Nazi Germany, 1938.*

30

buildings are without contact with the real spirit of the period?

The lost sense of monumentality
Periods of real cultural life had always the capacity to project creatively their own image of society. They were able to build up their community centers (agora, forum, medieval square) to fulfill this purpose.

Our period, up to now, has proved itself incapable of creating anything to be compared with these institutions. There are monuments, many monuments, but where are the community centers? Neither radio nor television can replace the personal contact which alone can develop community life.

All this is easily recognizable, but accusations alone do not help. We have to ask: what can be done?

The question of how to keep the people from going fur-

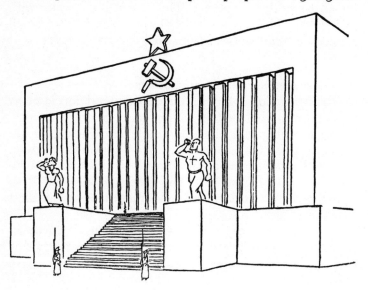

c. *Osbert Lancaster: "Monumental" architecture in Soviet Russia, 1938.*

ther astray cannot easily be solved. Only complete frankness will be of any use, frankness on both sides, of those who have to re-create the lost sense for monumentality, and those who will profit by it; of the artist on one hand, and the client on the other.

We outlined the reasons why architecture had to cut itself off from the past, and why architects had to concentrate on functional problems and to reëducate themselves through them. This had its consequences.

Didn't the new architects tend to ignore the higher aspirations of the people? That this danger still exists cannot be denied. In countries where modern architecture has won the battle and been entrusted with monumental tasks involving more than functional problems, one cannot but observe that something is lacking in the buildings executed.[3] "Something" is an inspired architectural imagination able to satisfy the demand for monumentality. What is more, architects, sculptors, and painters have become unaccustomed to working together. They have lost contact with each other. There is no collaboration. Why? Because all three have been banished from the great public tasks.

The community's emotional life

The situation of today's modern painter differs in many respects from that of the avant-gardists of the late nineteenth century. Paul Cézanne was proud when he could sell one of his pictures for 100 francs. Today, many private and public collections are filled with the paintings of Picasso, Bracque, Léger, Miró, and others. Modern art is regarded as a sure investment and America owns the most important collections.

But in one respect the situation remains unchanged: art is still regarded as luxury, and not as the medium to shape the emotional life in the broadest sense.

Only in exceptional cases (for example, Picasso's "Guer-

[3] This was written in 1944; compare Part 6, written in 1954 and 1956.

nica" in 1937) have creative contemporary artists been allowed to participate in a community task. Precious artistic forces, capable of providing the symbols for our period, linger unused—as in the nineteenth century when Edouard Manet vainly offered to paint free of charge murals depicting the real life of Paris on the walls of the City Hall.

Yes, the best known artists today sell well, but there are no walls, no places, no buildings, where their talents can touch the great public; where they can form the people and the people can form them.

Again and again it has been reiterated that modern art cannot be understood by the public. We are not sure that this argument is absolutely correct. We only know that those who govern and administer public taste are without the necessary emotional understanding.

Is the artist estranged from life? There are several reasons to believe that he is not. But the artist has been unable to do anything about it because he has been artificially expelled from direct contact with the community.

There are reasons to believe that the modern artists are right. Remember that, throughout the whole nineteenth century, the masses, poor and rich, under the domination of the press, academy, and governments, were always wrong in their taste and judgment, and that all the official art of that period appears so ridiculous today that the museums no longer show it to the public. Those artists, on the other hand, who had been driven into seclusion, reveal the creative spirit which permeated the nineteenth century.

The same situation exists today. Nothing has changed in this respect. I have seen in painting, sculpture, architecture, and poetry, a long row of artistic leaders (by this I mean those who shape our emotional life) living their isolated existence, far from the public and the understanding of those who could have brought them in touch with the community. How is it possible to develop an art "satisfying" to the people when those who personify the creative forces are not allowed to work upon the living body of our period?

33

Not the imitator, only the imaginative creator is fitted to build our absent centers of social life which can awake the public once more to their old love for festivals, and incorporate movement, color, new materials, and our abundant technical possibilities. Who else could utilize these means to open up new ways for invigorating community life?

I am not aware of any period but our own which, to such a frightening extent, has wasted its few available creative forces.

The demand for a decent social life for all has finally been recognized, after more than a century's fight.

The demand for shaping the emotional life of the masses is still unrecognized. Regarded as inessential this is left mostly in the hand of speculators.

Painting points the way

Painting, the most sentient of the visual arts, has often forecast things to come.

It was painting which first realized the spatial conception of our period and discovered methods of representing it.

Later, in the thirties, by these same artistic means, the horror of the war to come was foreshadowed many years before it came, when, for instance, Picasso around 1930 painted his figures with strange abbreviations and sometimes terrifying lines which most of us did not understand until these forms and expression were verified by later events. His "Monument in Wood," 1930 (fig. 14) may serve to illustrate this phenomenon.

It is a sketch for a modern sculpture of enormous scale. Picasso did not specify for what purpose these 1930 studies for a monument were meant. But it is now clear that these sketches forecast the reality and the inherent significance of the symbol did not reveal itself until later.

It symbolizes our attitude toward the war (of 1939–1945). It does not glorify war in a heroic gesture, as the

34

Napoleonic Arc de Triomphe on the Place de l'Etoile. It stands as a memorial to the horror of this period and of its tragic conflict: the knowledge that mechanized killing is not the way to solve human problems, but that nevertheless it has to be done.

It is frightening. It tells the truth. It has the *terribilita* that—for his contemporaries—emanated from Michelangelo's late sculptures, a terrifying threat which Picasso translates into present-day language.

Now, at a moment when we are living in blood and horror, painting announces another period. This is the rebirth of the lost sense of monumentality.

One trend can be observed in recent years, common to nearly all of the leading painters. Together with the urge for larger canvases, brighter colors have appeared, full of inherent hope. At the same time there is an impulse toward simplification. This has occurred after a development of three decades during which modern painting has become ripe for great tasks. Great and unresolved complexes have had to be expressed in the shortest, most direct way. What began as necessary structural abbreviations now emerge as symbols. The work of Arp, Miró, Léger, and many others is moving in this direction.

Modern artists have created these symbols out of the anonymous forces of our period. Nobody asked for them, they have just appeared. They have no factual content, no significance at the moment other than emotional response. They are not for those whose emotional life is still imbued with the last century's official taste. But children can understand them, because these figurations are as close to primitive life as they are to our complicated civilization.

For the first time in centuries artists have returned to the simplicity which is the hallmark of any kind of symbolic expression. They have shown that the elements indispensable for monumentality are available. They have acquired the rare power of a mural language.

Once more painting may forecast the next development in architecture. But not only in architecture; it may forecast a newly integrated life, far removed from the devastating idolatry of production.

Great changes are necessary in many spheres to accomplish this demand; and not least in the emotional domain. This is the moment when painting, sculpture, and architecture should come together on a basis of common perception, aided by all the technical means which our period has to offer.

Corn is planted for the winter. Wars have been prepared in peace. Why should not peace be prepared in war? The means for a more dignified life must be prepared before the demand arises. Will these means be utilized?

Technical and emotional means

There is an enormous backlog of new means and unused possibilities held in reserve by engineers and inventors of all kinds. At the same time there exists a tragic inability to use these treasures and to merge them into our human emotional needs. No period has had so many means and such a lack of ability to use them.

In one of his essays, T. S. Eliot says the seventeenth-century poets, "possessed a mechanism of sensibility which could devour any kind of experience." [4] Their emotional and their mental apparatus functioned like communicating tubes. Technical and scientific experiences inevitably found their emotional counterpart, as is revealed in the artistic creations of that period. This is just what we lack. Today this direct contact, this coherence between feeling and thinking, has vanished.

Now, after the great horrors of our period, age-old, perennial problems arise again. We have banned from life the artistic expression for joy and festivities. Both have to be

[4] T. S. Eliot, "The Metaphysical Poets," *Selected Essays* (New York, 1932), p. 247.

36

incorporated into human existence and are as necessary for our equilibrium as food and housing. That we have become incapable of creating monuments and festivals and that we have lost all feeling for the dignity of urban centers is tied up with the fact that our emotional life has been regarded as unessential and as a purely private affair. Behold the patterns of present-day cities!

Urban centers and spectacles

Urban centers will originate when cities are not regarded as mere agglomerations of jobs and traffic lights. They will arise when men become aware of the isolation in which they live in the midst of a turbulent crowd, and when the demand for a fuller life—which means community life —becomes irresistible. Community life is closely connected with an understanding of relaxation, with the urge for another vitalizing influence besides the job and the family— an influence capable of expanding men's narrow private existence.

No great civilization has existed which has not fulfilled man's irrepressible longing for institutions where such broader life can develop. In different periods these institutions have had different aims, but, whether called the Greek gymnasium or agora, the Roman thermae or forum, the medieval cathedrals or market places, all have contributed to the development of human values. These institutions were never conceived of as financial investments. Their function was not to produce money or to bolster up a waning trade.

The urban center of the coming period will never be a neighbor to slums. It should not be financed by bond issues on the basis that its cost will be self-liquidating within a period of years. The means must come from the community.

Community centers? What has the economist to say about the large expenditures involved in their building?

The hope of our period is that diverse groups are moving

unconsciously in parallel directions. The liberal economists, such as John Maynard Keynes, are stressing the fact that economic equilibrium can only be obtained by a surplus production not destined for daily use. Goods must be produced which cannot be conceived of in terms of profit or loss, supply and demand. Keynes does not speak of urban centers, he deals with the theory of employment and money. He observes that today the necessary large-scale expenditures for nonconsumable goods are only admissible in the case of catastrophes such as earthquakes, war, or "digging holes in the ground known as gold-mining which adds nothing to the real wealth of the world. The education of our statesmen on the principles of classical economics stands in the way of anything better." [5] Why not keep the economic machinery going by creating urban centers?

The problem ahead of us focuses on the question: Can the emotional apparatus of the average man be reached? Is he susceptible only to football games and horse races? We do not believe it. There are forces inherent in man, which come to the surface when one evokes them. The average man, with a century of falsified emotional education behind him, may not be won over suddenly by the contemporary symbol in painting and sculpture. But his inherent, though unconscious, feeling may slowly be awakened by the original expression of a new community life. This can be done within a framework of urban centers and in great spectacles capable of fascinating the people.

Anyone who had occasion during the Paris Exhibition of 1937 to observe the hundreds of thousands lined up in the summer evenings along the banks of the Seine and on the Trocadero bridge, quietly waiting for the spectacles of fountains, light, sound, and fireworks, knows that the persistent predisposition for dramatic representation, even in the form of abstract elements, has not been lost. There is no difference in this respect between Europe and America.

[5] J. M. Keynes, *The General Theory of Employment Interest and Money* (New York and London, 1936), p. 129.

In 1939, at the New York World's Fair, when aerial plays of water, light, sound, and fireworks were thrown into the sky, a sudden spontaneous applause arose.

Everybody is susceptible to symbols. Our period is no exception. But those who govern must know that spectacles, which will lead the people back to a neglected community life, must be reincorporated within urban centers—those very centers which our mechanized civilization has always regarded as inessential. Not haphazard world's fairs, which in their present form have lost their old significance, but newly created urban centers should be the site for collective emotional events, where the people play as important a role as the spectacle itself, and where a unity of the architectural background, the people, and the symbols conveyed by the spectacles, will be achieved.

ON MONUMENTALITY AND COLOR

(Written by Fernand Léger)

Colored space.

The craving for color is a natural necessity just as for water and fire. Color is a raw material indispensable to life. At every era of his existence and of his history, the human being has associated color with his joys, his actions, and his pleasures.

The flowers come into the home: the most usual objects cover themselves with color. Dresses, hats, make-up—all these things call for decorative attention the whole day long. It is color which remains the chief interest. Its action is multiple. Inside and outside, color imposes itself victoriously everywhere.

Modern publicity has taken possession of color and roads are framed with violent-colored posters, which are destroying the landscape. A decorative life is born out of this main preoccupation, it has imposed itself upon the whole world.

So color and its dynamic or static function, its decorative or destructive possibilities in architecture, is the reason for this study. Possibilities for a new orientation in mural painting exist; they should be utilized.

A bare wall is a "dead, anonymous surface." It will come alive only with the help of objects and color. They can give life to the wall or destroy it. A stained, colored wall becomes a living element.

The transformation of the wall by color will be one of the most thrilling problems of modern architecture of this present or the coming time.

For the undertaking of this modern mural transformation, color has been set free. How has color been set free?

Until the pictorial realization by the painters of the last

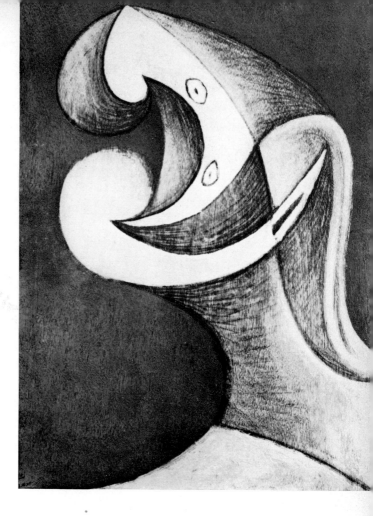

14. *Pablo Picasso* (*born* 1881): *Monument in Wood*, 1930. This painting is a sketch for a sculpture of enormous dimensions. Picasso never named the situation for which he designed this terrifying head in 1930. But today (1943) its inner meaning becomes slowly evident. It declared what was to come.

This sickle-shaped head-like form, with its cavities and spikes, is both monstrous and human, and symbolizes our attitude toward war. It does not glorify war, like the Napoleonic Arc de Triomphe on the Place de l'Etoile. This sketch in oils is a projection of the horrors of our period and its tragic conflict: to know that committing mechanized murder can solve no human problems, and yet be obliged to do it.

This monument is terrifying. Its symbolism shows war for what it is, ten years before the actual events. Its form emanates the same *terribilita* that Michelangelo's contemporaries sensed from his sculptures. A fearful warning, which Picasso sets forth in a modern idiom.

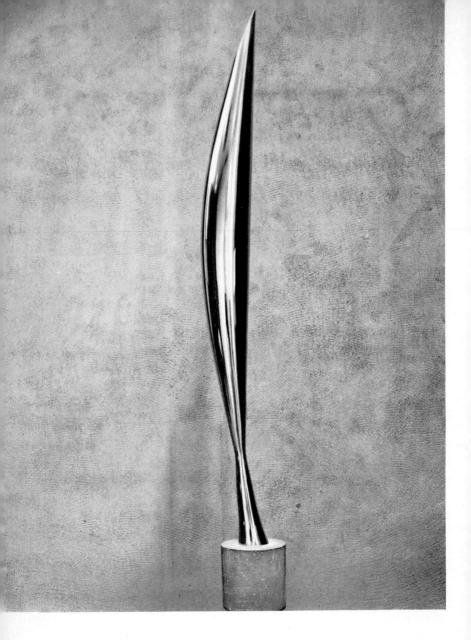

15. *Constantin Brancusi* (1876–1956): *Bird in Space, 1922–1941.* In magnif-
icent simplicity this elastic vertical seems to lunge directly upward and claim
possession of all space: "Bird created to penetrate the heavenly vault," in the
words of Brancusi. It required thirty years of labor before this sculpture came
to its final form. "Simplicity is not an end in art, but one arrives at simplicity
in spite of oneself, in approaching the real sense of things" (Brancusi).

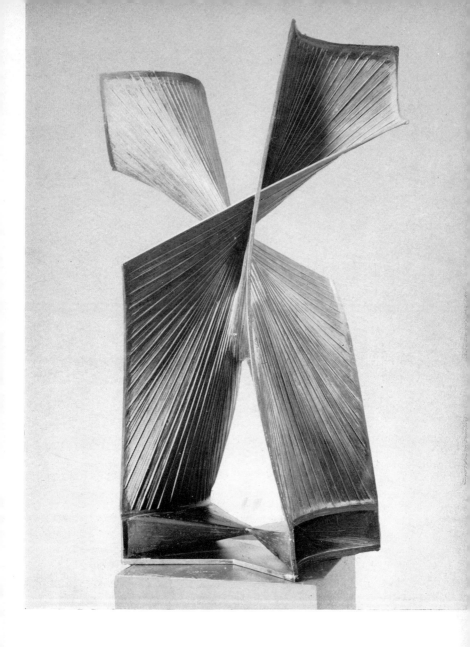

16. *Antoine Pevsner (born 1886): La Colonne Développable de la Victoire, 1946.* A column of victory developed from the wartime sign of "V for Victory." Its hollowing out of space is achieved by the juxtaposition of small straight steel rods, whose color changes with the angle of light.

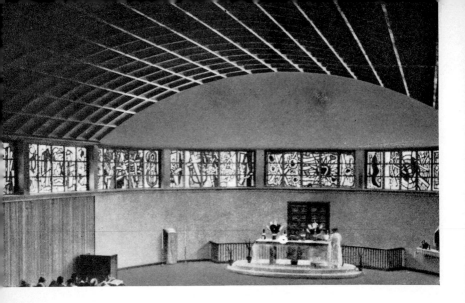

17. *Fernand Léger* (1881–1955): *Stained glass windows for the church at Audincourt, 1950.*

18. *Detail.* Christ before Pilate is symbolized by a lamb and a pair of blood-bespattered hands being washed in a basin.

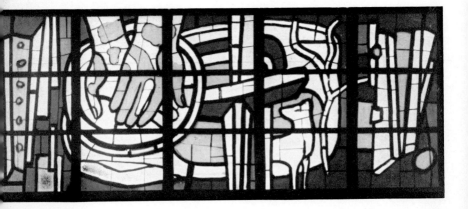

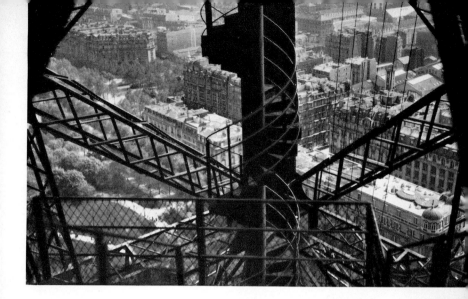

19. *The Eiffel Tower, 1889: view from the spiral stairway.* All unconsciously the forms of the engineers' constructions of the nineteenth century gave rise to a wider space conception than the work of either architects or painters. The simultaneity of inner and outer space and the everchanging point of view had never been perceived so strongly before.

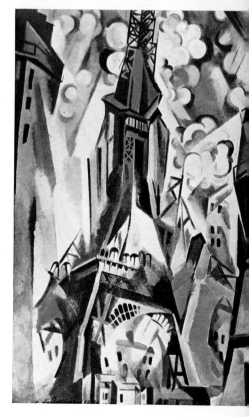

20. *Robert Delaunay (1885–1941): The Eiffel Tower, 1910.* The emotional content of the Eiffel Tower was first given artistic expression two decades later in the work of the poets Apollinaire and Blaise Cendrars, and the painter Delaunay.

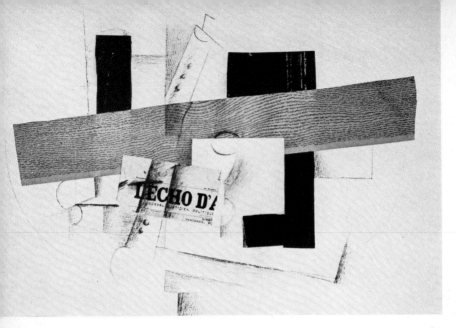

21. *Georges Braque (born 1882): The Clarinet, Collage, 1913.* Painters, architects, and even engineers, employed the plane surface as a means of presenting the new possibilities of expression.

22. *Piet Mondrian (1872–1944): Composition, 1930.*

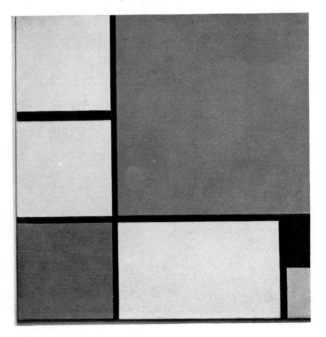

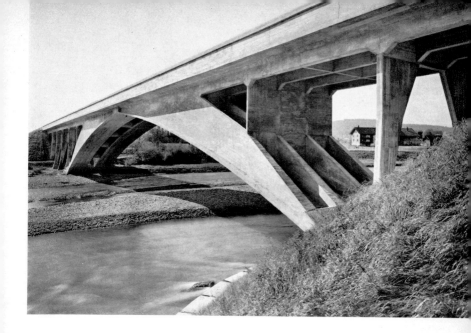

THE SLAB AS A CONSTITUENT ELEMENT

23. *Robert Maillart (1872–1940): Bridge over the River Thur near Saint-Gall,* 1933. All parts of Maillart's bridges, even the pavements, are active elements of the construction system that is based upon the flat plane or slab.

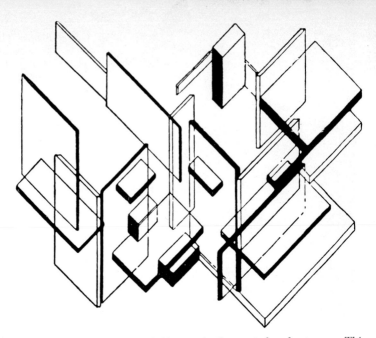

24. *Theo van Doesburg* (1883–1931): *Space study, about* 1920. This house was conceived as a transparent relationship between horizontal and vertical planes.

25. *Le Corbusier* (*born* 1887): *Construction system of the Domino House,* 1915. This construction system consists of three reinforced concrete slabs with separating supports.

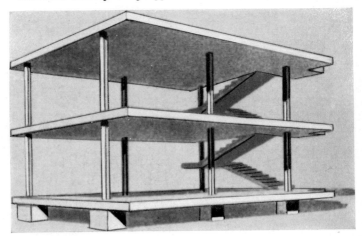

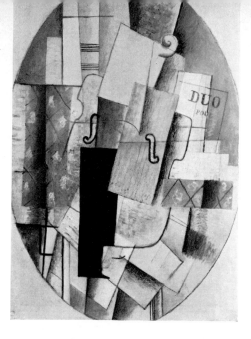

26. *George Braque: The Violin, 1914.* The advancing and receding planes of cubist pictures, floating, interpenetrating, and often completely transparent, stand in the greatest contrast to the converging lines of perspective.

27. *Rockefeller Center, New York City, 1931–1939.* The slab-like forms of the various tall elements that make up the Rockefeller Center betoken a revolt against the old solid skyscraper tower. The offices are all functionally organized around the peripheries.

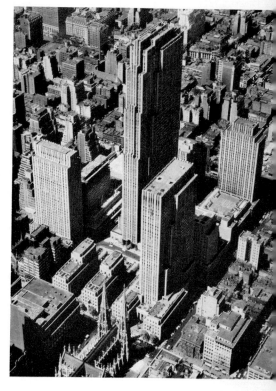

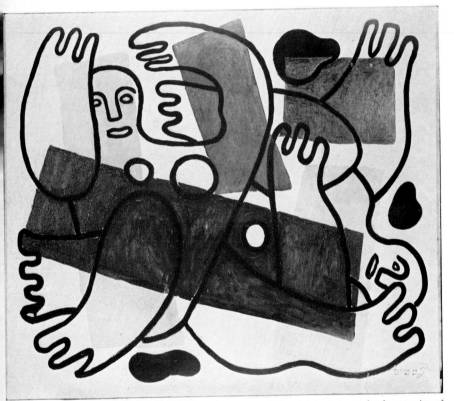

28. *Fernand Léger: The Bathers*, 1943. This picture is one of a long series of "bathers" and "divers" which Fernand Léger painted during his time in New York. In these, like Seurat (Fig. 12) or Picasso (*Dinard bathers, 1927*), Léger takes a banal daily event—the "subject"—and changes it into an "object." In other words, the artist extracts and immortalizes the secret eternal content of a gesture or a situation.

fifty years, color or tone, were fast bound to an object, to a representative form. A dress, a human being, a flower, a landscape, had the task of wearing color.

In order that architecture should be able to make use of it without any reservations, the wall had first to be freed to become an experimental field. Then color had to be got out, extricated, and isolated from the objects in which it had been kept prisoner.

It was about 1910, with Delaunay, that I personally began to liberate pure color in space.

Delaunay developed an experience of his own, keeping the relations of pure complementary colors (it was really the continuation on a larger and more abstract scale of the New Impressionists). I was seeking out a path of my own in an absolutely opposite sense, trying to avoid so much as possible complementary relations and to develop the strength of pure local colors.

In 1912, I got some pure blue and pure red rectangles into the picture ("Femme en bleu," 1912).

In 1919, with "La Ville," pure color, written in a geometrical drawing, found itself realized at its maximum. It could be static or dynamic; but the most important thing was to have isolated a color so that it had a plastic activity of its own, a plastic activity without being bound to any object.

It was modern publicity which at first understood the importance of this new value: the pure tone ran away out from the paintings, took possession of the roads, and transformed the landscape!

Mysterious abstract signals made of yellow triangles, blue curves, red rectangles spread around the motorist to guide him on his way.

Color was the new object, color set free. Color had become a new reality. The color-object had been discovered. It was about this time that architecture in turn understood how it would be possible to utilize this free color (color set free), its possibilities inside and outside the building.

Decorative papers began to disappear from the walls. The white naked wall appeared all of a sudden. One obstacle: its limitations. Experience will be able to lead toward the colored space.

The space, that I shall call the "habitable rectangle" is going to be transformed. The feeling of a jail, of a bounded, limited space, is going to change into a boundless "colored space."

The "habitable rectangle" becomes an "elastic rectangle." A light blue wall draws back. A black wall advances, a yellow wall disappears. Three selected colors laid out in dynamic contrasts can destroy the wall.

Destruction of a wall

The new possibilities are numerous. A black piano, for instance, before a light yellow wall, creates a visual shock, which is able to reduce the "habitable rectangle" to half its dimensions.

The visual and decorative revolution will appear even stronger if you put the pieces of furniture in an asymmetrical organization. Our visual education has been symmetrical. Modern scenery can be absolutely new if we employ asymmetry.

From a fixed dead condition in which no play, no fancy can be allowed, we are coming into a new domain which is absolutely free.

No possibility of interior arrangement was given to our imagination within the stiffness of the symmetric order.

We all have been educated in this symmetrical tradition. It is very strong as most middle-class people are still bound to this traditional order.

An anecdote can bring out the strength of this habit of mind.

Living in the Parisian suburbs, I had in my room an old, large chest of drawers, on which I put some personal artistic objects. I liked to place them always in an asymmetrical

way: the most important object on the left side and the others in the middle and on the right.

I had a maid, a girl of the people, who cleaned this particular room every day. When I came back in the evening, I always found my objects symmetrically arranged: the most important in the center and the others symmetrically placed on each side. It was a silent battle between the maid and me, but a very long fight, because she thought my objects were placed in a disorderly fashion.

Perhaps a round house would be the place to study this. It would be the best way to perceive "the spatial and visual destruction of the wall." The angle has a geometrical resistant strength which is only destroyed with difficulty.

The exterior volume of an architecture, its sensitive weight, its distance, can be reduced or increased as a result of the colors adopted.

The "exterior block" can be attacked, in the same way as the interior wall.

Why not undertake the polychrome organization of a street and of a city?

During the First World War, I spent my furloughs in Montparnasse; there I had met Trotsky and we often spoke about the thrilling problem of a colored city! He wanted me to go to Moscow because of the prospect of a blue street and a yellow street had raised some enthusiasm in him.

I think that it is in the urbanism of middle-class housing, the habitations where the workers are dwelling, that the need for polychromy is most evident. An artificially increased space needs to be given to the people in these areas.

No serious attempt has been made as yet in this direction. The poor man, or the poor family, cannot find a space of liberation through the help of a masterpiece upon his wall, but he can become interested in the realization of a colored space. Because this colored space is bound up with his inner needs for light and color. These are vital needs: necessities.

Color set free is indispensable to urban centers.

The urban center.

Polychrome problem, interior and exterior: a shaded view of static façades leading, for instance, to an attractive central place. At this place I conceive a spectacular, mobile, bright monument with some possibilities of change (attractive, powerful means), giving it the same importance as the form of the church that Catholicism has so well succeeded in imposing upon every village.

Liberated color will play its part in blending new modern materials and light will be employed to make an orchestration of everything.

The psychological influences, conscious or unconscious, of these factors, light and color, are very important. The example of a modern factory in Rotterdam is conclusive. The old factory was dark and sad. The new one was bright and colored: transparent. Then something happened. Without any remark to the personnel, the clothes of the workers became neat and tidy. More neat and tidy. They felt that an important event had just happened around them, within them. Color and light had succeeded in creating this new evolution. Its action is not only external. It is possible, while leaving it to grow rationally, wholly to change a society.

The moral emancipation of a man becoming conscious of three dimensions, of exact volume of weight! This man is no more a shadow, working mechanically behind a machine. He is a new human being before a transformed daily job. This is tomorrow's problem.

Paris Exhibition, 1937. The organizers summoned a number of artists to try to find an attractive sensational effect; a spectacular effect, which in their minds would bribe the visitors to keep the fete in memory when they went back home. I proposed: Paris all white! I asked for 300,000 unemployed persons to clean and scrape all the façades.

To create a white, bright city! In the evening, the Eiffel Tower, as an orchestral conductor, with the most powerful projectors in the world, would diffuse along these streets, upon those white and receptive houses, bright many-colored lights (some airplanes would have been able to cooperate

44

in this new fairy scene). Loud speakers would have diffused a melodious music in connection with this new colored world . . . My project was thrown back.

The cult of the old patinas, of the sentimental ruins: the taste for ramshackle houses, dark and dirty, but so picturesque, are they not? The secular dust which covers the historic, stirring remembrance, did not permit my project the opportunity of realization.

The polychrome clinic, the color cure, was a new unknown domain beginning to thrill young doctors: some green and blue wards for nervous and sick people, some others painted yellow and red, stimulating and nutritious for depressed and anemic people.

Color in social life has indeed a great role to fill. Color tries to cover over humdrum daily routines. It dresses them up. The humblest objects use it as a concealment of their real purpose. A bird on a handkerchief, a flower on a coffee cup. A decorative life.

Color keeps within itself its eternal magic which, like music, allows truth to be wrapped around. The men who like truth, who like to think of living with it raw, without any retouching, are scarce. Creators in all domains know how difficult it is to use truth, how it becomes dangerous to be too "true." Expressive strength resides in a balanced verity.

The work of art is a perfect balance between a real fact and an imaginary fact.

Pure color is more true in the realistic sense than shaded color. But the majority of the people like shaded colors . . . Color is a strength with two sharp knives. Sometimes when it has broken loose it attacks and destroys without any restraint, sometimes it lightly enfolds things and objects within a zone of good taste, which is called "la vie décorative."

The future will certainly belong to the effective collaboration between the three major arts: architecture, painting, sculpture. Since the Italian Renaissance, which was a time

of fullness for these three arts, no epoch has been able to keep this artistic collectivity alive.

It is for us to undertake this problem though under another aspect. The successive liberations which, since Impressionism, have allowed modern artists to escape from the old constraints (subject, perspective, copy of the human form) allow us to realize a wholly different architectural unity.

New materials, liberated color, the liberty of invention are able to transform the problem and to create new spaces. It is especially in the measuring of quantities, in a conscientious rationalism, that modern architecture must impose itself as the orchestral conductor of this collaboration. The present sickening profusion, this heaping up of works of art, should be avoided: they are making the art of the Renaissance into a confusion without example. A measure, a rule, the acceptance of constraints, a discipline, should be accepted by all three parties. This should be the basis of any collective work.

Daily we hear the word "beautiful": the beautiful bridge, the beautiful automobile. This feeling of beauty which is awarded to useful constructions is a proof of the enormous need which men feel within them for an escape through art.

The same term is used for a lovely sunset. There is then a common term between natural beauty and manufactured beauty.

Then why not make, why not manufacture the monument of beauty?

Useful for nothing, a magnificent place to repose, which would be a shelter for the anonymous crowd during their enervating day with its hurried rhythm, which is our cadence. It is possible to realize it, with the use of the new liberties, by means of the major arts: color, music, form. Everything is set free! Let us think of former times, when so many magnificent temples were built, which mark and express those passed civilizations.

It would be unbelievable that ours should not achieve

46

its popular temples. Architecture, in every time, has been the means of plastic expression most sensitive to the people: the most visual, the most grandiose. It dominates the view and fixes the gaze.

Architecture can be aggressive or welcoming, religious or utilitarian. In every case it is "ready for use" for us in a freer sense than ever before.

The exaltation of 80,000 spectators watching a football game is not the climax but the end of civilization. The new temple must foresee an answer to a natural need as important as this is for a great sports show.

Imagine a dazzling point, in which the feeling of bright, light steeples, religion, the need for verticality, high trees and factory chimneys would come to be unified and blended.

Man enthusiastically lifts his arms above his head to express his joy in this elevation. To make high and free. To-morrow's work.

NINE POINTS ON MONUMENTALITY

(Written by J. L. Sert, F. Léger, S. Giedion)

Que donneriez vous ma belle
Pour revoir votre mari?
 Je donnerai Versailles,
Paris et Saint Denis
Les tours de Notre Dame
Et le clocher de mon pays.
Auprès de ma blonde
Qu'il fait bon, fait bon, fait bon.
(From an old French song,
"Auprès de ma blonde")

(1) Monuments are human landmarks which men have created as symbols for their ideals, for their aims, and for their actions. They are intended to outlive the period which originated them, and constitute a heritage for future generations. As such, they form a link between the past and the future.

(2) Monuments are the expression of man's highest cultural needs. They have to satisfy the eternal demand of the people for translation of their collective force into symbols. The most vital monuments are those which express the feeling and thinking of this collective force—the people.

(3) Every bygone period which shaped a real cultural life had the power and the capacity to create these symbols. Monuments are, therefore, only possible in periods in which a unifying consciousness and unifying culture exists. Periods which exist for the moment have been unable to create lasting monuments.

(4) The last hundred years have witnessed the devaluation of monumentality. This does not mean that there is any lack of formal monuments or architectural examples

48

pretending to serve this purpose; but the so-called monuments of recent date have, with rare exceptions, become empty shells. They in no way represent the spirit or the collective feeling of modern times.

(5) This decline and misuse of monumentality is the principal reason why modern architects have deliberately disregarded the monument and revolted against it.

Modern architecture, like modern painting and sculpture, had to start the hard way. It began by tackling the simpler problems, the more utilitarian buildings like low-rent housing, schools, office buildings, hospitals, and similar structures. Today modern architects know that buildings cannot be conceived as isolated units, that they have to be incorporated into the vaster urban schemes. There are no frontiers between architecture and town planning, just as there are no frontiers between the city and the region. Corelation between them is necessary. Monuments should constitute the most powerful accents in these vast schemes.

(6) A new step lies ahead. Postwar changes in the whole economic structure of nations may bring with them the organization of community life in the city which has been practically neglected up to date.

(7) The people want the buildings that represent their social and community life to give more than functional fulfillment. They want their aspiration for monumentality, joy, pride and excitement to be satisfied.

The fulfillment of this demand can be accomplished, with the new means of expression at hand, though it is no easy task. The following conditions are essential for it: A monument being the integration of the work of the planner, architect, painter, sculptor, and landscapist demands close collaboration between all of them. This collaboration has failed in the last hundred years. Most modern architects have not

been trained for this kind of integrated work. Monumental tasks have not been entrusted to them.

As a rule, those who govern and administer a people, brilliant as they may be in their special fields, represent the average man of our period in their artistic judgments. Like this average man, they experience a split between their methods of thinking and their methods of feeling. The feeling of those who govern and administer the countries is untrained and still imbued with the pseudo-ideals of the nineteenth century. This is the reason why they are not able to recognize the creative forces of our period, which alone could build the monuments or public buildings that should be integrated into new urban centers which can form a true expression of our epoch.

(8) Sites for monuments must be planned. This will be possible once replanning is undertaken on a large scale which will create vast open spaces in the now decaying areas of our cities. In these open spaces, monumental architecture will find its appropriate setting which now does not exist. Monumental buildings will then be able to stand in space, for, like trees or plants, monumental buildings cannot be crowded in upon any odd lot in any district. Only when this space is achieved can the new urban centers come to life.

(9) Modern materials and new techniques are at hand: light metal structures; curved, laminated wooden arches; panels of different textures, colors, and sizes; light elements like ceilings which can be suspended from big trusses covering practically unlimited spans.

Mobile elements can constantly vary the aspect of the buildings. These mobile elements, changing positions and casting different shadows when acted upon by wind or machinery, can be the source of new architectural effects.

During night hours, color and forms can be projected on vast surfaces. Such displays could be projected upon build-

ings for purposes of publicity or propaganda. These buildings would have large plane surfaces planned for this purpose, surfaces which are nonexistent today.

Such big animated surfaces with the use of color and movement in a new spirit would offer unexplored fields to mural painters and sculptors.

Elements of nature, such as trees, plants, and water, would complete the picture. We could group all these elements in architectural ensembles: the stones which have always been used, the new materials which belong to our times, and color in all its intensity which has long been forgotten.

Man-made landscapes would be correlated with nature's landscapes and all elements combined in terms of the new and vast façade, sometimes extending for many miles, which has been revealed to us by the air view. This could be contemplated not only during a rapid flight but also from a helicopter stopping in mid-air.

Monumental architecture will be something more than strictly functional. It will have regained its lyrical value. In such monumental layouts, architecture and city planning could attain a new freedom and develop new creative possibilities, such as those that have begun to be felt in the last decades in the fields of painting, sculpture, music, and poetry.

SOME WORDS ON FERNAND LÉGER

During the Second World War the French painter Fernand Léger (1881–1955) lived in the United States. This was the period during which he produced some of his finest paintings. Léger was a foremost example of a painter who urgently wanted to work together with the architect: *Donnez-moi des murs!* This interest was evident from the time of his early work. In one of his first large paintings, "La Ville" (1919), the symbol of the mechanized town was displayed by signs and fragments. This painting is more an early example of a contemporary mural than an easel painting destined for a museum.

Our period would have been far richer if it had only known how to use the strength and simplicity of Fernand Léger, his power to translate subjects into objects, as he liked to say, and his capacity to juxtapose pure colors. His vitality appeared undiminished right up till the news came of his sudden death. After inserting his own contribution to our discussion on monumentality, permit me to include the lines that I was impelled to write when I received this bad news on a brilliant August morning in the Engadine.

Fernand Léger is the first of the great generation of septuagenarians to fall, and the last one would have expected to do so. Seeing him in his country place, in all his marvelous, rough-boned vigor, whose freshness was undimmed by time, one would have expected him to have a goodly amount of life at his disposal. He had only recently found an old country house in Gif sur Yvette, about fifteen miles from Paris. Abutting it was a former dance hall, with small chambers on the upper floor, "for gallant purposes," as he said. He had had everything cleared out and the place made into a lofty studio. There he stood, in his customary blue smock, a workman's cap on his head, surrounded by the large forms

of his pictures—just as grim and independent as the unfaltering outlines of his paintings; for he had, as no other, the ability to extract from the complexity of appearances their ultimate simplicity.

It is true that, through this, he exerted an immense influence on poster painting, but in his own art he was seeking something completely different. It was in no way related to short-lived publicity. What he was seeking is shown in the stained glass windows of the church of Audincourt near Belfort: the simplification of things till they can display their symbolic content (fig. 17). In these windows, which encircle the architecturally medieval church like a magic girdle, there are no "figures," only fragments of the tragic story of the Passion. One of them depicts "Christ before Pilate." There is no Christ, no Pilate, no henchmen, no people at all. At one side is the Lamb of God and in the center two hands are being washed—gigantic hands, like those of Léger himself—in a basin: blood flows over them in broad streaks (fig. 18). This fragment was sufficient to move the peasants and workers of Audincourt. The fragment stands as a symbol of our time.

Léger rebuilt his country place in the Chevreuse Valley without an architect. He thought it would serve him for a long time.

Here he invited his friends. A table was pushed into the studio and spread in the midst of the paintings. One ate here with delight, with all the necessary reverence a good meal deserves, for Léger was a first-class cook. He was also, in contrast to many great men, a most excellent companion. Some female creature was always around the place, but he never paraded this before the world. For him the problems of his work rested on a completely different level. I first got to know him well during a period of close contact in America 1942–1945. He lived then in New York, and, with a small circle of friends, which included the sculptor Calder and the town planner José Luis Sert, created there a kind of Parisian atmosphere, expounding plans and commenting

upon the American scene. Léger, with his Norman ancestry, could not accept America *tel quel*, but he didn't reject it in a defeatist manner as did so many Europeans. He resisted it in the sense that he opposed it with his work. This tension, as in the case of other creative natures, produced marvelous results. The paintings of his American period are, without doubt, among Léger's best work.

His studio in New York was near Fifth Avenue on 40th Street. Skyscrapers overshadowed it. Fernand Léger was working then on his great series of "Divers" which posed the problem of depicting with a simple black outline hovering, falling, interlocking and transparent figures in a weightless space (fig. 28). As he often did, Léger superimposed wide bands of clear colors. I stood in the studio with Moholy-Nagy and asked, "Why have red and blue patches been laid over the lineal structure of the bathers?" I knew that this was related to the play of contrasts that Léger always emphasized, but Moholy-Nagy gave the answer: "Don't you see that Léger must get even with those things out there?"— and he pointed to the skyscrapers. Defense by creative reaction.

Léger knew well what he needed in America for his artistic nourishment. Sundays, on several occasions, we went by bus out to La Guardia airport to look at the comings and goings of the planes from the gallery that encircles the building and to observe their movements. Each time the day ended in a lament, as he pointed to the glistening metal birds, "They are already too perfect. There is nothing for the painter to add."

Above all, Léger knew how to smell out the food he needed for his painting. Near the Canadian border is a village, Rouses Point, on Lake Champlain. Here, in from the lake, he rented a cottage. The whole district is French-speaking. I lived on the lake shore working on the last stages of *Mechanization Takes Command*. During the summers of 1944 and 1945 we daily strolled between these two points. Never before had I realized how much more the eye of the

painter sees than other people and how much deeper it is affected by appearances.

The important thing about Rouses Point was that here Léger could find artistic nourishment. He discovered a deserted farm, fifteen minutes' walk from his cottage: the house deserted, the barn full of rusted machinery already overgrown with weeds; apples hanging unpicked upon the trees. This aroused the Norman who had been brought up to be frugal with everything. And the deserted farm also aroused the imagination of the painter and provided the basis for the last pictures of his American period, which ended in 1945.

He never painted during the summer. But watercolor sketches or wash drawings accumulated one upon the other and, in fall and winter, would be placed upon canvas.

Fernand Léger was one of the few painters who have an instinctive relation with architecture. "Donnez-moi des murs," he cried ever and again. With the exception of an unsuccessful attempt in the United Nations building in New York, they were never granted to him. He had the ability to be a great mural painter. But the period did not permit his creations, in which simplicity merges into monumental greatness, to find the places for which they had been destined in advance. Now it is too late, and his ever friendly face and radiating confidence will always be lacking among those who had walked with him a step of the way.

Marginalia

Our century has quite a different attitude toward monumental sculpture than earlier periods had. This attitude is both tied to the art of eras of long-ago, and, at the same time, turned away from methods which form the basis of contemporary possibilities of artistic construction.

Through the official art of the ruling taste, which drugged the natural instincts of the people for so long, any sensitive approach to the really creative spirits of our time was lost. So it is understandable that the work of the greatest sculptors of this age has been banned from the townscape and the public view, and is concealed behind the doors of museums or private collections. The case is the same, whether their sculptures have the sublime purity of Constantin Brancusi, the organic vigor of Hans Arp's configurations, the space-emanating strength of Alberto Giacometti's figures, or the absorbing power of Antoine Pevsner's creations.

A dialogue follows which took place over the Zurich Radio in 1949, on the occasion of the opening of an exhibition of the work of Antoine Pevsner, in order to bring his art nearer to the general public. We chose, as the subject of our dialogue, one of Pevsner's most impressive sculptures, "La Colonne Développable de la Victoire" (fig. 16), which was displayed in the exhibition in model form. At that time we did not think it likely that this sculpture on which we focused our interest would be erected in something approaching the size for which it was conceived. But recently Eero Saarinen, architect of General Motors Technical Center at Detroit, had the courage to select the Colonne as the sculpture to stand, 60 feet high, before the administration building of this complex.

ON THE SPACE–EMANATING POWER OF CONTEMPORARY SCULPTURE
. (A Radio Dialogue)

SIGFRIED GIEDION: Mr. Pevsner, it is not surprising that the general public find your sculptures, or "constructions" as you yourself call them, somewhat strange. For a century and a half the public have come into daily contact with sculpture in the form of monuments which, as everyone today will own, have more and more lowered their taste and their natural sensitivity to sculpture. Things like this leave their mark.

So it is not surprising that the general public find your work, which conveys contemporary experience in quite a different way, more like a mathematically contrived shape than an expression of artistic emotion.

I have in front of me the beautiful brochure of your last exhibition, which has been brought out by the Museum of Modern Art in New York and the Galerie Drouin in Paris. It contains the manifesto which, thirty years ago, you wrote with your brother Naum Gabò, whose art is so different from your own and yet, with all its differences of means and materials, attempts to solve the same problems that concern you. Here you both state in a wonderfully succinct way, what you have since uninterruptedly carried through.

ANTOINE PEVSNER: In that manifesto of 1920 we made a new opposition to the popular conception of sculpture. Up till then only carved masses were accepted as constituting sculpture. By this means it is not possible to develop an expression of space and time. Instead of tightly shut-in masses, I make freely created, dynamic elements. The air is no longer wrapped up, it sweeps through, creating space. Light and

57

shadow become sculptural media, *éléments intégrants,* in my work.

GIEDION: I can see how you develop space between your plane surfaces. These seem to suck the space in—*ils appellent l'espace,* as Le Corbusier said. But how do you express time? What sculptural means do you use to give a three-dimensional form to time?

PEVSNER: This is achieved by planes which are conceived as in continuous development. I call them *surfaces développables.* In my sculptures there are no massive accumulations of material. I try to create perpetual movement and continuous change—the kinetic action—by means of these *surfaces développables.* They are composed of straight, thin, metal rods, carefully welded to one another and thrusting out into space in continuously changing angles. In their totality they constitute the spatial curves which my imagination imposes upon them.

GIEDION: Who carries out your sculptures?

PEVSNER: I do not let any craftsman touch my sculptures. Every rod has been laboriously welded in place by me.

GIEDION: This procedure, which in its careful craftsmanship reminds one of the tradition of the Middle Ages, seems to me also an artistic means. Perhaps here lies much of the secret of your creations. Everywhere they approach the organic and give an extraordinary impetus to the play of light. I don't know of any other sculptures which are able to absorb and to model the light with such intensity.

PEVSNER: *The surfaces développables* give one the possibility to accumulate both light and shadow and, at the same time, color. We all know that light and shadow contain the elements of color. Through refraction the *surfaces développables* change in color with changes in the intensity of light, without any direct application of color. This is a similar phenomenon to the forming of a rainbow.

58

GIEDION: You use, in principle, much the same methods to release color as you do to form your sculpture. Your planes that extend freely into space are not formed of heavily bent sheets of flat metal, but from curved planes made up of variously arranged strands of light metal. So you don't force a single color to remain always in a single place, but give life to your work by using the perpetually changing refraction freely contributed by the power of light.

Finally one more question, Mr. Pevsner. Undoubtedly your sculptures are most serious works of art which radiate out into the cosmos. Are they also in any way connected with your personal experiences?

PEVSNER: All my work relates to human experience. Take for instance the "Colonne Développable de la Victoire" as I call it.

How did it originate?

The impulse to make this sculpture was given to me by the moving experience of the entry of the Liberation Army into Paris in the early morning. The streets were crowded with an enraptured throng. Women threw themselves in ecstasy upon the ground; the people wept from happiness. The soldiers too showed their delight by stretching up their arms in the air in the magic sign of the "V" for victory. At this moment I was seized with the desire to find a symbol for this magic sign. From this grew the form of the "Colonne Développable de la Victoire."

GIEDION: This "Colonne Développable de la Victoire" seemed to me, in the exhibition hall, to be somehow a prisoner. Don't you somehow see it in the open air, in a wider expansion?

PEVSNER: I have always had the desire to see my sculptures standing amid the collective life of a great city.

GIEDION: Whoever senses the pulsing life in your metal sculptures, must feel that they are not just carefully considered constructions but far more creative projections of

59

organic life, with eternally dynamic happenings from the ever-changing light to the phenomenon of birth. To reveal their full intensity they need a free atmosphere, with the ever-changing nuances of natural light that no artificial lighting can reproduce.

I hope that we shall still see the beating wings of your "Colonne Développable de la Victoire"—this symbol of never resting nature freeing herself from the embrace of death—standing in full size, and in full light in some public place.

Postscript 1955

In Paris, in the spring of 1953, Fernand Léger brought me together with the Venezuelan architect, Villenueva, who built the new University at Caracas. Villenueva asked me what modern sculptors he should invite to take part in this undertaking. I named, among others, Hans Arp, Alexander Calder, and Antoine Pevsner. Today, as is well known, a large bronze sculpture by Pevsner stands in Caracas, in the place for which it was designed—in the midst of the people. This invitation from South America was the first major public commission that Pevsner ever received.

Postscript 1957

Not far from Detroit, in a wide-stretching open landscape, Eero Saarinen, the Finnish-American architect, has built a spreading complex of low buildings for General Motors Corporation: research laboratories, experimental workshops, administration buildings. It is an uncommonly clear and most carefully worked out project, employing large plane surfaces of glass, brick, and strong-colored ceramic tiles.

In front of the main administration building and the experimental workshops is a rectangular basin of water, large enough to be called a lake. Here Alexander Calder has re-

60

vived the long neglected dynamics of the play of water. But, before the main building, Antoine Pevsner's sculpture— the subject of this dialogue—now stands in the sunlight for the first time at almost its full height.

The bronze casting was built up in Paris between May 1955 and March 1956 and went without a hitch despite the great difficulties presented by the perpetual interlocking of inner and outer planes inherent in its enclosure of space.

Powerful sculptures, like all symbols, can be interpreted in many ways. General Motors gave this hovering column a new name, the "Flight of the Bird." The title varied— the inner sense remained the same.

Recently the title seems again to have been changed— this time to "Lines in Motion." Indeed, they are lines—even straight lines—in motion. But what the artist originally wanted to convey was the direct transmutation of an emotional outburst—Victory—into a symbolic sculptural form. We are moving toward an age in which many symbols are about to be reborn. We should hold onto the artist's intention, and I sincerely hope that the original title, "La Colonne Développable de la Victoire," will be the one accepted by history.

Part 3

ON THE COOPERATION OF ARCHITECT, PAINTER, AND SCULPTOR

On the Force of Aesthetic Values

Architects' Attitudes Toward Aesthetics

Architects and Politics: an East-West Discussion

Aesthetics and the Human Habitat

Marginalia

The question of whether or not we need artists today leads at once to the wider question of the influence of aesthetics—the force of aesthetic values.

To celebrate its bicentenary, Princeton University held a series of fifteen conferences on various subjects, such as "The Future of Atomic Physics," "The Chemistry and Physiology of Growth," and "Far Eastern Culture and Society." Among them was a conference on "Planning Man's Physical Environment." It was a brilliant group of people who were invited to be the guests of Princeton University in March 1947. The conditions of acceptance were somewhat original: each participant was compensated for his travel expenses, whether this entailed a ticket from nearby New York or from Europe (I received the invitation when in Zurich); each participant was permitted to speak for twelve minutes. My address was on the "Force of Aesthetic Values."

On leafing through the book of the conference, *Building for Modern Man*,[1] which was prepared by Thomas Creighton, editor of *Progressive Architecture*, one perhaps experiences a certain disappointment that no attempt is made to score the individual voices of the participants as a choral fugue. For the conference was attended by almost all the masters of contemporary architecture: Frank Lloyd Wright, Walter Gropius, Mies van der Rohe, Alvar Aalto, José Luis Sert, Richard Neutra; also the Deans of Harvard, Yale, Columbia, Princeton, and many others, including engineers such as Frederick N. Severud, psychologists such as Adelbert Ames, and historians such as Talbot Hamlin. The reason for this absence of synthesis was that the regulations laid down

[1] *Building for Modern Man*, ed. Thomas H. Creighton (Princeton, N.J., 1949).

by Princeton University for these conferences forbade the formulation of any resolutions or propositions and confined the sessions to an exchange of opinions. Despite this, there is no doubt that the speeches made there have had their influence upon subsequent thought and action.

The moment one touches on the question of the impact of aesthetics, another question arises, one that is somewhat delicate and that bears upon the contacts—and the cooperation—that can exist between architect, painter, and sculptor. The architect is not self-sufficient; in earlier times he was closely allied with both the painter and the sculptor—the finest often combining all talents in one person.

The problem today is that there is no cooperative work from the very start of a project. Immediately after the Princeton conference, I struggled hard with this question and determined to introduce it at the seventh CIAM congress to be held that fall.

We have repeated that, due to the conditions imposed upon painters, sculptors, and architects by the nineteenth century, they have become accustomed to work in complete isolation. As a result hardly any like to have working contacts with others. Most painters consider a building merely a necessary shelter for their work; most architects, encumbered with organizational detail, think of the artist only when all else is finished, and an empty spot—a leftover space—becomes available. Even in the case of the UNESCO building in Paris this same obsolete procedure was followed. In this instance the artists were certainly chosen from the best available. But they were not called in until everything was already fixed: Here is your place, these are the measurements!

This underrating of the artist's role in an integrated creation is utterly absurd. It will lead nowhere. And it parallels the unfortunate attitude that many clients still display to-

65

ward architects, regarding them as mere *confiseurs* whose usefulness consists in "embellishing" the work of the structural engineer.

There are a few exceptions to this rule, but unfortunately it is typical of the normal situation. This is why it is now incumbent upon us to break down the partition walls which separate creative artists in the different fields. In spite of this outward separation, each has an inner connection with the other, which appears in their use of a common outlook upon the shaping of space—a common space conception. This common outlook has been developing unconsciously along parallel lines. If this common ground did not exist it would be quite hopeless to work for a closer cooperation—for an organized teamwork—between architect, painter, sculptor, planner, and engineer; though this does not mean that cooperation between all architects and all painters is possible.

At the present state of development no truly creative architect or planner can exist who has not passed through the needle's eye of modern art. Civilization develops only when man consciously or unconsciously establishes an emotional and intellectual equilibrium. This condition is only possible after equilibrium has first been achieved in the emotional sphere: in other words, not until some common basis of understanding has been established between the arts.

ON THE FORCE OF AESTHETIC VALUES

There can be no doubt that the purpose of this Symposium is to look beyond the utilitarian and functional values of the human environment and to assume the existence of aesthetic and spiritual values.

To begin with, we don't believe that aesthetic values can be arbitrarily added to or subtracted from an object. Aesthetic values are inherent in things. They emanate from them, somewhat as odors do from food or from flowers. Like intangible perfumes they determine our sensitive or emotional reaction.

Aesthetic impacts influence us at all moments. Consciously, or in most cases subconsciously, they provoke friendly or hostile reactions. Evading our rational strongholds they directly attack our emotions and are therefore out of our control.

This means aesthetic values are no simple trimmings but, indeed, have their roots in the depth of the soul. Their impact on man's decisions reach even to the most practical problems, into the shaping of things of daily use—cars, bridges—and, above all, of our human environment.

If man's aesthetic or, as I would prefer to express it, if man's emotional needs are not satisfied, he will react immediately. He will reject most violently the slightest deviation from his aesthetic standards. He will do everything in his power to shape things according to his emotional convictions.

An example

We have in Switzerland the case of Robert Maillart, the bridge-builder who died without the opportunity to erect in any of our cities an arch in the pure forms which

67

he was able to master as no one else has done. His bridges were permitted only in remote mountain valleys—because they were cheap and, above all, because nobody would see them. Why? Their extreme lightness and elegance offended the taste of the laymen and the specialists, who detested their rhythmic power. Said one, "We have had enough of this puff pastry."

In Berne, where Maillart's bridges had to span the river Aare (fig. 23), he was forced to disguise them completely with heavy granite stonework, thus annihilating his own elegance. The officials preferred massive bridges. It made no difference whatsoever that this massiveness was very costly. It satisfied their emotional needs.

Today we can observe this astonishing dictatorship of aesthetic values, or emotional needs, in every country. One can admire the officials concerned with building parks and highway systems for the courage of their conceptions, but the moment they approach architecture their courage vanishes. We then see them clinging anxiously to nineteenth-century habits. This is a world-wide official disease.

The emotional training of the average man lags far behind the advanced nature of his thinking. The whole disaster of nineteenth-century architecture derives largely from this divergence. T. S. Eliot once said the nineteenth century still lingers on in the twentieth.

In our period, feeling seems to be much more difficult than thinking. Man is able to invent nearly everything he wants in science and in all kinds of gadgets; but as soon as we approach the emotional, or, if you prefer, the aesthetic sphere, we meet the strongest resistance. This was not always so. It was often the reverse. Artists like Michelangelo, in spite of their bold and revolutionary inventions, were conscripted by the Pope, as present-day atom physicists are by the government. But scientific thinkers like Galileo were condemned and outlawed for their discoveries, just as today we exclude the inventors in the emotional field—the creative artists—from public activity. The result is that aes-

68

thetic values born out of the spirit of our period remain ignored.

Humanity versus technology

Today the immediate impact of aesthetic or emotional values has become of the utmost importance. Why? Suddenly we have become aware of our predicament. Suddenly and unavoidably, we know that human needs must dominate the problems of production.

The task ahead of us seems nearly impossible, and yet we must accomplish it. We must simultaneously shape the elements and their synthesis. Town planning, the highest expression of architectural synthesis—and not only in respect to the field of architecture—normally comes to its height at the peak, or even at the end, of an era. So it was in Greece. So it was in the thirteenth century with its frantic founding of cities. And so it was in the late eighteenth century when urbanism of the highest spatial order was within the reach of every speculator.

But what happens today? Building techniques, when compared with other techniques, are lagging behind. How should people be housed? Apartments? Single houses? The very existence of the city itself is questioned. Look at the aesthetic uncertainty on the drawing boards the moment a larger synthesis is required, as in civic centers! Yet we must work simultaneously at the beginning and at the end. For there is a revolt in the making, a revolt which can be no longer suppressed. This is the revolt of the humiliated human instincts.

Marginalia

In September 1947, in the small town of Bridgwater in Somerset, England, the subject of aesthetic problems was introduced into the discussions of CIAM 7, the first postwar Congress (International Congresses for Modern Architecture). It can be easily understood that this was not done in the present-day situation without hesitation. To some it seemed that we would lose our footing; others considered aesthetic problems to be a purely personal matter; still others thought that one could only discuss aesthetic questions if restricted exclusively to architecture and in connection with a particular problem, such as the relation of volumes of high and low buildings in a settlement.

The main center of interest was divided and grouped around two different aspects. The MARS Group (England) was especially interested in one aspect of the problem—the emotional reactions of the common man to modern art, and especially to architecture. This led to the formation of the pivotal question: How far should one follow the prevalent ruling taste to satisfy the desires of the common man, or how far should one go ahead—as any research worker does —according to one's own consciousness? J. M. Richards, editor of the *Architectural Review*, London, summed up the problem in a simple question: Need the architect concern himself with the reactions of the man in the street? He queried: "What can the architects do to take into account those qualities in buildings that have, at the present moment, a symbolic or emotional significance for ordinary people, so that architecture shall remain an art in whose adventures they can share? The Russians have tried to solve this problem by reverting to a completely eclectic idiom such as

we associate with the predominance of the bourgeoisie in the nineteenth century."

The second aspect was concerned with the fact that close contact between the architect and planner, painter and sculptor, has been lost for a century and a half. Is it possible that they will ever again be able to work together from the outset, as was usual in other periods: in the Middle Ages due to an all embracing spiritual unity: in the Renaissance for the simple reason that the best artists were simultaneously the best sculptors, painters, architects—even fortress builders.

We know that we shall never be able to satisfy fully the aspirations that slumber unconsciously in the common man unless we can again reach an integration of the arts. This is a thorny problem today, and so Hans Arp, the sculptor and poet, and I set about drawing up a kind of questionnaire which laid less emphasis upon the techniques of cooperation than upon the fact that for cooperation to succeed a certain humility was demanded from all participants.

As the discussion on aesthetics developed in Bridgwater, it excited the whole Congress, and J. M. Richards brought out the two alternative attitudes of the architect toward the man in the street: "He can produce what he for his own reasons believes to be good architecture and hope that people will come to like it by habit. . . . Alternatively the architect can say to himself that he has some direct part to play in preventing a new architecture from being frightening because it commits the public to the unknown."

When summing up I tried to set down how we stand today in our relation to the problems of aesthetics.

ARCHITECTS' ATTITUDES TOWARD AESTHETICS

(CIAM 7, Bridgwater, 1947)

CIAM is concerned with those problems that are just emerging over the horizon. In 1928 it was the industrialization of building methods; then standardization; then the development of contemporary town planning. Now we consciously take another step, a step toward a rather intangible subject: aesthetic problems or, as I prefer to say, emotional expression.

It may not be unwise to repeat that it is often said that aesthetic values are not suited to theoretical or public discussion. But twenty years ago, Alfred North Whitehead —the great scientist and far-sighted philosopher—showed us the fallacy of a belief that aesthetic values exist only within the personal and private sphere. And Herbert Read, in one of his essays, points again to Whitehead's arguments which show that this erroneous belief can be traced back to Descartes. It was Descartes who first divorced science from philosophy. After that philosophy assumed charge of the cogitating mind and science took charge of the materialistic nature. This divorce was the start of one-sided rationalism. It split the world in two: on the one side the cogitating mind, on the other independent matter.

The cogitating mind which recognizes only personal experiences—as in the case of Descartes—is restricted to a private world of morals: of ethical and, as Whitehead stresses, also of aesthetic values.

Modern science no longer recognizes the split between objects independent of mind, and mind independent of objects. In modern physics, experiments and experimenter are regarded as interdependent.

This means that we are within the ambit of two periods, and that we have begun to realize that rationalism has wid-

ened the gap between the cogitating mind and the whole sphere of emotional expressions to such an extent that it has become insupportable. Proof? We have all experienced how rationalism merged into mechanization, and how the tools, or what the tools produced, have become master and an end in themselves. We are on the turning point; the period of rationalism is nearing its end.

If this is so, then the more intangible methods of expression will reconquer equal rights with the world of logic; and we will no longer be afraid of losing our footing when touching on the impact of aesthetics, or continue the fallacy of the nineteenth century that aesthetic values are a strictly personal matter.

If we really agree with the right of the emotional world to exist in this sphere, then architecture and town planning can no longer be isolated from their sister arts. Architecture can no longer be divorced from painting and sculpture, as it has been throughout a century and a half, and as it still is today.

The problem is clear, but not its solution. There is no doubt that most of the contemporary architects and most of the modern painters and sculptors have lost the capacity or even the will to work together.

A short time ago, in Cornwall, I gave the CIAM questionnaire to Barbara Hepworth to get the point of view of a sculptor. I should like to quote her fine letter which, with a few words, illuminates the whole situation and hits the nail on the head.

Barbara Hepworth

Chyan Kerris, Carbis Bay
September 10th, 1947

Dear Giedion,

I was immensely interested in what you had to say during your short visit the other day, but I was left with a very sad feeling that the gulf between architects and sculptors is a very large one and that it can only be bridged by a change of heart in the

architects. I felt that the questions to be asked should not be "should the architect and sculptor collaborate from the beginning?" but "why do the architects and sculptors not collaborate from the beginning!"

To all the questions relating to sculpture and painting I felt that the answers lay implicitly in the work done during the last twenty-five or thirty years by the sculptors and painters. I feel as a sculptor that we have said what we have to say and played our part and that architecture, as the co-ordinating part of our culture, has failed so far, to unite (and even to understand!) the work that has been done in our time by painters and sculptors. Without this unity we cannot achieve a robust culture.

During my last exhibition I found there was a keen sense, among all kinds of people, of the part that sculpture plays in life, *except* among the architects. They all stood with their backs to the sculpture and bewailed their lot, or chattered about new materials. I was shocked by this attitude because we are working, all of us, for something much greater than planning. We are working for a spontaneous sense of life, a unity of purpose which will give heart to the nature of our own living. I cannot say anything new of great importance the answers are all there, in the history of architecture.

New conditions, new materials cannot alter the basic prin ciples.

It is then, up to the architects.

I could not write before, I find it so difficult to find words when I am carving.

I hope great things will come out of your meeting at Bridgwater.

<div align="center">ever,
Barbara Hepworth.</div>

This letter mirrors the present situation: the architects with their backs turned to the sculptor, chattering about new materials, and the only possible solution of the whole problem is expressed in the few words—

"Why do the architects and sculptors not collaborate from the beginning?"

Le Corbusier

Le Corbusier replied:

It has given me great pleasure to hear Giedion ask us to place art in the forefront of our preoccupations. Yesterday I had the pleasure of hearing our president, van Eesteren, reveal certain matters that he keeps in the depths of his heart, and beliefs: a delicate taste in art and philosophy. After our hard work during all the week, we see that blossoms are unfolding.

For twenty years, ever since I started upon my serious work, I have been convinced that, in face of the immense changes around us, the important thing, the thing at issue, the thing that must happen, is the re-making of individual consciousness. "I think therefore I am!" For each of us, within each consciousness, this means to realize the quality of that intrinsic light that illumines our actions, and consequently dictates our program of work.

Personal experience; private endeavor; the participation of each in the creation of the whole. The whole can become renewed by these molecular efforts, infinitely multiplied. Responsibility rests with the individual.

The first era of mechanization spread chaos—a disaster on the debit side of a prodigious and magnificent century of conquests in the fields of science, ethics and intellect. Everywhere dishonor, an unspeakable ugliness, a lack of grace, of a smile, an absence of delight. But there is no reason to despair, all the constructive elements are still available, at hand—an unlimited supply of means. It is only harmony that is absent, because we have not had the time, nor had the inclination, not had even the idea to regard it . . . HARMONY is the important word for today. Put everything in harmony! Let harmony reign over all! To do this,

Let it break through,
Let it blaze forth,
As a poetic phenomenon!

Here is the collective enterprise!

Poetry! The word needs to be proclaimed. Poetry which only exists in the context of associations. Associations which bring precise objects and precise concepts into context in a desired form —not foggy notions and unformulated, or unformulatable, intentions. These exact objects and objectives become assembled

75

in such a way that a marvel springs up—unexpected, unthought-of, astonishing, a miracle!

A MIRACLE of precise associations appears before our eyes, a result of mathematically exact precision.

My friends, our efforts can produce such miracles!

For whom is the miracle? For the general public.

For what general public? For the simple people.

I repeat: for the simple people. It is concerned with the relation between man and man. It is the speech of an individual to his brothers. For communal endeavor, at the moment of its birth, is held between the hands of the one who takes responsibility.

This man addresses himself to strangers.

But to strangers who exist,

who stand there,

who are waiting,

and for whom EMOTION and ART

are just as necessary as bread and water.

These strangers, in our modern society, may well be those in important positions, people here and there in control of parts of the essential machinery of the state; those who, by their decisions and administration, can guide the country toward a future that is ugly or beautiful. Some among them cannot help but be susceptible to poetry.

At this time of great industrial undertakings, of collective enterprise designed to bring security, abundance and a delight in living and to save the world from imbecile catastrophe—at this time of indescribable possibilities of transforming into harmony the puerile dishonor which now plagues us—the individual assumes an immense importance. The individual stands there, bearer and transmitter of human emotion.

I say to you that, despite the common problems which have brought us together through twenty years in a productive and friendly gathering, responsibility, in the end, lies with each of us individually.

Harmony can result from a re-fashioning of the individual consciousness.

The young Dutch architect, A. van Eyck, Amsterdam, asked CIAM two decisive questions:

76

Does CIAM intend to guide a rational and mechanistic conception of human progress toward an "improvement" of human environment, or does CIAM, criticizing this attitude, intend to help transform the background against which it projects its activity?

A. van Eyck

The old struggle between imagination and common sense ended tragically in favor of the latter. But the scales are turning: CIAM knows that the tyranny of common sense has reached its final stage, that the same attitude which, three hundred years ago, found expression in Descartes' philosophy—Giedion has just mentioned its sad implications—is at last losing ground. Yes, the deplorable hierarchy of artificial values upon which contemporary existence has come to rest is beginning to totter.

A new consciousness is already transforming man's mind. During the last fifty years or so, a few—ranging from poet to architect, from biologist to astronomer—have actually succeeded in giving comprehensible shape to various aspects of its nature. They have tuned our senses to a new dimension. It is the firm belief of CIAM, that the collective idea which brought us to Bridgwater from so far, is the seed of a new outlook, a new consciousness, still latent today, but awaiting general recognition tomorrow. *CIAM is first and foremost an affirmation of this new consciousness.* The achievement of men like Le Corbusier, Mondrian, or Brancusi compels us to believe, surely, that we are indeed approaching a brighter era; one in which grace is expressed in life as it is in art.

CIAM refuses to overhaul outworn values that belong to an outworn world by giving them a new dress straight from the laundry of common sense. On the contrary, it desires to stimulate a universal revaluation toward the elementary; to evolve a transformed language to express what is being analogously transformed. No rational justification of CIAM can therefore satisfy us. Imagination remains the only common denominator of man and nature, the only faculty capable of registering spiritual transformation simultaneously, and thus of significant prophecy. It is the prime detector of change. Although architecture—planning in general—answers very tangible functions, ultimately its

77

object differs in no way from that of any other creative activity, that is, to express through man and for man the natural flow of existence. The more tangible functions—those implied by the word "functionalism"—are only relevant in so far as they help to adjust man's environment more accurately to his elementary requirements. But this, after all, is no more than a necessary preliminary. The question thus arises whether CIAM, accepting the contemporary situation as an inevitable background for practical realization, should nevertheless adopt a critical attitude toward it and act accordingly. Does CIAM intend to "guide" a rational and mechanistic conception of progress toward an improvement of human environment? Or does it intend to change this conception? Can there be any doubt as to the answer? A new civilization is being born. Its rhythm has already been detected, its outline partly traced. It is up to us to continue.

ARCHITECTS AND POLITICS: AN
EAST–WEST DISCUSSION
(CIAM 8, Bergamo, 1949)

Bergamo is a small medieval city in Italy not far from Milan. The Palazzo Vecchio, the city hall, which is raised on arches, faces across the piazza to a palatial library partly built by Vincenzo Scamozzi. This piazza, with its two great buildings linked by simple private structures, is situated on the crown of a hill overlooking the river Po. The Palazzo Vecchio achieved its present form as a result of centuries of growth. It is said to be the oldest town hall of Italy, its use going back to the twelfth century, to a period when in other cities the Town Council still assembled within the church. It was a fitting place to debate questions of the impact of aesthetic forces.

On the hot afternoon of July 29, 1949, the discussion within the city hall also became heated as two different attitudes toward art made themselves evident. It became clear that aesthetic problems are not just personal affairs but that they are part of our attitude toward the world, and that they merge—sometimes tragically—into politics.

Some fragments of the discussion are here recorded. I had to open it, and proposed that we should confine ourselves to the main points that had emerged from the questionnaire of 1947:

1. Are there direct connections between the plastic arts; and if so, what?

2. Is cooperation possible between the architect, the painter, and the sculptor; and if so, how?

3. Is the "common man" able to appreciate the results of such a synthesis?

Eighteen people took part in the discussion, among them Roland Penrose, surrealist painter, London; Alfred Roth, Zurich; José Luis Sert, New York (now Dean of the Gradu-

ate School of Design, Harvard University); Le Corbusier, Paris; C. van Eesteren, Amsterdam; Max Bill, Zurich; Helena Syrkus, Warsaw; Isamu Noguchi, sculptor, New York; James Johnston Sweeney, then Director of the Museum of Modern Art, New York; Ernesto Rogers, Milan.

Roland Penrose: Collaboration between the major arts is essential for the life of the arts. The question is only how this can be achieved.

During the war, painters did a lot of research into the effects of colors and textures for the purposes of camouflage —of rendering buildings invisible. It would be quite possible to use the same techniques to render buildings more beautiful.

The importance of the economic aspect should not be overlooked. The architect is in a position to make a living available to the artist, for the architect is nearer to the means of production.

The roots of all collaboration are in education. In London there are now two schools in which artists and architects cooperate in work on the same projects.

An important obstacle to new work in the Western world is our complex about the value of permanence. In India, on the other hand, decorated walls are often whitewashed over every year and then redecorated with mural paintings by local artists. We need ourselves to create works which shall be destroyed when their time has come.

José Luis Sert: I want to begin by saying that I have always believed in the possibility of cooperation between painter and architect and sculptor. Perhaps because I come from a Mediterranean country, where these things have always been seen together, I have never been able to separate them.

I remember in the early days of CIAM, when I was associated with what one might call the group of extreme purists, that my friends stripped their walls of all pictures,

80

except perhaps a photograph of the Alps. I was even then against this attitude. I always believed in the possibility and desirability of a close liaison between architect and painter, and, since this time, I have often had the honor of working together with some of our most famous painters and sculptors.

In 1937 I worked with my friend the architect Lucio Acosta on the Spanish Pavilion at the Paris Exhibition. There we invited the cooperation of Picasso, Miró, Alberto, Gonzales, and other painters and sculptors who were then with us. This was an extremely interesting experience and resulted in the production of "Guernica," which has since been exhibited all over the world. I remember discussions at the time with some people, who were of another way of thinking and had a different approach to painting, who said that we ought to replace "Guernica" by a more realistic painting. I was also faced with the problem of a fountain of Mercury that was given us to exhibit, but which was quite impossible both in form and conception for the situation. I approached the authorities and suggested that we should commission another by the one man whom I knew would be capable of the work at that time—the American sculptor Alexander Calder.

These two examples of modern art by two great creative artists—quite different from one another but both expressing the spirit of our own time—made a very great impression. Calder's "Fountain of Mercury" was extremely popular and was understood by everyone. Picasso's "Guernica," in quite a different style, was the greatest product of contemporary art. The theme of this mural was also understood by everyone, discussed by everyone, and commented upon by everyone. It has since been exhibited throughout the world and continues to deliver its message.

It was when working in that pavilion, a place of public assembly, that I realized the importance of placing works of art in places where many people gather together, and that, in these places, they form an indispensable comple-

ment to the architecture. Unfortunately we have today very little opportunity of finding places of this sort, and for this reason we have today quite a different conception of the place of sculpture in our towns.

We cannot talk about the importance of cooperation between the architect, painter, and sculptor when there are no places where their work can be assembled. Create such places and a new sculpture will be created that will respond to the spirit of our own time!

Where were the plastic arts displayed in ancient times? In the public places of Greece, in the open places before the Gothic cathedrals, and, to a less extent, before the Royal palaces in Renaissance towns which, though controlled by the authorities, did serve as places of general assembly of the arts—Versailles, for example.

But since our towns have become abandoned to private interests such centers of assembly no longer exist. New York, for example, has only Times Square, a road crossing in the center of constant tumult and uncontrolled furors of publicity. Yet it was here that New York had to barricade off the streets for the peace celebrations after the last war. New York, the center of the world, entirely lacks any civic center of assembly.

As long as we have no centers, I do not see where we can place our works of art. We cannot just stand them on the sidewalks! Where can they be put? Only in the cramped surroundings of public buildings and in museums or private houses where everything is on an entirely different scale and where they are only seen by a selected few.

But, when works of art cannot be seen by everyone, they cannot be painted for everyone nor can they be understood by the people. One must show these things to the people. It is not that artists should only create works following certain principles in order to be understandable. They must be allowed to create freely. But if their creations are not seen by the people, these can have no idea what they are about. While works of art remain immured within muse-

82

ums and private galleries, with entrance by payment or through turnstiles, they will not be seen by the great mass of the people.

Our task therefore as town planners is to create places in our towns where people can walk freely and look around them without being in constant danger of their lives: places that are protected by the cities or the state from advertising, swayed only by questions of profit or propaganda. Such places, consecrated to gatherings of the citizens and where artists can display their work, have existed in cities of the past. The means by which artists of today would express themselves in such places is unknown to us. One cannot define things before they happen. Surely the people before the Gothic era can have had no conception of how the areas in front of the cathedrals were going to develop. This was a thing brought about by life itself. These public places began with simple things and then rose to a wonderful height of magnificence enriched with glowing colors. Theatrical performances, civic ceremonies, lectures, all were held here. But the center already existed, ready for any purpose.

We cannot define the life of such new centers. This must be developed by life itself. But we do need a conviction that such centers themselves are necessary. This is the absolute essential. Within the centers, once they are formed, there must be absolute freedom of expression. Today we have not only the traditional materials with which to work. We have also water, movement, light—a whole mass of things that have not yet been used fully. There is a whole language to be interpreted by new mural artists. Not murals in the traditional sense, but maybe entirely new things. There must be a period of great experimentation, but first we must build the places themselves!

We will not have static exhibitions in these places, but things will be continually changing. There must be living exhibitions where the people can see and comment on everything that is produced in the world of art and where

83

artists are free to express themselves as they will. It is here then that the people will themselves judge of the results and make their opinions known. One will not be obliged to give way before the majority point of view. All should be freely expressed and then the scene changed from time to time, like the changing scenes of a theater. Our job is only to create the places themselves. Life itself will do the rest!

Le Corbusier: The help we can give in developing a culture is no more than the help we can give to the growth of a bean. We can do very little about this beyond making the first gestures. We can plant the bean in the ground, water it, protect it and take care of it and then—just pray for fine weather! From this time on the bean will have to hold its own against external influences.

I am hoping that a permanent center for the plastic arts may be inaugurated. This would be a center for experimental work which will be taken down and rebuilt each year. It would be a shell within which we could experiment with external and internal spaces in complete shadow, in full sunlight, and so forth; where one could develop examples of plastic art from the first drawings to their full-scale expression in color and volume: a place where one could try out all that the plastic arts can do for architecture—whether by rendering homage to their walls or by destroying them, or by evoking symbols, and so on. This center would become a manifestation of human poetry—a manifestation of the sole justification for our existence: a center for which we must produce works that are noble and irrefutable witnesses of our age, and not works which are full of excuses for our failings.

How can such works be produced? First the architect must also be an artist. It is not necessary for him to be a practicing artist, but it is essential for him to be receptive and responsive to all plastic art. His own artistic sense must influence every line that he draws, every volume and every surface that he decides upon.

84

Penrose has commented upon the obsession of permanency. Permanency for the artist consists in his own pleasure and patience during the period of creation of a work of art and in his endeavor to bring it in tune with his own period. After that—farewell! If it is destroyed it matters nothing! The next generation will create its own works of art. It is the world's obsession with permanence that obstructs building, obstructs town planning, and obstructs sculpture. This is due to our obsession with profit—that on every work, in the course of time, both the capital shall be recovered and interest be earned.

Painters all long for the pleasure and publicity of painting walls. I say to them, "But take them. There are walls everywhere! And if you can't find one, go to your friends and paint on their walls freely and without payment." It is not so easy to paint murals. I speak from experience. One requires practice. The same goes for sculptors. For the sculptor, experimentation is not quite so easy, but a determined man can find temporary sites in some open place where it is possible for him to make his experiments in plaster. It is not absolutely necessary always to use granite and it is not important that the object should always be of great size. It is not size that matters in art, but concentration.

Color has been mentioned. This is a field in which architects can make an immense stride forward to aid the coordination of the major arts.

We have said that we desire to see places created where the major arts can be assembled. Our civilization has created no places worthy of being consecrated to this purpose. Sert, however, told us of his experiment in the Spanish Pavilion at the Paris Exposition of 1937. He had no idea what would result when he invited Picasso to paint his "Guernica" on the wall of the Pavilion. Here was a bean well planted.

C. van Eesteren: The architect must have a feeling for art, but one cannot reason too much about art. In front of a work of art it is one's instinct that says "Yes, that's it"

or "No, that's not it." The development of one's instinctive sensitivity is the important thing. Of course one must have an idea before one can create, but, provided the artist holds the same idea as the architect, the rest will come of itself.

I am doubtful of the receptivity of the "common man" though we must work for this all the time.

In this matter of cooperation the architect must take the initiative. If his conception is good, artists will be happy to work with him. We architects have great need of close contact with contemporary art for the solution of our own architectural problems. I will give, as a personal example, the work of Schwitters. His collages opened my eyes to certain aspects of the world around, by revealing, as it were, the world within a corner of the ground. Those banal fragments of contemporary life—of a certain aspect of contemporary life—display to us a reality that we may not find pleasing, but that we cannot but accept.

Helena Syrkus: We wish to see the transformation of man of the human conscience and of the architect himself . . . We lack a fair attitude toward the people. Art belongs to the people and must be understandable by the people . . . I am in entire agreement with Luis Sert that we lack civic centers. The Greek Agora had its function; the medieval piazza at Bergamo has its function; but open places have been deliberately degraded by the capitalist system in order that people should not have the opportunity to unite against the system.

We need art, but an art which responds to human needs and uplifts the spirit of the people. The words written on Corbusier's Pavilion of the New Spirit were "Understanding: Decision: Assertion." Unfortunately, people have not yet the understanding. This is the reason why it is realized in the U.S.S.R. that we have fallen into a formalism.

Formalism is born from the abyss created by the capitalists between art and reality, between *Dichtung und Wahr-*

86

heit. Artists detached themselves from life and started to create art for art's sake.

Real artistic revolutions have always been swept forward by social revolutions. Goya changed the whole of his technique and palette in order to portray the disasters of war. The aim of a socialist realism is to raise the status of man, but there are many sorts of realism. The work of Picasso is realistic in the sense that he has developed a method of showing the rottenness of capitalist society. For this reason his works are considered valuable in the people's democracies. In the East, where the people have reached a positive phase of development, the works of Picasso have no meaning and are forbidden.

The "formalism" of CIAM was positive in the early days —it was a revolt. It made use of analytical methods, which were also socialist methods. Functionalism discovered many good things (orientation, and so on), but its importance has gradually grown less and less . . . Construction is but a skeleton. It has great interest for the anatomist, but for the rest it only becomes beautiful when it is covered with fine muscles and a lovely skin. We had nothing else to offer at the time when CIAM began, and so we made a fetish of the skeleton.

The countries of the East have come to the conclusion that we should have a greater respect for the past. We do not need to fall into the eclecticism of drawing our material directly from the forms of the past but we should have a greater respect for the spirit of the past . . . The new Warsaw will conserve its link with the past—that is to say, it will preserve all that is good in the lines of roads, open places, the connections with the Vistula, and with all remaining evidences of its ancient culture. In defending and preserving our national culture we defend and preserve international culture.

We of CIAM must revise our attitude. [Looking through the large windows toward Scamozzi's palace, Helena Syrkus concluded]: The Bauhaus is as far behind us as Scamozzi.

87

Ernesto Rogers: We are profoundly grateful for the sacrifices made by the peoples of Eastern Europe, but for which we would probably not be here today. This does not however prevent us from holding different points of view on cultural matters. . . . I share the opinion of Helena Syrkus that culture is essential. Our differences relate to the fact that Helena Syrkus [in the earlier part of her talk] emphasized figures, quantities. But it is only quality that counts. She has said that art must come near to the people. We believe on the other hand that the people must be given the means to come near to art.

She has cited Goya: but in speaking of Goya one cannot forget his "Maja nuda" and "Maja desnuda." His portrayal of the disasters of war are not superior to these works . . .

We have a respect for the past. Its spirit is alive and we wish to understand its message. But we must stand firmly in our own period. There is no excuse for repetition of the past, whether this is done eclectically or otherwise. It is cheating the people to give them forms which have no relevance to living art . . . We must be the defenders of art: the eternal life of the spirit.

J. J. Sweeney: I shall make the shortest speech of this congress. The words "common man," in the sense they have been employed in this conference, simply mean a layman, a man not professionally interested in any of the arts. This "common man" is found equally in all social classes and in illustration of this, I will quote the following extract from a letter of President Truman published in the American Press in June 1947: "I do not pretend to be an artist or a judge of art, but I am of the opinion that so-called 'modern-art' is merely the vaporings of half-baked, lazy people. An artistic production is one that shows infinite ability for taking pains, and if any one of these so-called modern paintings shows such infinite ability I am very much mistaken. There are a great many American artists who still believe that the ability to make things look as they are is the first requisite of a

great artist. There is no art at all in connection with modernism in my opinion."

Giedion: [I summed up the discussion thus] I will say frankly that I would have been happier if we could have penetrated a bit deeper into the problem of the means of artistic expression—for it is here that I find the greatest chasm. However, I am very grateful to Sweeney for having spoken as he did. He might seem in a way to have been speaking against his own country, but this was not so. He just told the simple truth, and that is what is necessary. It is not treason to show up one's own faults or the faults of one's own country. One is not working against one's country in doing this, one is working for it.

Now to another matter. Helena Syrkus has talked to us today of the role of culture and of history. If the question of the method of expression is important to us it is just because it is not only a question of the outward appearance of things, for Art is for us a matter of ethics. It is something that comes from the depths of our whole being: it is the projection of our actual entity. Everything however depends on the manner in which that entity is projected. If the form in which it is shown is but a reflection of the forms of the past it is nothing.

We have a love for the past. But the modern historian and the modern painter cannot reënact the past . . . I have noticed in a recent architectural development that there are signs of a return to the eclecticism of the nineteenth century, though with new labels. These new labels are extremely dangerous. It is a form of reaction. We are altogether for the past—as modern artists have themselves shown. But it is quite another matter to hang a façade of colors or a fresco over the front of a building. This kind of thing is for us pure reaction, call it what one will. . . .

We are for the past and modern artists have shown us why we should be so. Why? Because we can now see the whole of history as a single entity. Today we can see right

across to the prehistoric period when man first began to "feel" and to ask "What is this that is around us?" This is the method that Miró has employed; it is the method of Picasso. Today more and more we see our connections with the past and most especially we see that modern painting (now declared in Russia to be a form of bourgeois decadence) is deeply rooted in the past . . . Another point. We believe profoundly in a modern tradition. We believe that we are developing this modern tradition. We believe further that we should have no inferiority complex when we are accosted by the common man.

One final point. We need always to realize that today "thinking" is easier than "feeling." This means that one of our tasks is also to educate people and that we must not believe that we can satisfy the real aspirations of the people by fobbing them off with shoddy work.

Postscript 1957

CIAM did not revise its attitude, but others did. It seems that the architectural horrors of the ruling taste (which has prevailed with dictatorial powers behind the Iron Curtain, suppressing to a tragic degree all contemporary development) are now nearing their end.

It is somehow comforting that our unwavering contemporary consciousness has shown itself able to outlast dictatorships—whatever their nature.

Marginalia

Slowly the CIAM discussions on the problem of aesthetics passed from general demands to questions of practical application. At CIAM 9, at Aix-en-Provence in the summer of 1953, where discussions were focused on the Human Habitat the committee on aesthetics no longer debated the role of painting and sculpture as such, but instead tried to outline the plastic structure of the new form of the city. Around the walls were displayed drawings in the form of standard panels or "grilles" from all parts of the world. This means the subjects were analyzed and presented in a similar manner so that comparisons could readily be made and conclusions drawn. These "grilles" were all concerned with the Human Habitat, now in process of regaining and reëstablishing human dignity.

The task given to our committee [2] was not easy and demanded hard work from us, lasting throughout the days and far into the nights.

We considered it necessary to awaken the architect and the urban designer to an awareness of the contemporary plastic sense which he so often overlooks. Notwithstanding the great variety of solutions displayed in the "grilles," we found it possible to divide them under two main headings:
1. Preservation of the human scale in the face of the mechanization of this period.
2. Attitudes toward natural conditions and primitive civilizations.

Our conclusion was: the necessity for cooperation from the start of a project between the urban designer-architect

[2] Giedion, chairman, Auer, Bagnall, Bourgeois, Braeti, Brera, Chastanet, Coulomb, Gregotti, Haefeli, Laidlaw, Maisonseul, Richard, Sekler, Senn, Tamborini, van Eyck, Vert, Voelcker, Wicker, Tournon-Bramly, secretary.

and the sculptor-painter who can contribute a keen sense of rhythm and volume.

Some of the suggestions submitted at this congress may find a place here. They were the outcome of genuine teamwork.

AESTHETICS AND THE HUMAN HABITAT
(Proposals of Commission II on Aesthetics at CIAM 9,
Aix-en-Provence, 1953)

The human scale
The architect-planner normally used to work with two coordinates, the one perpendicular to the other. The houses were ranged along the length of the road, they were as far as possible of the same height, perhaps even of the same size. Such a system relieved the architect of many responsibilities.

The subjects shown on the "grilles" have once more confirmed that this cartesian system is still susceptible of employment in some instances, but in a new sense. Usually the architect-planner is concerned with laying out a fairly large area—a residential section, or even an entire city—where no gridiron delineation of the roads is able to serve as a skeleton for his plastic intentions. He suddenly has all directions at his disposition. This gives him a number of possibilities of approach that he can use in handling the territorial and social problems that have to be solved.

This demands a new plastic sensibility: a new development of a sense of spatial rhythms and a new faculty of perceiving the play of volumes in space. There are many instances in which it is clear that these capacities are as yet only very incompletely developed. And yet, without them, urbanism in the contemporary sense cannot be developed. The development of these faculties, based upon three-dimensional relationships, should form part of a university education, starting with the disposition of quite simple elements.

In opposition to the crowded and inarticulated city, which results in mere chaos and disorder, we are trying to rediscover a city with light and air where nature is not banished

but which conserves its urban character by means of its plastic expression.

This new city will contain well-defined and well-differentiated sectors, linked and integrated into an over-all plan from which greenery will not be absent. The architect needs to be sensitive to the plastic possibilities afforded by each site and to employ them to the full.

The "right of the pedestrian" will give an inspiration to the spatial imagination of architects. It is indispensable for man's equilibrium that he should have the feeling that everything in the urban setting has been conceived for him to his own human dimensions. This implies research into a new order conditioned by the needs of our period, which is characterized by large-scale mechanized production.

Apart from their role of liaison between the different vital sections of the city, the streets should enable nature to penetrate into the city so as to isolate the pedestrian as much as possible from all mechanical traction. This is of the greatest importance in considering the plastic conception of urban plans.

Studies of the plastic form of the new urban scene must always be guided by the human scale, always being aware that essential functional and material elements must at the same time express man's immaterial aspirations and desires.

The housing group—the unit of habitation—must contain in an embryonic state all functions of life. These functions must then be developed and enlarged in the social group forming the community.

Each habitable section of the city should possess a certain range of the necessities of existence integrated into a whole and independent from the rest of the urban agglomeration. This new conception is far more supple than the normal interpretation of "zoning" which is associated with the separation of all functions from one another.

Life today results, or should result, from the association of people in groups of different dimensions.

It is necessary to set up a spatial scale within each area

94

based upon the individual. This scale will be expressed plastically by the repetition of structural elements, such as the dwelling, and in the disposition of these elements in space so as to compose the new organic components of the city.

The degree of repetition will decide the forms; the resulting scale will determine the means that can be employed to give a plastic identity to each of the sequence of group sizes.

We accept the use of repetition as an active factor in the creation of a plastic expression.

Each functional element should express itself by means of a differentiation of form and color which would serve to give both a diversity within the larger of the residential sectors and, at the same time, a certain unity which would contribute a general rhythm throughout the city as a whole.

To maintain the necessary degree of unity within each element, so that a harmonious whole be created, certain impositions will have to be enforced regarding use of building materials, which may be identical or varied to suit each particular case.

The administrative determination of the three-dimensional expression of the elements of the habitat (the housing groups, or units of habitation, and the social groups forming the community) should not be arbitrary, but be the plastic form that grows out inevitably from the emotional, social, and physical requirements that govern the functions and reasons for existence of each.

Attitude toward primitive civilizations

Contemporary architecture has become involved in the great process of the extension of a way of life, up to now more or less confined to certain parts of the Western Hemisphere, over the entire globe.

New centers, new cities, are in the process of formation over the whole world. Through its contacts with both primi-

95

tive civilizations and ancient civilizations, contemporary architecture has enlarged both its domain and its scope. It has been deepened as well as widened.

The attitude of contemporary architecture toward other civilizations is a humble one. We do not regard primitive civilizations from the point of view of an advanced technology. We realize that often shantytowns contain within themselves vestiges of the last balanced civilization—the last civilization in which man was in equipoise. We realize that they can teach us forms that can be used to express specific social, territorial, and spiritual conditions. From this our social imagination may be able to form an aesthetic unity.

A low standard of life or a primitive standard of life is not necessarily linked to a low aesthetic standard. A primitive Cameroon hut has more aesthetic dignity than most prefabricated houses.

Everywhere in the cultural life of the Western civilization a weakening can be observed in the acceptance of a purely rational approach. At the same time we are met by the desires of the rest of the world to adopt the results of our scientific methods of approach.

Primitive architecture, when approached fairly, can be seen as a symbol that directly reflects a way of life which has come down through the ages, and which has roots that penetrate deeply into human and cosmic conditions. Modern painters, for the last forty years, have been demonstrating to us that primitive and prehistoric art can help us to rediscover more direct means of expression. In the same way primitive architecture can give a new depth to contemporary architecture that can enable it to meet urgent challenges of today.

For this approach to be fruitful, the social imagination and the aesthetic imagination must be inseparable.

It is accepted that modern technical methods of approach can perfectly well be combined with the use of traditional, and indeed primitive, materials.

To satisfy the material demands and requirements of

96

simple peoples it is necessary to provide only the structural skeleton. The vitality of their innate sensitivity for decoration will enable them to transform it into architecture, provided this vitality is not blindly blunted or destroyed.

It is the duty of Western man to provide the essential tools of his technical inventions, but it is also his duty to permit the people to complete the work according to their own vital standards.

In many countries now undergoing rapid technical development, different degrees of evolution are likely to be maintained among the population for a considerable time. In some cases (notably North Africa) a progressive pattern of urban development has been worked out and adopted. The spatial module employed has generally been the smallest repetitive unit—usually a room or enclosed yard—which can be repeated to become house plots, small piazzas and access ways. Provided the module is kept unchanged, the area can be re-developed progressively and with the minimum disruption to meet changing habits of life of the community, and yet always present a coherent physical expression.

Conclusions

The architect's widened field of operations demands the development of a far greater sensitivity than is usually evident today in the handling of spaces and in the dispositions of volumes. For the present, until a mastery of these arts is attained, it is most important that the architect should work closely from the start of each project with painters and sculptors, as these are specialists in the handling of surfaces and in the siting of volumes in space.

The problem of the architectural solution of the possible methods of construction is divided into two parts:

The first is the plastic determination, which should be solved in collaboration between the artist and the technician.

The second is entirely the concern of the technician. Its aim is to secure a permanent and stable structure by disciplining and arranging the essential parts, while leaving full liberty of expression in all details.

The role of the architect is not arbitrarily to impose his own solutions as opinions, but, on the contrary (after a very careful study of regional conditions and of the inner life of a community, not omitting its position in a period of change), to create a situation that can permit of the free and harmonious development of each individual.

Part 4

ON THE FORMATION OF THE ARCHITECT

On the Education of the Architect

History and the Architect

Marginalia

After the formal proceedings of the conference at Princeton on "Planning Man's Physical Environment" (1947) had been concluded, some of the many people gathered together there who were closely concerned with education began to discuss the form and reform of the training of the architect.

At the end of my conference address I also touched on this problem by pointing out that the creative budding of the young architect is often blighted by the kind of education he is offered in most universities and technical institutes.

"We have to prepare the next generation for the enormous tasks lying ahead. The present curricula are insufficiently adjusted to the necessities of this period. The students feel it strongly, sometimes more strongly than their professors. In every country the same question crops up: How should our training be organized so that we may realize the social, moral, and emotional demands of our work?

"I shall illustrate from my own field. History is often forced upon students as if nothing had happened in architecture for the last hundred years. History is taught as if it were static. But history is dynamic. The past lies within us and acts in us. As the French philosopher Henri Bergson, whose shadow looms larger with the years, puts it, 'the past gnaws relentlessly into the future.' We must forge history into a weapon which will enable the coming generation to measure where they stand, to judge their strength and their weaknesses.

"A world-wide reform in architectural education is necessary."

I therefore proposed that the conference should request Dr. Julian Huxley, then General Director of UNESCO, to

set up a committee to establish a plan for the basic reorganization of architectural education.

At the time I was quite unaware that the regulations of the Princeton conference did not permit of resolutions or conclusions; its purpose being only to permit of an exchange of ideas from which perhaps certain general guiding principles could be drawn.

An unofficial letter to Julian Huxley was therefore prepared; it was signed by a great number of the conference participants and others, including Gropius, Le Corbusier, Mies van der Rohe, Neutra, and many more. Julian Huxley answered encouragingly, and in the fall of the same year Maxwell Fry, the well-known English architect, and I met him in Paris. We then decided that CIAM should prepare a statement on architectural education for submission to the General Assembly of UNESCO in Mexico, November 1947. The statement follows.

ON THE EDUCATION OF THE ARCHITECT

The world-wide dissatisfaction with the present training of the architect comprises all aspects of his education, from the abilities required to the qualifications and the degree of responsibility attained.

The main reason for this malaise is a one-sided *specialization,* one of the fundamental diseases of our time. Education in architecture, therefore, cannot be regarded as an isolated case, but must be integrated in the long run in the all-over reform of educational training.

In sharp contradiction to the present situation, the most vital task of this period is to learn again how to *coordinate human activities,* for the creation of a coherent whole.

What we urgently need are people with coordinating minds, and it should therefore be one of the first purposes of education to promote in the young the development of this faculty. To achieve this, we must free ourselves from the departmentalized and encyclopedic conception of education and encourage instead the understanding and comparing of the specific problems encountered and the methods evolved in the various domains of human thought and activity.

No single organization, no university, and no country is in a position to perform this task. UNESCO seems today the only agency in existence having the necessary means to accomplish this integration, which has to come about if our civilization is not to collapse.

In the field of architecture the situation may be described as follows:

In former periods a common pattern ran through the whole domain of architectural activity, uniting the craftsman and the artist, the builder and the town planner. A common cultural background integrated almost unnotice-

ably the various professions. The teamwork necessary to create a comprehensive whole could almost dispense with a conductor. The spirits were tuned together like the instruments of a string quartet.

All this has changed. The professions involved in architectural activity acquire in their training a very limited outlook. The attempt is being made to turn the architect into a specialist in an ever-increasing number of continuously expanding disciplines: into a dilettantic mathematician, engineer, statistician, art historian, sociologist, etc.

This hopeless undertaking must be abandoned, for a strictly *methodological* approach which will enable the student to know what questions he may ask and what solutions he may expect from other disciplines. He must be trained, of course, to become as skilled a craftsman as ever, but the stress must be laid today on his future role of a *coordinator*, so that he may be enabled to integrate the elements supplied by specialized knowledge into a *work of art*.

This involves in many respects a departure from present curricula and methods. As a historian, however, I shall limit myself to sketching the consequences of this conception for the architect's study of history.

The architect's relation to history and to the past is changing. In the nineteenth century the architecture of the ruling taste, and consequently the training of the architect, was concerned with shapes and forms. Students were trained to regard the past as a warehouse of forms, where one could borrow or pilfer *ad libitum*. Today a different attitude toward the past has evolved. Past, present, and future are regarded more and more as an indivisible whole. What we are looking for are the living forces and the spiritual attitudes which shaped the various periods, and most particularly we are interested in those problems of bygone civilizations which reveal a deep affinity with the present-day situation, just as modern painters and sculptors went back to so-called primitive cultures, to get support for the shaping of their own inner reality.

History conceived as an insight into the moving process of life comes closer and closer to the biological approach. We are interested today in knowing more than political, sociological, and economic occurrences. We want to know, in the manner of biologists, how the life of a culture took shape. This means exploring what one might call *anonymous history*. Methodological study of other periods will give the student a better insight into the specific nature of his own time, into its own accomplishments, and shortcomings in comparison to former civilizations.

The practical consequences in respect to the teaching of history, which still goes on as if nothing had happened since the middle of the last century, are that, instead of a history of styles and forms, a *typological* approach has to be introduced: instead of elaborating a false continuity from the Stone Age to the twentieth century, through an over-simplification and a purely formal description of various periods we must concentrate on the vertical lines going through history.

History teaching is ever tied to the fragment. But these fragments have to be chosen in such a way that new constellations will arise in the minds of the students. History can only be taught in this sense by people who have an intimate understanding of the architectural and the planning problems of the present, of their emotional as well as of their social aspects.

Closely related to this demand is the selection and limitation of subject matter in such a way that it can be tied up with the interests and the work of the student, as John Dewey has been proclaiming for the past half century. This, too, will help to eliminate nineteenth-century methods based on a mechanistic piling up of unrelated facts, forgotten as quickly as they are acquired.

Marginalia

The letter to Julian Huxley, mentioned earlier, remained buried in a drawer. But the demand that history be taught in a way that conformed to a contemporary approach toward architecture remained alive.

During the next few years, in my regular courses at the Federal Institute of Technology, Zurich, a method started to develop. It seemed to me that an encompassing approach to the history of architecture could only be based today upon conceptions of space.

In *Space, Time and Architecture* I had tried to develop this approach within the limitations of one period. In the course of my recent studies of the beginnings of art and the beginnings of architecture, I have been developing an outline of the evolution of space conception from its birth.

When I went to Harvard in 1954 the method had already become formed and I was able to introduce it there. I was not at all sure that this attempt would meet with success, but it worked out better than I had anticipated. The students reacted favorably, and in saying this I am not referring to those students who are prone to present mechanical repetitions of the ideas and even the words of their instructor in order to simplify the task of passing their all too frequent examinations. Rather, I am referring to those students who showed that the courses had provided a certain stimulus that had pricked their own powers of thinking into action—one of the main functions of a teacher.

Toward the end of the first semester at Harvard, in a lecture on "History and the Architect," I gave a short outline of the role I believe history should play in the education of the architect.

HISTORY AND THE ARCHITECT

Uncertainty and hesitancy are noticeable in the attitude of many Universities and Institutes of Technology regarding the relations between history and the architect. The importance, or the unimportance, of the study of history has repercussions upon the whole training of the architect.

There are many opinions in the profession about this relationship, and there are also many who have not made up their minds.

One, perhaps oversimplified, attitude is that of the practitioner: "History? An architect has to build. He must be taught the necessary know-how for this. That's what his training is for. What has history to do with this job? History courses are only a waste of precious time in an already overloaded curriculum."

Another familiar attitude held in the profession is the belief that a study of the historical just intimidates the young architectural student, and that history—if taught at all—should be taught only toward the end of his studies.

Others hold that the study of history produces eclectics and that students will be seduced by the past to become copyists instead of inventors.

Opinions such as these are trying to eliminate contact with the past, considering it as something useless, and even obstructive, to present-day development.

Now suddenly an interest in history has reawakened and we find discussions on this subject taking place in professional circles and in the architectural magazines—with more scheduled.

How can all this be explained?

Undoubtedly it stems from the period when the vocabulary of contemporary architecture was being formulated —above all in the 1920's—following all the harm that had

been done to architecture by the nineteenth-century plundering of historical forms.

At that time those who were framing the new architecture had to search within themselves and in the life around them to produce an architectural language equivalent to their own period.

Today this first step has been accomplished and contemporary architecture has become a universal language, a language capable of being adapted to meet the needs of different conditions and different idioms in the varied regions of the world. This is something quite different from an "international style"—a misnomer to be carefully avoided.

The horizon today has been considerably widened. Closer relations between Eastern and Western civilizations, and their consequences, are in the forefront. Moreover, there hovers in the background the demand for a wider range of inner relationships, and, to a certain degree, even a feeling for what is common in human existence: a new demand for continuity.

This may be the real reason why, from all sides, interest in history has revived. But our approach to history is, of course, quite different from that of the nineteenth century.

The nineteenth century

In the nineteenth century the architectural historian stood upon firm ground. An encyclopedic treatment of architectural history presented the student with a sort of inventory of the acknowledged masterpieces of architecture. A second inventory consisted of the classical orders and Gothic structural features; this was accompanied by all the details of entablatures, friezes, and other ornamental accessories. This presented the young architect with a history of styles that proved very useful to him in the design of Classical, Romanesque, Gothic, or Renaissance banks, city halls, law courts, and so on.

In the nineteenth century one stood upon firm ground. The study of history certainly fulfilled a useful purpose.

Banister Fletcher's *History of Architecture on the Comparative Method*,[1] in some respects still useful today due to the exactness of its descriptive material, is significant in that it is an epitome of all the history that was then considered necessary and useful for the young architect to know.

But when, early in this century, the collapse of eclectic architecture finally came about, this materialistic way of approach slowly began to be regarded as insufficient or even detrimental to the training of the student.

The twentieth century

During the formative period of contemporary architecture, in the twenties and thirties, Universities and Institutes of Technology still clung to their former comparative, descriptive methods of teaching the history of the styles of building. And when contemporary architecture—after many long and often deceptive battles—finally won the day, there was an immense backlog of mistrust which, coupled with a deep inner uncertainty, caused the teaching of history to be banished altogether from many architectural curricula—thus throwing out the baby with the bathwater.

This is still to some extent the situation today.

How do we regard history today?

We have ceased to regard history as a static process, in which past, present, and future are listed in separate columns as in a bookkeeper's ledger. The result is that the past —those things that have happened—is no longer seen as something dim and fusty, dead as dust, but as an inseparable part of our living human destiny.

This brings us to our main problem: *How can the history*

[1] Banister Fletcher, A *History of Architecture on the Comparative Method* (16th ed., London, 1954).

108

of architecture be taught today so that it can take account of our changed viewpoint—that history is not static but dynamic, that history is an ever-changing process, depending upon the point of view of each succeeding generation.

This was already implicit in Jacob Burckhardt's *Force and Freedom, Reflections on History*, written nearly a hundred years ago. In this book he stated: "We, however, shall start out from the one point accessible to us, the one eternal center of all things—man. Man, suffering, striving, doing, as he is and was and ever shall be. . . . We shall study the *recurrent, constant* and *typical*, as echoing in us and intelligible through us . . . and now let us remember all we owe to the past as a spiritual *continuum* which forms part of our supreme spiritual heritage." [2]

We now must find where lies the key to our problem today, and in this connection we have to ask whether there are any phenomena that clearly run through the whole of historical development, upon which the history of architecture, as taught today, can be basically founded. Such phenomena—such notions—must be extracted from the innermost heart of architectural concepts.

The objectivity of the historian

Before delving further into this, however, there is a certain prejudice that must be cleared away. This is the fiction that the historian is a man who stands above the turmoil of the milling crowd and, from an ivory tower, surveys the scene with a dispassionate eye, interpreting it with a timeless rightness.

This so-called objectivity of the historian is a product of the last century, which somehow believed itself able to erect buildings of a timeless quality by piecing together a sort of photomontage of the ornamentations of bygone periods.

There is, in fact, no such thing as an objective historian.

[2] Jacob Burckhardt, *Force and Freedom, Reflections on History* (New York, 1943), pp. 81, 82, 85.

His seeming objectivity usually consists in a regurgitation of the beliefs of former generations which have become generally accepted truths and thus he gives an appearance of impartiality.

All great historians have been creatures of their own period: the more so the better. The historian should find inspiration in the same creative forces that animate what Paul Klee has called the "real artist."

The historian has to give insight into what is happening in the changing structure of his own time. His observations must always run parallel with those specialists of optical vision whom we call artists, because it is they who set down the symbols for what is going on in the innermost life of the period before the rest of us are aware of it.

The problems of the past are as innumerable as the trees of a forest, but there are certain problems especially related to the strivings of each particular period. In order to recognize these, the historian must himself be a real creature of his own time. He must know which are the urgent problems that have to be solved, and he must be able to develop his own researches out of them. For this the historian must have an understanding of his own period in its relation to the past and maybe also some inkling of those trends leading into the future.

History is a mirror which reflects the face of the onlooker. The historian has to show the trends of development as clearly and as strongly as he is able. But his so-called objectivity is nothing but a fiction.

How should the historical past of architecture be presented to students of architecture?

The method of presenting history should not differ from the methods of presenting any other subject considered necessary in the formation of the architects, as, for instance, statics or the theory of structures.

In many schools of higher learning, Universities, and Institutes of Technology, there has been, and still is, a tendency to try to teach the architect to undertake the sort of

calculations of structures that are required of the civil engineer.

The result has been to turn the architect into some kind of dilettante engineer with no understanding of what "statics" really means. Some time ago I asked Ove Arup, the English structural engineer who works in close contact with architects, what place he considered statics should play in the education of the architect. He told me that, from his experience in working with young architects in the London Architectural Association School, he had become convinced that it was far more important to give them a certain *sense for statics* than to teach them the techniques of complicated calculations. The great structural engineer, Luigi Nervi, once complained to me that the plans he gets from architects often reveal an astonishing lack of structural understanding. It seems, therefore, that the aim when teaching statics to architects should be to develop in them a sense of the potentialities of structural materials so that the architect's own spatial imagination may be kindled, and, second, that he may know what he can and what he cannot demand from his best helper, the structural engineer.

In other words, the architect needs to be given a methodological approach, or, to remember the statement of Walter Gropius, "In an age of specialization, method is more important than information."

The system of presenting history should be in the same way based on a method, rather than specialization. The student should be helped to widen his outlook. But this outlook should be widened not by a host of facts or purely historical knowledge. His outlook should be widened by strengthening in him a certain faculty: the sense for space.

As a by-product, a method for encompassing architectural history today can be developed.

Space in the historical approach to architecture around 1900

From the point of view of the present day, the innermost heart of architectural development rests upon two inseparably connected concepts: *space* and *space conception*.

At the end of the last century, three great scholars were the first to undermine the current factual and materialistic approach to this problem. They were the Swiss, Heinrich Wölfflin, in his early work on *Renaissance und Barock*; the Austrian, Alois Riegl, in *Spätrömische Kunst-industrie*; and the German, August Schmarsow, in *Grundbegriffe der Kunstwissenschaft*.[3] The analysis of formal shapes appeared to these men as too coarse a tool to apprehend the spirit of a period.

Despite their differences, Wölfflin, Riegl, and Schmarsow all recognized that the formation of space is fundamental to architecture, and that it is the changes, which occur continuously, in the formations of space that provide the unquestionable basis of the history of architecture.

The three stages of architectural development

Nothing is more embarrassing today than when small-minded people, taking advantage of the fact that they have been born later in time, venture to criticize those who first opened up the paths along which we are now treading.

We are today born with the belief, based on a development of nearly 2000 years, that architectural space is synonymous with hollowed out interior space. It is, therefore, easy to understand how Alois Riegl, around 1900, considered that real architectural space could only be fully developed when it was given a vaulted ceiling.

We, who have been born later, have the advantage that

[3] Heinrich Wölfflin. *Renaissance und Barock* (Munich, 1888); Alois Riegl, *Spätrömische Kunst-industrie* (Vienna, 1901); August Schmarsow, *Grundbegriffe der Kunstwissenschaft* (Leipzig and Berlin, 1905).

112

our outlook, thanks to the work of modern artists, has been considerably widened in regard to spatial conceptions. It is, therefore, not so difficult for us to recognize that the first great development of architecture was not concerned with hollowed out space.

In the birth country of architecture—Egypt—there was no inner space in the accepted sense. In Egypt volumes were set in the boundlessness of endless space, and architectural space was developed by the interplay between volumes and light.

We can divide the whole evolution of architecture up to the present day into three stages—the third only now beginning.

The first stage encompasses architecture from its genesis in Egypt and Sumer, including the Greek development and to some extent also the Roman, up to the building of the Roman Pantheon.

This long evolution that connects the Pyramids with the Pantheon had very many facets, gradations, and differentiations, and it is an exhilarating spectacle to observe how within this first architectural evolution, characterized by the placing of plastic artifacts in boundless space, the second step is already in preparation.

We can observe for instance how Egyptian architecture, dominated by plane surfaces, with columns closely connected to inner walls and concealed from the outside, becomes changed during the Greek development. The plane surfaces, with their shadowless low reliefs and interior columns, here turn into temples surrounded by peristyles. The interior columns have come outside and now offer themselves to an exuberant play of sunlight and shadow. The low reliefs have become high reliefs and three-dimensional statues, their limbs no longer pressed closely together, reach out in all directions, their agitated movements accompanied by wind-blown garments. To an Egyptian they may have seemed as distorted as a 1938 figure by Picasso would have appeared to an onlooker of 1890.

113

But despite all these contrasts, the same space perception pervaded Egypt, Sumer, and Greece—*le jeu savant des volumes sous la lumière.*

The second stage of architectural development opened in the midst of the Roman period. The interior of the Pantheon, with its dominating dome and eternally open eye, still exists as the most impressive witness of that instant when hollowed out space, modeled by light, attained its monumental expression, exploiting simultaneously form, light, and shadow.

This is not the moment to discuss the origin and use of the dome, nor whether it was derived from the East or developed independently upon Eastern Mediterranean soil.[4]

This second stage extended from the time of the great Roman vaults and Byzantium through the Medieval, the Renaissance, and the Baroque periods, up to the end of the eighteenth century.

In absolute time, this period is far shorter than the first stage, but it was far more animated in its spatial development.

Even stronger contrasts in form, scale, organization, and construction meet the eye than during the first stage. However, in tracing the development from the Pantheon to the Gothic cathedrals, and on to the spatial vortex of a late Baroque church, the continuity of the space conception itself remained fundamentally the same.

Since late Roman times hollowed-out space, a circumscribed interior space, has been the major problem of the art of building. The most creative talents have concentrated upon its further development, and the ever-changing form of this interior space distinguishes the phases of this second stage of architectural evolution.

This connotation of architectural space with hollowed out interior space is so familiar to us that it requires a considerable effort for us to appreciate its relative nature.

At the end of the eighteenth century came a short in-

[4] See Part 6, "Spatial Imagination."

termediary period during which the nineteenth century searched everywhere to find its own soul. Quite aside from the nineteenth century architecture of the ruling taste, new trends were being developed in the neutral area of construction techniques.

In the early years of our century, a new space conception begins to emerge, first in painting and then in architecture, as I tried to indicate to some extent in *Space, Time and Architecture.*

This third stage of architectural development is still in the convulsions of its formative period, yet already some of its features can be outlined.

It is different from the first stage and from the second. Yet elements of both are preserved alongside new elements of its own.

The constituent fact of the second stage—the hollowed out space—continues to be further developed. Simultaneously the space-emanating volumes of the first stage are reintroduced. New elements also appear, some of them partly announced during the last years of the second stage, such as transparency which is combined with the interpenetration of inner and outer space.

Hollowed out space; juxtaposition of volumes; perforation—all lead up to what has been termed the space-time conception of our period.

History and curriculum

Finally the practical question must be raised: How can history of architecture be built into the general curriculum? This can be solved in many different ways, according to the purposes of different types of schools, yet there are some constant leading principles.

In many universities an introductory survey course in the History of Art is offered as part of the general undergraduate program. It would be as well if such courses were made mandatory for all students wishing to enter the architectural

schools, and considered just as important as the usual requirements for a basic knowledge of mathematics. These general courses provide the student with a certain foundation and some points of reference in regard to the development of art which serves as a basis for his specialized studies in architecture.

In cases where such courses are not at present available to the young student, one must consider in what form a first general introduction to architecture, painting, and sculpture can best be given.

The whole question of incorporating the teaching of history within the architectural curriculum circles around three problems:

How should history be taught?
How much?
When?

How?

From the moment the student enters the school of architecture, history should be presented to him from a point of view that corresponds to our present-day demands and our present-day attitude toward the past.

In my opinion this means that history of architecture should be taught from the very beginning to the present day on the basis of space conception. This is an all-embracing postulate, intimately related to the demand for spatial imagination which is so urgent today.

The widespread nature of this demand for knowledge of the historical development of space conception in many fields is instanced by the recent appearance of a book entitled *Concepts of Space* by Max Jammer, which contains the statement:

It is the history of scientific thought in its broadest perspective against the cultural background of the period which has decisive importance for the modern mind.

The concept of space, in spite of its fundamental role in physics and philosophy, has never been treated from such a historical point of view.[5]

The same must indeed be said of space conception in architecture.

How much?

If history of architecture is taught on the basis of space conception, then it can incorporate much of the material that is often now handled in separate courses such as Theory of Architecture, Architectural Philosophy, and others.

A one-term course on the Visual Arts, at the outset of architectural studies, destined as a kind of eye opener to arouse a visual excitement in the student, can be based upon first-rate visual material or color slides, without historical amplification. This course can and should be handled by an architect.

But the courses on Space Conception need to be the responsibility of a fully trained art historian. History is as much a full-time job as architecture or planning, and the frame of reference within which courses on space conception have to be set must be rather comprehensive if misleading dilettantism is to be avoided.

Care should be taken, however, that these courses do not stand in isolation. Apart from the courses themselves, history should be brought into coordination with design problems in the workshops. When, for instance, there is a design problem for a museum, a church, an assembly building, or a shopping center, the historian should be required to give an introduction whose length would be dependent upon the importance of the problem. The purpose is to give the students a greater oversight into the nature of the prob-

[5] Max Jammer, *Concepts of Space, the History of Theories of Space in Physics* (Cambridge, Mass., 1954), p. v.

lem and the ways it has been tackled in the past, so that they can approach it with a wider outlook and are less seduced to imitate the latest fashionable examples in the current magazines.

History should be as closely connected with the workshop problems as is structural design.

The whole development of architecture today leads us toward a greater attention to the long neglected study of proportions. We know of course that a knowledge of proportions alone can no more produce a good architect than the rules of sonnet-writing can produce a poet such as Petrarch; but in a period like our own, which is slowly beginning to demand a coherence of parts in relation to the whole, whether in a single building or in a larger complex, the study of proportions can provide a necessary backbone.

This cannot be successfully handled in lecture courses, but only in seminar work and discussions, as I have discovered since I first started to work along these lines in 1951.

Such studies provide another way of bringing theoretical orientation into contact with the workshops, and I have had occasion to note how they have a direct impact upon the practical work of the students.

Finally, how much space can really be given to history in our already overcrowded curriculum, which needs to be curtailed rather than extended in time? Courses on space conception demand at least two hours weekly throughout four terms. This space can be found only by avoiding any kind of repetition and overlapping, and by an acceptance of the fact that the history of space conception can include much that is now being studied under other names.

When?
If taught in this way, contact with the past should accompany the student from the beginning to the end of his architectural training, as has been done for instance in the Architectural Association school in London.

In this event, the question as to whether history should be taught at the beginning or at the end of the total program of studies becomes unimportant. History walks beside the student as a friendly guide, liberating but not inhibiting his spatial imagination.

Part 5

ON THE RENEWAL OF THE
HUMAN HABITAT

The Humanization of Urban Life

The New Regionalism

Marginalia

The next part of this book must deal with the question of the structural forms which correspond to the contemporary way of life. It is evident that new forms for the human habitat must be found if we are to check an ever-widening expansion of the present human chaos.

Much is still unclear. Crucial questions are in a state of flux. But outlines, which may set a framework for the final realizations, are already fairly definite.

The past century, even as our own, had no respect for the land. It abused the earth, allowed erosion to remove the topsoil, sliced up the ground, and destroyed the landscape by the straggling extensions of widespread cities.

The gravity of this situation compelled Frank Lloyd Wright to issue the following heavy warning in 1937: "Man cannot be taken, still less can he take himself, away from his birthright, the ground, and remain sane any more than he can take himself away from the air he breathes, the food he eats, the water he drinks." [1]

A plan to achieve this preservation of the earth can be designed in various ways. In the Garden City movement, as proclaimed by Ebenezer Howard in 1898, land was seen mainly as a living place for people who worked in the neighborhood of London. Ebenezer Howard's plan was throughout conceived as part of a greater whole. But the idea and its realization, as so often, became separated from one another. The intention was smothered by row upon row of small houses in small gardens.

Frank Lloyd Wright's own proposal—Broadacre City—

[1] Baker Brownwell and Frank Lloyd Wright, *Architecture and Modern Life* (New York, 1937), p. 301.

was based on the idea of self-sufficient homesteads, organized in gridiron fashion, but each with enough land to grow food for the household. This presupposed the existence of large available tracts of land, such as exist in certain parts of America. Thickly settled Europe and much of the United States can no longer think in such terms.

The Garden City movement, like the Broadacre City idea, implied a broadcasting of dwellings over the land, and grew from the supposition that the greater concentrations of people—even the city itself—would disappear.

The development of the city's structure took another direction from that anticipated. Even so, this also demands that man should not forgo his natural right of contact with the soil. The asphalt deserts must disappear. A wider separation of structures is needed so that earth and landscape are not choked to death. The form and relationship of these structural volumes to the spaces between them and to one another is dictated by a new space conception, which is displayed by the play of relations of surfaces: by the interaction of high with low buildings. This is consonant with the basic demand for a diversified habitat, diversified in the sense that it contains a variety of dwelling types—for single people, for families with children, and for older people. This compatibility of form with function, of an emotionally felt desire with a sociologically necessary trend, is one of the signs which indicates that we are once again moving in accord with a universal conception.

But even the most beautiful housing project remains but a segment when it stands in isolation, when it has no "heart," no place that serves as a bridge between private life and community life, no place where human contacts between man and man can again be built up. The destruction of human contacts and the present lack of structure of the metropolis are mutually urgent problems.

The city as an arch-symbol of a diversified human society appeared in the earliest high civilizations, and has continued throughout all periods. The community life that was developed in each period—its intensity or its weakness—was a measure of the level of its civilization, as is briefly indicated in the following article.

If we look at the city as a place in which private life and community life find a meeting place, then the mark of a true city is the balance between YOU and ME. It is this you and me relationship that we must build up again today. No machine can replace physical nearness, neither telephone nor radio, home movies nor television.

Anyone who still does not realize that the most important effect of face to face human contacts is the immeasurable inward and outward psychic forces which can be generated, is past helping. But, to enable this to occur, special receptacles must be provided. There can be no doubt that in the last few years the demand for such developments has grown ever stronger. What is needed to bring these into being is imagination on the side of the planners, and a sensitive understanding on the part of the clients—be they civic corporations or private undertakings.

THE HUMANIZATION OF URBAN LIFE

If we examine, from a human point of view, the road which architecture has been obliged to follow during this century in order to come to terms with its own period, we shall find this divided into two distinct stages.

The development started as a fight against an "infected atmosphere and as a moral revolt against the falsification of forms" (Henry van de Velde). It began far back in the nineteenth century with William Morris' purification of the immediate human environment by giving dignity of form to objects of daily use. From here it passed on to architecture, nowhere more markedly than in the single-family houses built around 1900 by Frank Lloyd Wright and others in the suburbs of Chicago. The American spark reached Europe. The work of the Stijl Group in Holland, Mies van der Rohe's projects for country houses, Le Corbusier's first Paris house in reinforced concrete, were all produced early in the century and all were single-family houses. A study of the single-family house—man's most intimate environment— enables one to understand better than anything else whether a man really knows how to build. The climax of this development came later in California.[2]

The family cell was still the motif of the different forms of multi-storied dwellings that were developed parallel in time, including three-story row houses and skyscrapers. The so-called "tower" houses that have been particularly developed in Sweden are a compromise between high and low forms of housing and, for several reasons, they may become discarded sooner than expected.

[2] I was able to develop this observation when editing a volume of the works of CIAM architects from twenty-two countries—*A Decade of Contemporary Architecture* (Zurich, 1952).

The beginning of a link between social and aesthetic aspects of the housing movement was marked by J. J. P. Oud's Rotterdam worker settlement (Tusschendyken 1919–20). It reached an experimental climax in Le Corbusier's *Unité d'Habitation* at Marseilles which, by reason of its aesthetic importance as well as its internal organization, is as much a contribution to urban design as it is an agglomeration of family dwellings.

This has been the first part of the route. The second stage of contemporary architecture is more concerned with the humanization of urban life. The relation of the parts to the whole, the contact between the individual and the community, has to be restored.

A glance at the big cities, whose functioning has become paralyzed by the impact of mechanization, gives rise to skepticism. Where in a "megalopolis" does one find any trace of community life, or of enjoyment based upon spontaneous social intercourse, other than as a passive observer?

Absolutely true. Yet the suppressed demand for social contact, which has lived on imperishably in the human soul ever since men first met in caves during the ice ages and left their ritual symbols on the walls, breaks out spontaneously when man is shaken by some great event. I remember the gathering that collected at the tiny Rockefeller Center at the end of the Second World War, when the voice of Lily Pons suddenly arose and gave expression to the emotion that moved the masses.

It is one of the curious features of present-day civilization that the contemporary creative focus can no longer be traced to a single area. Today creative impulses within the same movement arise all over the earth.

The heart of the city

The endeavor to reëstablish an equipoise between the individual and the collective sphere is proceeding today throughout the world. This may have been the underlying

126

reason for the selection of the "Core of the City" as the theme for CIAM 8 (Hoddesdon, England, July 1951). The term "core" which was introduced by the MARS group of London in the place of "civic center" (whose meaning has become too closely restricted to administrative buildings) may soon come into general use.[3] Since 1300, according to the Oxford English Dictionary, the word "core" has meant "the central innermost part, the heart of anything" and it was defined by the MARS group as "the element which makes a community a community and not merely an aggregate of individuals."

Contemporary interest in the core is part of a general humanizing process; of a return to the human scale and the assertion of the rights of the individual over the tyranny of mechanical tools. It seems possible that this demand for the reëstablishment of community life is likely to be satisfied sooner in the new town cores which are now coming into being in Peru, Colombia, and India than in the highly mechanized cities of the United States.

Is it possible, in our Western civilization, to build functioning city cores in the absence of a well-defined structure of society? In contemporary art—poetry, music, painting, architecture—we can see that during the last forty years a new language has been evolved out of our own period by artists, who themselves seldom adhere to a formal religious creed or well-defined political convictions.

This development is not without an inner significance. It seems that a new stage of civilization is in formation in which the human being as such—the bare and naked man—will find a direct means of expression. We do not know consciously, for instance, why certain forms or symbols which have no direct significance appear again and again in the works of the most diverse painters. All of these forms are somehow bare and naked as yet. They are, at any rate for the present, symbols without immediate significance.

[3] This was developed in *The Heart of the City*, ed. J. Tyrwhitt, J. L. Sert, E. N. Rogers (London, 1952).

127

Sartre once wrote that we need today signs and symbols which spring directly to the senses without explanation. He then strengthened this statement by reference to experiments that have been carried out by certain psychologists.

The problem of the core is a human problem. The extent to which it will be fired with life will depend on the people themselves. Architects and planners know that they cannot solve this problem alone and that they need the cooperation of sociologists, doctors, historians. For example, no one at the eighth congress of CIAM was listened to with greater attention than Dr. G. Scott Williamson, founder of the Peckham Health Center in London, which was indeed a "core" based on the spontaneous activities of people of all ages. Then the historian was asked to present the historical background of the core, because our period has lost so many of the formerly accepted norms of human behavior and human relations that a special interest has arisen in the continuity of human experience. We are vitally concerned to know how those who came before us handled certain like problems. For instance, how did they develop social intercourse and community life? There is, of course, no suggestion that we should imitate our forebears, but I believe (and here I come back to the symbol of the bare and naked man) that there are certain continuous features running through human history—certain experiences which appear and are lost and then come up again.

To take only a very simple example: the right of the pedestrian in the center of community life—in the core. This was carefully respected, and indeed self-evident, in all former civilizations. Today this right of the pedestrian—this human right—has been overridden by the automobile, and so the gathering places of the people—the places where people can meet together without hindrance—have been destroyed. Today one of our hardest tasks is the reëstablishment of this human right, which is not merely imperiled but has been destroyed altogether.

So, when we look back into history we wish to pose very

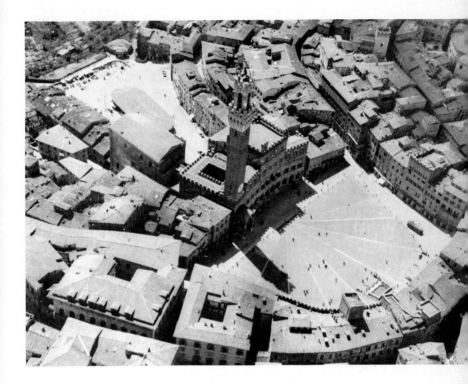

29. *Siena: Piazza del Campo, completed 1413.* This shell-like plaza lies between the three hills upon which the city is built. The natural slope has been turned to excellent account to accentuate the domination of the central City Hall. Eleven streets lead into it. The white marble stripes in the pavement radiate out like the rays of a lantern from the heart of the city's community life.

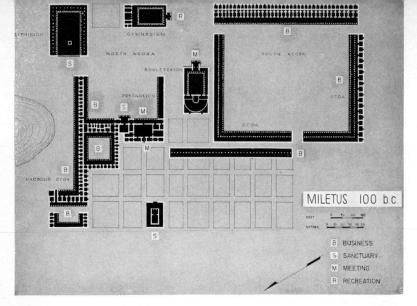

30 and 31. *The Agora and City of Miletus*. The Greek gridiron system in this, the home town of Hippodamus, was laid out when the city was rebuilt after its destruction by the Persians in 494 B.C. The gridiron as such was invented much earlier in Sumer and Egypt, but a completely new sense of order was introduced into it as a result of the Greek conception of the *polis* in which all civic emphasis was concentrated in the agora, the core of the community: the city. (From comparative town planning studies, Harvard Graduate School of Design, 1955.)

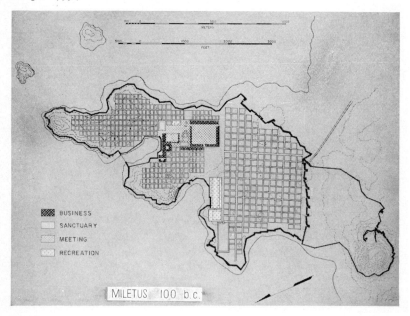

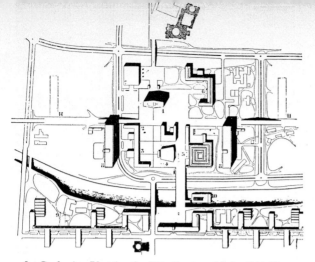

32. Le Corbusier: *Plan for the City Center of Saint-Dié, Vosges, France, 1945.*
The spatial conception for rebuilding the city center of Saint-Dié, which had
been destroyed in the war, set up a milestone in urban development. It is
one of the few examples in which the inner forces of the modern space con-
ception are brought to fulfillment. The principal buildings stand freely each
within its own space.

32a. Le Corbusier: *Saint-Dié. Photograph of model in the Le Corbusier ex-
hibition in Zurich, 1957.* The building in the lower center of the square is the
department store; to the left is the museum; in the further corner of the
square is the cafe; and in the center is a tall office building.

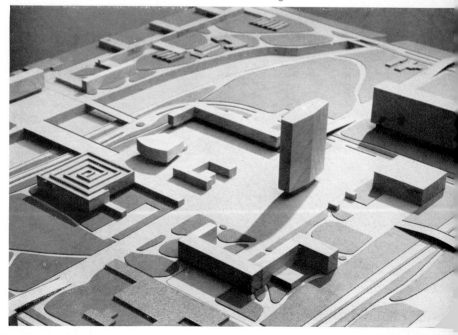

33. *Oscar Niemeyer: The architect's weekend house, Mendes, Brazil, 1949.* At first glance these two houses by Richard Neutra and Oscar Niemeyer have nothing whatever in common. But both are imbued with the same contemporary spirit.

THE NEW REGIONALISM

34. *Richard S. Neutra: Tremaine House, Santa Barbara, California, 1947.*

35. *Kenzo Tange: House in Tokyo, 1953.* Another example of the new regionalism. The elements of the traditional Japanese house, with its mastery of the organization of plane surfaces, its impeccable feeling for clean, undisturbed space and purity of form and structure, require only minor changes to satisfy contemporary needs. But the different habits of living in East and West cannot be so easily bridged.

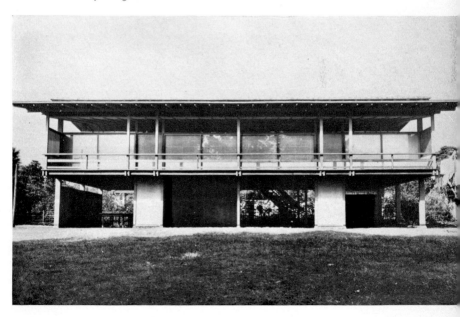

RETURN
TO THE
PRIMEVAL
HOUSE
FORM

36. (Left) *Oval House, Crete, about* B.C. *1500.*

37. (Right) *Frank Lloyd Wright: Circular house in California, about 1940, for Glenn McCord house.*

38. (Bottom) *House at Uruk-Warka (Irak).* This house of rammed earth with its curved wall had a thatched roof. Though of our time it is a continuation of the form of the Mesopotamian house of the third or fourth millennian before Christ.

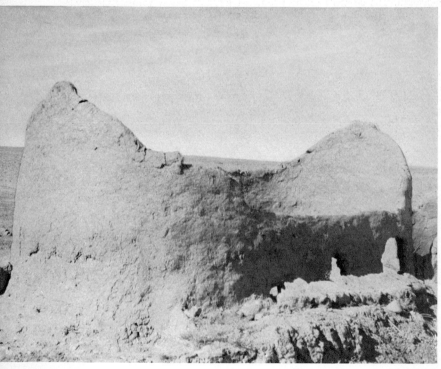

39. *Frank Lloyd Wright: Sol Friedmann circular house.*

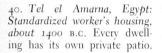

40. *Tel el Amarna, Egypt: Standardized worker's housing, about 1400 B.C.* Every dwelling has its own private patio.

41. *J. L. Sert and P. L. Wiener: Housing project for Cuba, 1952.*

THE NEW REGIONALISM AND AGE–OLD TRADITION

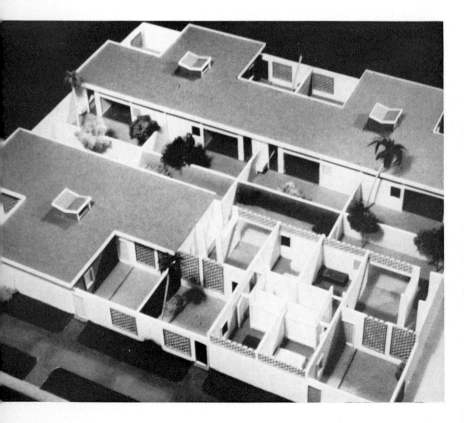

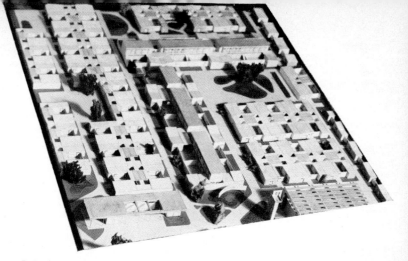

42. *J. L. Sert and P. L. Wiener: Housing project for Cuba, 1952.*

43. *André Studer: Pyramidal apartment block in Morocco, 1955.* The pyramidal organization of this structure has a reason: it is to permit not only the sun but also the rain to penetrate every dwelling and so carry out their hygienic functions. This certainly also gives the structure a pleasing aesthetic appearance.

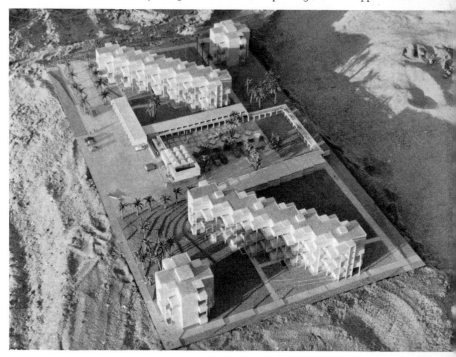

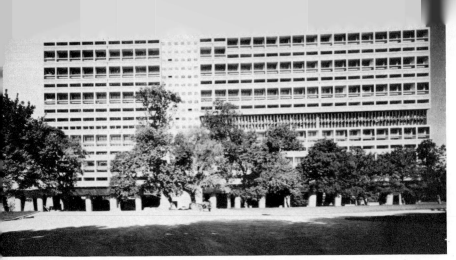

44. *Le Corbusier: Unité d'Habitation, Marseilles, 1946–1952.* General view.

THE HUMAN HABITAT IN A LARGE CITY

45. *Le Corbusier: Unité d'Habitation, Marseilles, 1946–1952.* On the roof terrace a wall has been reserved for children's frescoes. Le Corbusier presented the first paints and colored chalks.

46. *Le Corbusier: Unité d'Habitation, Marseilles, 1946–1952.* The roof terrace. "Architecture is the true and conscious play of volumes in space."

A RARE COMBINATION OF SOCIAL AND SPATIAL IMAGINATION

47. *Le Corbusier: Unité d'Habitation, Marseilles, 1946–1952.* Paddling pool.

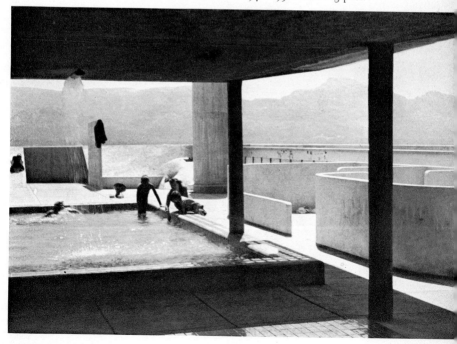

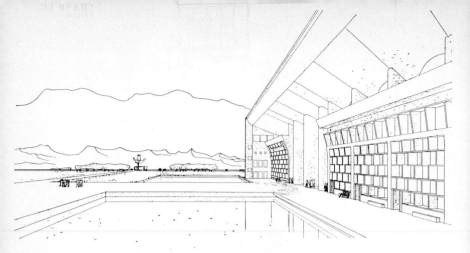

48. *Le Corbusier: Chandigarh, Capital of Punjab, India, 1951–1955.* The façade of the High Courts of Justice, opened in 1955.

THE GOVERNMENT AND COMMUNITY CENTER
OF A NEW CAPITAL CITY

49. *Le Corbusier: Chandigarh, Capital of Punjab, India, 1951–1955.* The monument of the Open Hand.

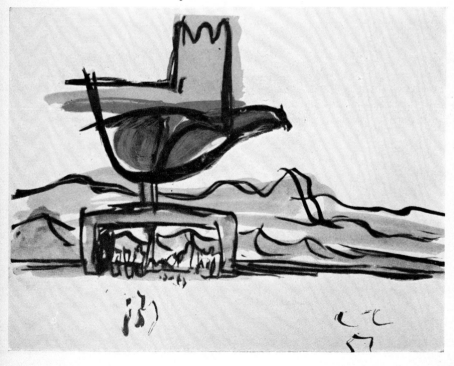

CHAND LC
CAPITOL
achala - 1:1000
dessiné por leon
à para , le 8-2-56.
L. Corbusier
N

50. *Le Corbusier: Chandigarh, Plan of the Capitol.* The building at the far right is the High Court of Justice with its three pools (4), opposite is the assembly hall (1), to the left the Secretariat (2), upper right "the open hand" (7).

51. *Le Corbusier: Chandigarh, the High Courts of Justice.* The High Courts of Justice and one of the three pools presenting with its reflection "the double square" (Le Corbusier).

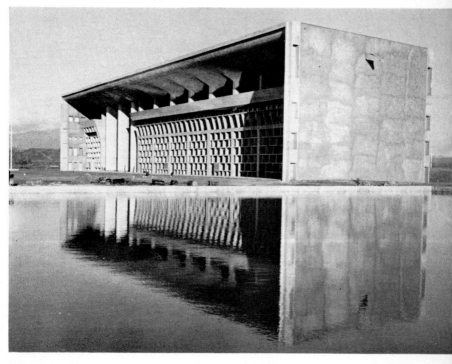

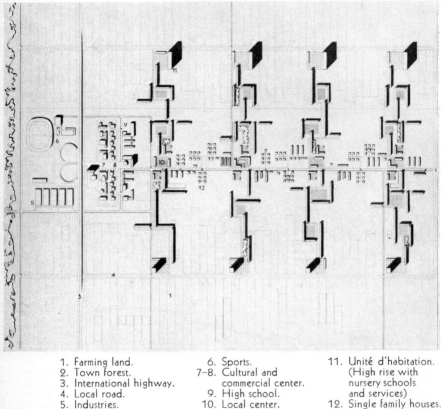

1. Farming land.	6. Sports.	11. Unité d'habitation.
2. Town forest.	7–8. Cultural and	(High rise with
3. International highway.	commercial center.	nursery schools
4. Local road.	9. High school.	and services)
5. Industries.	10. Local center.	12. Single family houses.

52. *J. B. Bakema and Group OPBOUW: Plan for Alexander Polder, Rotterdam, 1955.* Designed as a typical section of a large city such as Rotterdam for a definite number of inhabitants—30,000.

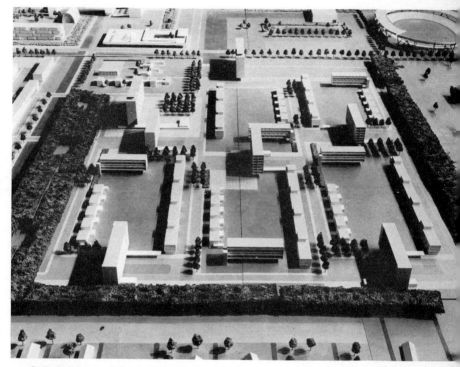

53. *J. B. Bakema and Group OPBOUW: Alexander Polder, Rotterdam, 1953.*
Model of an earlier version of the same project.

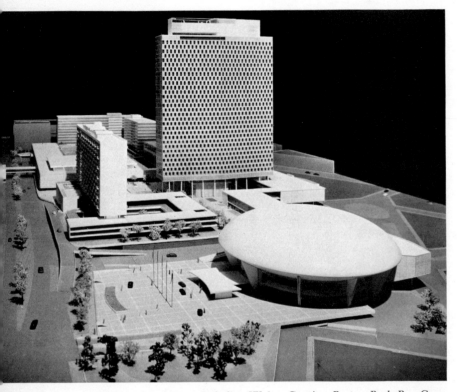

54. *Group of architects, including Walter Gropius: Boston Back Bay Commercial and Community Center, 1953.* In America also there is a movement to reduce the chaos of the large cities. One of the most important projects in this direction was this proposed new center for Boston. It is only for the use of pedestrians (6000 cars parked underground). As a consquence the center no longer faces upon the street. This urban center will never be built. It was unfortunately replaced by a less than mediocre apartment house project because of so-called "vested interests" and under the pressure of politicians who had no understanding of what Boston could have gained by such a community center for a great city—and of what it has now lost.

human questions such as, "What is still the same and what is quite different between you and me?" Or, in this particular case, "Is there still today a need for the core?"

Does this question really need an answer? There are many architects and planners at this moment engaged in the actual work of construction and reconstruction of city centers; who are in the midst of the practical problems of realization of their plans for the core. Besides this there are also other anonymous signs of interest in this question, which are, from the point of view of the historian, just as important. These are direct impulses that are arising from the general public.

Spontaneity

The man in the street—and that means each of us—undoubtedly has an urgent desire to get away from his purely passive position as an onlooker. Today he wants—and this is different from the nineteenth century—to play his own part in social life.

In June 1951, we had a festival in Zurich to celebrate the six hundredth anniversary of the entrance of Zurich into the Swiss Confederation. The streets of the medieval city center were closed for two days to all traffic, and benches were spread over the tracks of the street cars. It poured with rain, and yet one couldn't chase the people away from the streets. Everywhere there was music and throughout the whole night people danced in the streets under umbrellas, and medieval nooks and squares were used as open air theaters. The festival was a reunion of people from the whole canton of Zurich. Those who came from the different parts of the canton gathered spontaneously together and performed their own plays. We had been very much afraid that the medieval core of Zurich had been altogether destroyed. Suddenly we discovered that something still remains and that—given the opportunity—people will dance and put on plays in these open spaces.

129

Everybody was astonished at the spontaneity of the public. To be actor and spectator in one person is what is wanted! Clearly the public is ready. The question is whether *we* are! Let us not wait for a structurally well-defined society to arise. Let us ask what is alive in the bare and naked man that needs to be given form and expression. Let us ask what there is that lives in the bare and naked man, who is not just a symbol but is you and me.

I had another experience recently in Amsterdam. I saw a number of children's playgrounds which have been created under the guidance of van Eesteren and designed by a young Dutch architect Aldo van Eyck. These have been made from very simple elements—a circular sand pit, some upright steel hoops, a parallel pair of tree trunks lying horizontally. But these simple elements are grouped so subtly—with a background of the Stijl movement and modern art which injects some kind of vitamin into the whole performance— that they act as fantastic starting points for the child's imagination. These playgrounds also, simultaneously, fulfill another function. The careful design of their layout has transformed useless pieces of waste ground into active urban elements. One needs only to provide the opportunity and we, the public, who are also maybe children of a kind, will know how to make use of it.

The core in Greece and Rome

Like plants, human settlements require certain conditions for growth, though human community life depends upon far more intricate conditions than the plant. What is common to both however is that there are certain periods which favor growth and other periods which hinder it. There are periods in which many new cities are founded, and hundreds of years during which no new cities are started at all.

A city is the expression of a diversity of social relation-

ships which have become fused into a single organism. The conditions which influence its growth can be of a widely dissimilar nature. New cities have arisen in periods of dictatorship, when the despot has had power to compel everyone to build in conformity with a single design. They have also arisen in periods of purposeful communal energy. The despot has the advantage of his capacity for rapid and ruthless action; but, as his sovereign will is bound to ignore the imponderable laws which stimulate human cooperation, a city built under a dictatorship can never acquire that essential quality of organic diversity. In cities that have been developed by the united efforts of their citizens, everything—even to the last detail—is permeated by a marvelous strength.

Never since the fifth century B.C., when the democratic way first found expression, has so much loving care been lavished upon the gathering places of the people, or space been so amply provided for them. Nor has the place where the decisions of the people have been enunciated ever dominated the physical and moral structure of the town so effectively as the agora of these Greek cities.

When I was in the United States I felt very conscious of the absence of places where one could stand about—to rest, to stop, to speak, just to move about in. To make the future generation of architects consciously aware of this absence, I conducted a seminar on "Civic Centers and Social Life" first at Yale in 1942, then in Zurich, the Massachusetts Institute of Technology, and Harvard, where some of the illustrations (figs. 30, 31) were made by the students. These illustrations follow the normal methods of CIAM in that each city is represented in the same manner and upon the same scale.

A sociological question came up immediately: "What was the relation between the plan of the city and its social life?" and we were plunged at once into this curious experiment of Greece—the most exciting that mankind has ever

131

experienced—this sudden awakening of the individual mind with, behind it, the enormous background of Oriental and Egyptian tradition.

The gridiron system is an oriental invention. This is clear, not only from recent discoveries in the Valley of the Indus, but, above all, in the work of the only Egyptian revolutionary, the Pharaoh Akhnaton, who in the fourteenth century B.C. built, within twenty-five years, a city on the Nile (on the site of the present village of Tel el Amara), which is an absolutely clear-cut gridiron. But the Greek gridiron of Hippodamus (figs. 30, 31) is something quite different from the gridiron of Akhnaton (and also completely different from the gridiron of Manhattan). In both Egypt and the cultures of the Near East the gridiron had within its center either the palace of the king or the temple. In Greece it was completely different. Here the core of the gridiron was the agora—the gathering place of the people.

What is the agora? It is now established that in the beginning the agora was above all the gathering place of the people and not just a market. It was only with increasing trade and wealth in the fifth century B.C. that it became more intermingled with commerce. The agora in principle is an open space—a square—surrounded loosely by simple buildings intended for public use. In the Hellenistic period the agora came to be bounded by standardized elements, still very simple in form—columns, porticos, and an entablature—that formed the *stoa*, a covered way protected against rain and sunshine which served above all as a meeting place for the formation of public opinion. Sociologically, it is especially interesting that no buildings faced directly upon the agora itself. The stoa was supreme. The public buildings, such as the prytaneum [4] and buleuterion (council Hall), were in close contact with the agora, but stood behind the stoa. The agora itself was for the community: not for the council, not for anyone else, but only for the people, and ex-

[4] Public building enclosing the eternal hearth, mystical court, and the assembly of the elders.

clusively for the people. On the inner wall of the stoa, and in the square itself, objects were placed in memory of those who had worked well for the community.

Priene is one of the best examples for study because of the excellence of its excavation, and it is interesting to notice here the lack of direct relation between effect and cause. Here, as in so many other cities, the final status of the agora only appeared after the Greeks had in fact lost their liberty. Agoras in their final form were made at the time of Alexander or later; very few before. But the idea of the agora is inherent in the democratic conception of Greek life.

One thing more. In the Greek cities there is a clear classification of functions. Monumentality is only for the gods. The acropolis was never a gathering place. First it was the quarters of the king, then, when he was eliminated, it became the quarters of the gods, the consecrated area with the temples. Recent American excavations have shown that there was a temple on the agora at Athens, but this agora, which was gradually built throughout centuries, was an exception. The agora is a community place, well-defined and nicely arranged, but very simple. Finally there is the private life. By the law of Athens any citizen who had too large a private house was chased out from the city. Private life was very humble. These three degrees—first the gods, then community life, then private life—were never again distinguished so clearly. Even in medieval cities—the only period in which we can see a continuation of antiquity— different functions were intermingled.

Now the Romans. What is the difference between the Forum Romanum and the agora? It is very clear and very great. The Forum Romanum was a completely disordered place. It would have been impossible in Greece to place the prison, the *carcer*, next to the *rostrum*, the people's platform. Carcer, rostrum, temples, treasure houses, and *comitium* (the patricians' stronghold): this was the nucleus of the Roman Forum Romanum. The Romans, from the beginning, intermingled business, religion, justice, and pub-

lic life. But this does not mean that the Romans did not understand how to build cities. It is true that Rome itself never had a plan. All failed who made the attempt—Julius Caesar, Nero, the Antonines. The city of Rome was so much a disorder that traffic had to be forbidden in the streets during the day by law. The rich lived in the best places on the hills and the poor in squalor in buildings of five to eight stories.

But there are small Roman cities such as Ostia or Pompeii where their urban development becomes more evident. In both of these—in contrast to the Greek practice—there is a temple dominating the forum.

But besides differences between Greece and Rome, which reveal divergent conceptions of community life, common features prevail. The right of the pedestrian is regarded as sacrosanct in both agora and forum. For instance, the surface of the main forum of Pompeii was depressed: "stepping stones" and columns made it impossible for wheeled traffic to enter.

One word about the imperial fora of Rome, which were built over a relatively short period—50 B.C. to 115 A.D.—from Julius Caesar to Trajan. The imperial fora in their sterile pomp are, for me, the beginning of academic architecture. They somehow foreshadowed the nineteenth century.

The core in the Gothic period

What happened through the medieval period? First, decay, decay, decay, through centuries. The standard of life sank rapidly. Existing cities became depopulated and hung heavily, like overlarge garments, upon the shoulders of their shrunken inhabitants. Then came a sudden awakening. In the eleventh and twelfth centuries new cities were founded all over Europe. I may have a certain prejudice, but I find the most interesting are those in South Germany and Switzerland. The normal view of the romantic medieval city is here entirely debunked. These new towns were not in

any way haphazard foundations. As a consequence of the low standards of living that had prevailed through centuries, these new medieval cities, in contrast to the cities of Greece and Rome, show an intermingling of public and private life. The market place, whether bordered or not by arcades, is surrounded by the private houses of the citizens. Also, in contrast for instance to Pompeii with its "stepping stones," no care is taken to see that traffic is kept out of the public square. On the other hand, the street—the shopping street—acquired a new and much more intense significance.

The city of Berne may be taken as an example of one of the planned towns of the thirteenth century (and also to destroy the romantic conception of the medieval cowpath city). Berne was laid out in regular and equal ground plots, 100 × 60 feet, along three parallel streets. These plots determined the whole construction of the town. The front length of 100 feet could be subdivided into four, five, six, or eight parts—a system which still prevails today. The streets and the porticos which stood in front of the houses were owned by the protector of trading rights, the emperor or his representative. Both street and porticos were, therefore, *respublica*, destined for the market, for public affairs, and for justice. The life of the city took place along the street: the town hall with its square was not built until the fifteenth century.

The core and the artists
Finally we may come back to our question: How can we build cores today in the absence of a well-defined structure of society? There is certainly some relationship between the social structure of a city and the physical structure, or urban form, of its core. But one must issue a warning that this is not always strictly true.

It was all so easy in the old days—even in the nineteenth century! History was simple and so was physics: effect and cause in history, effect and cause in physics, effect and cause

in psychology. It was the physical sciences that first abolished this rule, and today we are forced to recognize that the relation between the core of the city and the social structure of the city is not at all so simple and so rational as we once thought. It does not always obey the law of effect and cause.

Let me finish with a single example. It is a tragic example: Michelangelo's Capitol in Rome. The Area Capitolina occupies one of the hilltops of ancient Rome. It is composed of a complex of the square itself (which is not a real square, but more of a trapezoid); a broad ramped stairway (the *cordinata*), and three buildings (the Senatorial Palace or town hall in the background, the Palace of the Conservatori on the right, and the Capitoline Museum on the left).

The architectural composition of the Capitol can be rapidly summarized as a comprehensive development in depth: plaza, stairway, and the relation with the old medieval city of Rome.

In 1530 the city-republic of Florence lost its independence to the Medici despot, Cosimo the First. Michelangelo came from an old Florentine family and, in 1534, he left Florence forever and spent the remaining thirty years of his life in voluntary exile in Rome. Here he gave concrete reality to what he had derived from his youthful democratic experiences in Florence. Here, in the Rome of the Counter Reformation, a Rome in which there was no freedom and no democracy, Michelangelo's Capitol—a perfect expression of the core—was a symbol of the vanished liberties of the medieval city-republic that he held in his heart. It was, at the same time, a memorial to the tragic dreams of its creator.

The lack of imagination usually shown today (though there are a few exceptions) in our attempts to devise new city centers—new city cores—is invariably excused on the ground that we no longer have a way of life that it is possible to express. What Michelangelo has mirrored in his Area Capitolina is the baffling irrationality of historic events and the enigmatic omission of any direct relation between effect

136

and cause.[5] Once more we realize that a great artist is able to create the artistic form for a phase of future social development long before that phase has begun to take shape. This is our task today!

[5] In *Space, Time and Architecture*, this problem is treated more extensively (3rd edition, pp. 64–71).

THE NEW REGIONALISM

The state of contemporary architecture is such that a historian is compelled to refer back to points that, one would have thought, had been made abundantly clear many years ago. But, during recent years the origins of contemporary architecture, and indeed its very nature, have again become clouded and confused. No single country, no single movement, no single personality can be claimed as the originator of contemporary architecture. Trends shuttle to and fro, from one country, one movement, one personality, to another, and become woven into a subtle pattern that portrays the emotional expression of the period.

When one seeks to isolate a single movement or personality, or a single country, and there to trace back the sources of all developments—such as the birth of contemporary architecture—the proportions of this subtle pattern become distorted.

There is a word that we refrain from using to describe contemporary art. This is the word "style." In a primitive sense the word "stylus" was used even in Roman times to describe different manners of writing, but "style" did not come into general use to describe specific periods until the nineteenth century, when different periods of architecture were analyzed according to a materialistic description of details of form. Today, the moment we fence architecture in within a notion of "style" we open the door to a purely formalistic approach. Purely formalist comparisons have about the same effect on the history of art as a bulldozer upon a flower garden. Everything becomes flattened into nothingness, and the underlying roots are destroyed. Today we are concerned with something other than merely tangible form; for we know that this is inextricably interwoven with the whole shaping of the environment.

138

The architect of today regards himself not merely as the builder of an edifice, but also as a builder of contemporary life. In other words, the architect of today refuses to consider himself a mere *confiseur* employed to attach some trimmings within and without after the structure has been delivered to him by the engineer. No, the architect himself must conceive it as an integrated whole. Like all real artists, he has to realize in advance the main emotional needs of his fellow citizens, long before they themselves are aware of them. A wholeness, a togetherness of approach, has become a "must" for any creative spirit.

This forecasting of future development has become the noblest task of the contemporary development. Its cause is not hard to find. It is more than a century since a stable and secure way of life vanished from the scene. The powers that earlier stood behind it and gave environment its stability now decline more and more. In earlier times the architect and planner had merely to provide the container for an accepted way of life—whether it was the way of life of a Versailles or of the bourgeois houses and squares of Bloomsbury. Today the planner has to discover for himself how the human habitat, the outlying suburb, the changing structure of the city, can be shaped so as to avoid utter chaos. To accomplish this, the architect-planner or urban designer must possess within himself the sort of social imagination which formerly resided in society.

This can lead to dangerous results. Such architect-planners have everyone against them: their most powerful clients—city and state—on whom they are economically dependent, the bankers, and perhaps even the majority of their colleagues, who hold another view of the duties of an architect.

In the final resort, this means that the urban designer's functions include a moral attitude. This is now very evident among architects and planners, but can also be found among today's scientists, who are no longer able to limit themselves to pure research. Their consciences have become

troubled. They have begun to feel responsible for the results of their researches. The historian too has been drawn into this process. He refuses merely to submit a series of bald facts, for history is not something dead. We are its product. It is human fate. The historian, like the architect, is closely bound up with contemporary life.

All this is involved in the reason why we today abstain from labeling the contemporary movement with the word "style." It is no "style" in the nineteenth-century meaning of form characterization. It is an approach to the life that slumbers unconsciously within our contemporaries.

The word "style" when used for contemporary architecture is often combined with another password label. This is the epithet "international." It is quite true that, for a short period in the twenties, the term "international" was used, especially in Germany, as a kind of protest to differentiate contemporary architecture from *Blut und Boden* advocates who were trying to strangle at birth anything and everything imbued with a contemporary spirit. But the use of the word "international" quickly became harmful and constantly shot back like a boomerang. International architecture—the international style—so went the argument, is something that hovers in midair, with no roots anywhere.

All contemporary architecture worthy of the name is constantly seeking to interpret a way of life that expresses our period. If history teaches us anything it is that man has had to pass through different spiritual phases of development, just as, in prehistoric times, he had to pass through different physical stages. There are some signs that go to show that a certain cultural standard is now slowly encompassing the entire world. In historic periods cultural areas have usually been more limited in extent; but in the prehistoric era—the hundreds of thousands of years of dark ages—we find everywhere the hand axe, the *coup de poing*. This hand axe is a universal, triangular, pear-shaped tool whose sides slope to a fine edge. It has been found in China, in Africa, in the gravel bed of the Somme in the heart of France, in the Ohio

140

Valley. Everywhere this flint implement was shaped the same, as though the wide-flung continents were but neighboring villages.

Never again has a single culture spread universally over the whole earth nor lasted for such an unimaginably long period. Since then the establishment of great states has resulted in national boundaries, in spheres of influence, and in cycles of culture, which still remain with us.

The way of life that is now in formation is the product of Western man. Again today, as in the time of Neanderthal man, it is passing round the whole world, only now its tempo has become vastly accelerated, and its speed excessive.

Since the beginning of his all-powerful urge for conquest at the time of the Renaissance, Western man has committed acts, in ever-growing numbers, against primitive peoples and in the face of cultures far more ancient than his own, which now leave feelings of shame. Every Western man feels himself somehow guilty.

When I recently had to write a short foreword for a Japanese edition of *Space, Time and Architecture* I felt it in some way my duty to explain that Western man has now, very slowly, become aware of the harm he has inflicted by his interference with the way of life of other civilizations— whether this has been interference with those natural rhythms in the lives of primitive peoples, which have been the cause of their bodily and mental persistence since prehistoric times; or whether it has been an injection of rational Western mentality into the oldest existing civilizations, without simultaneously presenting some worthy antidote. But, even while writing this, I was obliged to add that Western civilization is itself actually in a stage of transition. Experience is slowly showing us that the rationalist and exclusively materialist attitude, upon which the latest phase of Western civilization has been grounded, is insufficient. Full realization of this fact can lead us slowly toward a new hybrid development—a cross between Western and Eastern civilizations.

Now that we no longer adhere to a creed of production for production's sake, the civilization that is now in the making draws closer to the mental outlook that is shared by primitive man and Eastern man. We in the West are again becoming conscious of something that they never forgot: that continuity of human experience always exists alongside and in contrast to our day-to-day existence.

A dangerous urge to mimic drags both the primitive and the ancient civilizations helplessly toward a low level of achievement. Japan is today torn between two heterogeneous ways of life: the codes of conduct evolved through a thousand years of isolated development, and the flooding power of mechanization. In Syria a Swiss photographer had his camera confiscated because he took pictures of camels instead of their "progressive" trucks. In many African cities a bicycle is the most prized personal possession. In Bagdad, the city of a Thousand and One Nights, one shop after another sells electric gadgets and parts for motor bicycles. In the village of Babylon we wanted to have a cup of coffee. It was unobtainable; one could only get Coca-Cola. Even here, this soft drink, the hallmark of Americanism, in its world-conquering mission has ousted ancient, almost legendary customs. All these are straws that indicate the direction of a tremendous danger. Just at the moment when we ourselves are ready to set these things in their proper proportion in relation to our lives, they have become the heart's desire of the "technically less developed countries."

This may be enough to indicate that the image of this emerging civilization, especially our particular interest—the form of contemporary architecture—cannot be described by so drained and bloodless a term as an "International style."

What is the new regionalism?

Every period has had its own emotional structure and its own particular attitude of mind. This was true for the

Renaissance; and it is true for us today. It is true for each period. The all-embracing factor—insofar as our subject is concerned—is the Space Conception of each period, and not the individual, separable forms which have been developed.

The space conception of the Renaissance—linear perspective—radiated out from a single point of vision. For almost half a millennium this aspect dominated the composition of every picture, every building, every urban design. Present-day art, architecture, and city planning have as a basis a space conception that was developed by the painters between 1910 and 1914. Instead of the outgoing "pyramid of vision" emanating from the eye, as Leon Battista Alberti named it at the start of the Early Renaissance in Italy: instead of this rigid and static viewpoint, the concept of time has been incorporated, which, with the concept of space, is one of the constituent elements of our period.

This space-time conception embraces all artistic manifestations, and is becoming ever more dominant. One can tell, through observation of any project (irrespective of "modernistic" details), whether its author is still spiritually within the space conception of the Renaissance, or whether he is creating in the spirit of the space consciousness of today.

It seems—and this cannot be too often repeated—that all creative efforts in contemporary art have, as their common denominator, this new conception of space. This is true no matter how different the movements themselves may appear from one another, or in what country they originate.

It has been stated over and over again—indeed, I have said it myself—that the plane surface, which earlier had lacked any emotional content, has become the constituent element of our new representation. Furthermore there is no doubt that the use of the plane as a means of expression was evolved from cubism between 1910 and 1914. On two facing pages of *Space, Time and Architecture* I tried to show how the same spirit emerged in several different countries, by presenting a visual comparison of a collage by Braque, a painting by Mondrian, an architectural study by Malevitch,

143

a country house by van Doesburg and van Eesteren, and Gropius' Bauhaus.[6]

Art magazines have recently been stressing that the right angle and primary colors used with black, white and gray, disposed in an asymmetrical arrangement were the basic elements of "de Stijl." This factual analysis is perfectly correct as far as it goes, but it does not touch the reason behind the use of these simple elements—the essential heart of the matter, which "de Stijl" shared in common with the whole contemporary movement. This was the introduction of the plane as a constituent element to express the new anti-Renaissance space conception. The right angle, the vertical, and—to a certain extent—the primary colors are by-products and not essential features of the modern conception.

It is well known that the "de Stijl" people around van Doesburg never organized themselves into a formal group, as for example the Futurists did. "De Stijl" consisted of various individualists working in different places. There was sometimes a certain amount of collaboration—as at one time between Doesburg and Oud, and, in the twenties, between Doesburg, the young van Eesteren, and Rietveld. But, on the whole, they remained individualists. J. J. P. Oud (whose early accomplishments will always form part of the history of architecture) is typical of these individualists. When I met him for the first time in 1926 he even then emphasized "I was never a member of 'de Stijl.'" And, in his own way, Piet Mondrian (who called his work "neo-plasticism") expressed a similar standpoint. It was indeed just this free cooperation of strong individualists, often in dissension with one another, that gave the Dutch movement its undeniable intellectual strength.

All contemporary architecture and painting is permeated with the spirit of our period, but there are a number of different movements. All share the new space conception, but each connects it in some way with the region in which he operates.

[6] Giedion, *Space, Time and Architecture*, third edition, pp. 436–437.

This does not mean that the modern architect should strive to produce an external appearance in conformity with traditional buildings. Sometimes the new buildings will conform to a certain extent, sometimes they will be basically different. This difference may be due to two reasons: sometimes it will be because of new production methods and the use of new materials; sometimes, more importantly, it will be caused by the new aesthetic, the new emotional expression, that the builder is giving to the habitat of man.

There is one other thing that the modern architect has learnt: that first and foremost, before making any plans, he must make a careful—one might almost say a reverent—study of the way of life (the climate of living) of the place and the people for whom he is going to build. This new regionalism has as its motivating force a respect for individuality and a desire to satisfy the emotional and material needs of each area. As the outlook changes, our attitude toward our environment—the region or country in which our structures are rising—also changes. Contemporary architecture and painting are embraced by a pervading mentality—the spirit of this period. But, from out of the innumerable possibilities of each region, each period selects just those which correspond with, or help to express, its own specific emotional needs. Now that we are separated by several decades from the birth period of the early twenties, we are able to discern that certain regional habits and regional traditions lay concealed within the germinal nuclei of the various contemporary movements.

Two examples, one from Holland, the other from France, may serve to make this point clear. First, Holland. When we look at a painting by Mondrian (fig. 22) or at one of van Doesburg's architectural schemes, their abstract forms (Mondrian called them "neutral forms") seem very far removed from any specific regional influence. They seem so, but they are not.

At the Congress of Art Critics in Amsterdam in 1951, for which the "de Stijl" exhibition was first assembled, I was

asked to speak on this movement. Rietveld, who was in the audience, sprang to his feet and sharply protested when I tried to show the inner ties that exist between Dutch tradition and these so-called "neutral forms": how, in fact, these forms are rooted in the Dutch region and in the Dutch mentality.

In the seventeenth century—the great age of Dutch painting—and perhaps even later, no other people laid such stress on the plane surfaces of interior walls, or of the careful organization of the position of doors and windows (Pieter de Hooch). Similarly one can note today the careful manner in which the Dutch gardener lays out his fields of red, white, and yellow tulips. Certainly I would never wish this interpreted as though I were claiming Mondrian's paintings to be reproductions of tulip fields! But I do maintain that the organized plane surface is in no other country so prevalent as here, in the region of the polders. It is not mere chance that neither the Russians, nor the Germans, nor the French, made such use of the plane surface, framing it and extracting from it innumerable details. The plane surface, for reasons which do not need to be reiterated, is a constituent element of contemporary art; and it seems to me that van Doesburg and van Eesteren's simple drawings of the transparent interior of one of their projected houses, 1922–23, is one of the most elucidating achievements of "de Stijl" (fig. 24).

The house was shown in this "x-ray" drawing as a superimposition of horizontal and vertical planes that could somehow be made transparent or translucent. It was a radical departure from the usual structural massivity. Today there can be no doubt that this simple model was of tremendous assistance in clearing the minds of contemporaries in other countries. This was made evident in two plans of Mies van der Rohe for country houses, which were never built. They show how he had grasped the intentions of the Dutchmen and developed them further.

France's contribution comes from another source. Ever

146

since her daring experiments in Gothic cathedrals, France has shown a great facility and a great eagerness to experiment with new forms of structure. We have only to recall the *Halle des Machines* or the Eiffel Tower of 1889 (fig. 19); and here it is interesting to note that the painter Delaunay (a representative of the so-called "orphic cubism") was first inspired by Gothic churches and later by the structure of the Eiffel Tower whose poetic content was first revealed by him (fig. 20) and by the poet Guillaume Apollinaire.

France's early and extensive use of ferroconcrete as a means of architectural conception is but one more link in the same chain. Already around 1900 Tony Garnier, in his Prix de Rome project, used the new construction methods of ferroconcrete in his Cité Industrielle for all kinds of buildings. Perret soon followed with his Paris houses, garages, theaters; and one of Le Corbusier's first sketches of the ferroconcrete skeleton construction for the Domino House 1915 with its intersecting planes (fig. 25) is as revealing as van Doesburg's sketch.

These are but two examples of regional contributions to a universal architectural conception. But one thing more: it has not been necessary for the architect to be a native of the country in which he is working in order to be able to express its specific conditions. We all know how Frank Lloyd Wright's Imperial Hotel in Tokyo (1916) has withstood earthquakes better than Japanese structures. The reason is that the modern approach encompasses both cosmic and terrestrial considerations. It deals with eternal facts.

This is no international phantom that is appearing everywhere today. It is evident that the interior of a seventeenth-century house is quite different from a picture by Mondrian and also quite different from contemporary Dutch interiors, and that Gothic cross-rib vaulting is quite different from a concrete construction by Freysinnet. Even so, a current flows through them that binds them together in time and

from which the forms of our period have been drawn. It has been mentioned already that the aspect of the new structures may be very different from the traditional appearance of the buildings of a certain region. There is also a great apparent difference between a wide-open redwood and ferroconcrete house built in the kindly homogeneous climate of California (fig. 34) and a weekend house built for the tropical conditions of Brazil (fig. 33). In form these two houses, built by Richard S. Neutra and Oscar Niemeyer, have practically nothing in common, yet both are imbued with the same contemporary spirit. Formalistic analysis will not help us here.

I would like to give a name to the method of approach employed by the best contemporary architects when they have to solve a specific regional problem—such as a building for the tropics or for the West Coast, for India or for South America—whether it is for a house, a government center or a problem in urbanism. This name is the New Regional Approach.

This new regionalism meets its greatest problem in the so-called "technically underdeveloped areas." Innumerable new city plans are in the making. Sometimes these are made without insight, but sometimes they indicate a positive way forward. A few are in the far north (Canada) but most are in tropical countries. This leads to an exceedingly difficult problem of the greatest urgency: the urban pattern in tropical and subtropical countries. This has been neglected for far too long. Now, suddenly, great masses of their populations, who up till now have been living in shacks made up from old packing cases or flattened gasoline cans, are having dwellings erected for them. Yet these dwellings must be related to the basic customs of their inhabitants, and not be facile copies of European or American rental houses, which cannot meet the emotional or the material needs of the particular region.

We can only refer here to a very few examples: the work done in Chandigarh, the new capital of Punjab, India, un-

der the guidance of Le Corbusier, Pierre Jeanneret, Maxwell Fry, and Jane Drew; important projects on the Gold Coast of Africa also carried out by the last two; and successful experiments in Latin America (Peru, Colombia, Venezuela, Cuba) initiated by José Luis Sert and Paul Lester Wiener. Figures 41 and 42 show some row houses built in Cuba for the better-paid workers. No glass is used; instead a modern version of the lattice-like openings common around the Caribbean has been employed. Each dwelling has two bedrooms and a living room wide open to a private enclosed patio.

In Morocco, under Michel Ecochard, and later Georges Candilis and S. Woods, concrete walk-up apartments have been built for a very poor population. In this case the problem was the erection of several thousand dwellings very rapidly and very cheaply and employing only the simplest techniques. Each dwelling has two bedrooms that open onto a patio living room surrounded by a six-foot wall that insures privacy for the family. Great care is taken to see that every corner of the dwelling is at some time penetrated by the bacteria-destroying rays of the sun. The use of the patio as the central motif has also been employed by the young Swiss architect, André Studer, to create a new solution for the many-celled block of dwellings (fig. 43).

The regional approach that satisfies both cosmic and terrestrial conditions is a developing trend, but there is another symptom that is emerging, and giving evidence of the many-sided face of contemporary architecture. Many of the problems of contemporary painting can also be discerned in the earliest beginnings of art. Architecture is different from painting; it is not so intimately related to man's direct projection of what flows in the subconscious mind. Yet we cannot leave unnoticed a certain symptom which has been appearing in architecture, above all in the recent work of Frank Lloyd Wright (especially since 1940). We can now follow the exciting path which the human mind had to travel before man came to standardize (if we may call it

this) upon the rectangular house with its square or rectangular rooms. We are all born to this rectangular house and are so accustomed to live with it that it seems it could never have been otherwise. Yet it is important to note that an artist like Frank Lloyd Wright is plunging deeply into problems that concerned the human spirit during the period when mankind was contemplating the effects of transition from the life of a nomadic herdsman to that of a settled agriculturalist.

At the very beginning of architecture the paramount type was not the square house, but the curvilinear house—sometimes round, sometimes oval, sometimes freely curving. Today this is attempting a reappearance. Sometimes the round form is dictated by purely mechanistic reasons, such as the mast houses of Buckminster Fuller (the shape dictated by his means of construction) and other houses which are built around a central mechanical core. Such examples, which are not fully thought through, do not concern us here. Suffice to say that, from the standpoint of urban design, or close grouping in an architectural composition, the round house is undoubtedly bad. But Frank Lloyd Wright follows exclusively the line of his artistic vision, maybe adapted to a particular site, maybe adapted to the particular man who is to inhabit the house, maybe under the compulsion of expressing that which slumbers in himself.

Each of us carries in his mind the results of five thousand years of tradition: a room is a space bounded by four rectangular planes. Whether we can feel at ease in a Cretan oval house of about 1500 B.C. with its curved outer walls and irregular three-sided or four-sided rooms (fig. 36), or in Frank Lloyd Wright's circular house (fig. 37) with its remarkable similarity to this Minoan farmhouse, is a question that does not permit logical discussion.

What interests us at the moment is the symptom that, together with the desire to use the means of expression at our disposal to give form to the requirements of the soil and the climate, there comes also a desire to free ourselves from

the tyranny of the right angle and to search for a greater interior flexibility. It is not my intention to discuss the pros and cons of this kind of contemporary architecture, but it seems a duty not to ignore it. What we need more today than anything else is *imagination*.

Part 6

ON THE DEMAND FOR IMAGINATION

Social Imagination

Spatial Imagination

Marginalia

How mysterious is Imagination, that Queen of the Faculties! . . . It decomposes all creation, and with the raw materials accumulated and disposed in accordance with rules whose origins one cannot find save in the furthest depths of the soul, it creates a new world . . . As it has created the world (so much can be said, I think, even in a religious sense), it is proper that it should govern it.[1]

In the following chapter of this report on the Salon of 1859, entitled "The Governance of the Imagination," Baudelaire returns to this subject, saying that, after he had written that the world was created by and is ruled by imagination, he had looked through Edward Young's "Night Thoughts" written in 1741, and found the following passage, which he then quoted for (as he said) his justification:

By imagination, I do not simply mean to convey the common notion implied by that much abused word, which is only fancy, but the constructive imagination, which is a much higher function, and which, in as much as man is made in the likeness of God, bears a distant relation to that sublime power by which the Creator projects, creates and upholds his universe.[2]

Every period capable of giving concrete expression to what existed unconsciously in the minds of its people through the means of its architecture has had to possess a creative imagination.

Imagination is the power to fashion new artistic or intellectual concepts. By imagination an image can be created of something that has never till then existed. Thus, in A Midsummer-Night's Dream,

> . . . imagination bodies forth
> The forms of things unknown.[3]

[1] Charles Baudelaire, *The Mirror of Art*, pp. 232–233.
[2] *Ibid.*, p. 236.
[3] William Shakespeare, *A Midsummer-Night's Dream*, Act V, scene 1.

Imagination is the root of every creative thought or creative feeling. Whether a building has an emotional impact or remains mere dead material depends entirely on whether or not it is imbued with imagination.

Imagination has been necessary in every period, but perhaps never so keenly as in our own, when science and industry constantly pile up a perturbing mound of new materials. Some of these are seductive but dangerous to employ; others call for imagination that they may give birth to "things unknown."

The contact between the builder and the building is no longer as immediate as it was in the period of brick, stone, and wood. Nowadays the immense apparatus of the building industry stands between the architect and architecture. It is difficult for the architect to use this complicated instrument of production, and the building industry often sets up independent standards of its own.

There is another reason for the scarcity of imagination today. Is it possible in our Western civilization to build a bridge between a man's personal life and the life of the community? Does the man in the street want to shift from his passive role as a mere onlooker and become an active participant in social life?

Part 5, "The Humanization of Urban Life," lists certain positive signs which seem to indicate that man is in truth not satisfied with his position as a passive spectator. Similar signs are emerging all over the world. They can be observed in a number of spontaneous outbursts, in which the onlooker suddenly has become transformed into an active participant, as well as in the interest and pleasure with which the general public again cooperates in the celebration of age-old customs. However, feast days and festivals are not enough. We need crystallization points for our everyday life.

This latent demand for a more developed social life is

155

breaking through in many countries and is made manifest in new plans and projects which, once again after a long lapse of time, provide such points of crystallization for the social life of the people. This self-healing process can be seen operating in many countries: in America, both North and South; in Japan; in India; in many parts of Africa; as well as in several recent European rebuilding projects. In some countries purely commercial undertakings are providing the opportunity (for example, in some of the out-of-town shopping centers that are springing up everywhere in the United States); in others there is the ambitious founding of new towns (such as Chandigarh in India). All give evidence of the newly realized need to provide some space where long neglected contacts between the inhabitants can take place. In all these plans and projects a new social imagination can be sensed.

Imagination? Well . . . But we have to be more specific. What kind of imagination? Or, perhaps better, what kind of imagination is it that we most urgently need today?

In asking this, we are led to discuss two kinds of imagination in architecture, which are both rather rare today. These are: Social Imagination and Spatial Imagination.

SOCIAL IMAGINATION

The creative architect and the creative planner of today both need to possess a strong social imagination because their tasks are far more complicated than they were in former periods. For instance, in the Baroque period, the architect had only to give form to the programs of a clearly structured society.

Today's architect must give shape to vague tendencies which exist only half-consciously in the minds of the general public. This means he has to take upon himself great responsibilities and that he must have an instinct for the shaping of unformed future needs. For this, above all, he has to have the rare gift of a peculiar sensitivity that I call Social Imagination.

The architect has to have this social imagination because among those who should possess it—the politicians, administrators, chairmen of boards, and so on—it is usually conspicuous by its absence.

We can understand today the truth of Louis Sullivan's definition of an architect in one of the most marvelous books ever to come from the pen of an architect: *Kindergarten Chats*. Here he describes how the architect is not a surveyor, an engineer, nor a builder. He is an architect and his "true function" is *"to interpret and to initiate."* "Of course," he says, "I assume that other men than architects may be and are products and agencies and interpret and initiate: in fact, in the broadest sense, all are such under the terms and conditions of modern civilization. But not one of these is expected to interpret the wants of the people with a view to initiate buildings. *Hence the true function of the architect is to initiate such buildings as shall correspond to the real needs of the people."* [4]

[4] Louis H. Sullivan, *Kindergarten Chats, and Other Writings* (New York, 1955), p. 139.

Most schemes of this nature have remained on paper. But a few examples have been executed in which social imagination has been given three-dimensional expression. There are not many in all the world, but they stand—from Finland to South America—like outpost radar stations calling to the future.

Contact between the individual and the community

Town planning and democracy have a common basis: the establishment of an equilibrium between individual freedom and collective responsibility. This is an ever-fluctuating problem that can never be solved once and for all. It all depends on how far intentions can be implemented. In other words, the level of a civilization depends on how far a chaotic, incoherent mass of humanity can be transformed into an integrated and creative community. This requires that the human approach is always given pride of place.

A French sociologist, René Maunier, in a forgotten booklet, *Origine de la Fonction Économique de la Ville*, recognized that the essential nature of a city lies in its complexity. He saw that the city was not simply an economic or geographic phenomenon but, above all, a social complex. The city must be recognized *comme un fait social* and not *comme un simple phénomène géographique ou économique*.[5] If first place is given to questions of financial remuneration and if no more of the human factor enters into the picture than can be enforced by building codes, then we inevitably arrive at the situation we see all too often today. A cancerous growth spreads through and destroys both inner and outer structure of the city, and the life of the individual becomes atomized.

Contemporary artists do not wait to give expression to the symbols that grow within them until these can be given

[5] René Maunier, *Origine de la Fonction Économique de la Ville* (Paris, 1907).

meaning by changes in our conception of the rights of the state, by the rise of a new religious force, or by a new political order. Nor do the creative urbanists wait to form their plans until conditions are ripe to realize them. Their starting point is the man of today, the conditions under which he is now living, and the terms he is obliged to come to with them. Then from their inner vision they attempt to evolve a form which reinterprets those eternal laws which human nature is bound to follow. The urbanist has the moral responsibility of awakening in man a realization of needs and aspirations which are slumbering within him. That this is possible is evident from developments over the last ten years.

The world situation seems in one direction to look toward a time of utter destruction, but yet, in another direction, it is clear that we are in an ever-developing process of humanization. These two contradictory trends persist simultaneously. Whichever gains the upper hand will determine the destiny of our civilization.

The urbanist, who inevitably stands for humanization, is required to provide an answer to the question: What form should the contemporary city take in order to restore the distorted equilibrium between individual freedom and collective responsibility? His starting point must be the diversified residential unit: in other words the housing group that caters for households of differing social structure and differing circumstances. We have seen that new dwelling types are coming into being that express this point of view and that imply a new social implementation of the human habitat.

It is ever clearer that, despite differences in detail, there is universal agreement as to the kind of operation that the present city structure must undergo to recover those values that have been lost to our period: the human scale, the rights of the individual, the most primitive security of movement, within the city. How can one overcome the isolation of the individual, induced to a large extent by the chaotic

structure of the city? How can one stimulate a closer relationship between the individual and the community?

The diversified residential unit

It is a long-drawn-out and difficult process. Massive agglomerations of high-rise buildings offer no more of a solution than the endless sprawl of single family dwellings and row-houses. The starting point must be the diversified residential unit. This can provide differentiated dwellings for our ever more complicated social structure: dwellings that take account of the existence of single men and women and that allow for the normal changes of family life—the young married couple, the period of growing children, the later shrinking of the family circle, and the period of old age. These needs cannot be met by an endless series of similar cells, whether arranged horizontally or vertically. Right from the start the social needs of the different age groups must be taken into consideration—not merely the requirements of small children, but also those of young people and adults.

The vocabulary of contemporary architecture was formulated between 1920 and 1930, and the vocabulary of the new city structure in the following decade. This fell outside the normal purview of the layman and of many architects. Nevertheless, a fairly clear picture of the future city can now be envisaged. What is here in process of formation is certainly of greater importance than all before in the contemporary movement: to confront a chaotic way of life with positive action.

It is astonishing, when looking over the developments in methods of town planning during the last two decades, to realize in how short a time uncertain gropings have been transformed into almost universal acceptance of the form the new city must take.

We shall limit ourselves here to five examples, all of

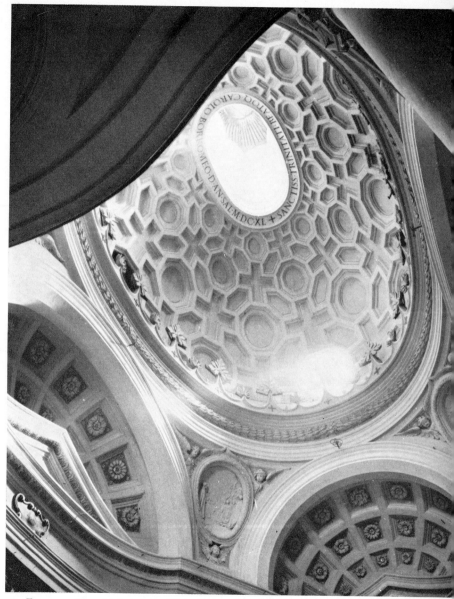

55. *Francesco Borromini, (1599–1667): Dome of S. Carlo alle Quattro Fontane, Rome, 1634–1641.* The hollowing out of space is most effectively portrayed in this photograph by Kidder Smith.

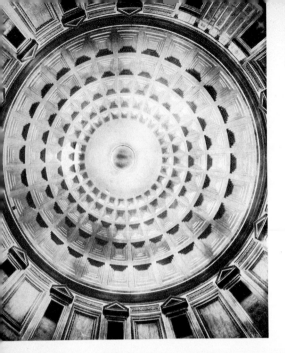

56. *Dome of the Pantheon, Rome.* One of the most beautiful domes of Imperial Rome, when the vaulting problem was first solved on grand majestic scale.

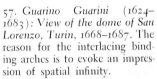

57. *Guarino Guarini (1624–1683): View of the dome of San Lorenzo, Turin, 1668–1687.* The reason for the interlacing binding arches is to evoke an impression of spatial infinity.

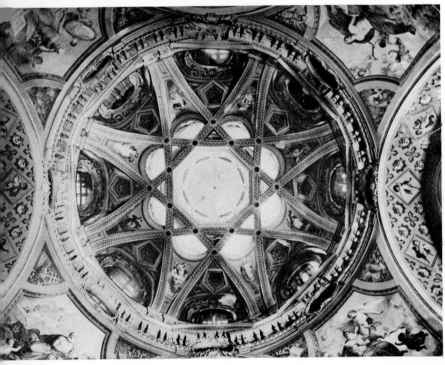

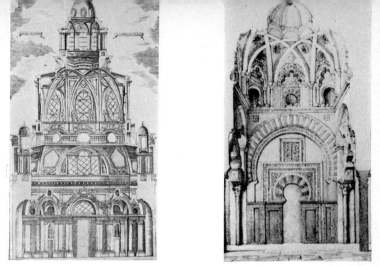

58. *Section through the cupola and lantern of San Lorenzo, Turin.*

59. *Section through a mihrab of the Mosque at Córdoba, Spain, ninth century.* The Arabs developed the binding arch as a structural device long before the time of the Gothic cathedrals.

60. *Pier Luigi Nervi, engineer, with M. Loretti and M. Marchi, architects: Festival Hall in Chianciano, Italy.* The dome is elliptical, a space frame made up of prefabricated concrete elements.

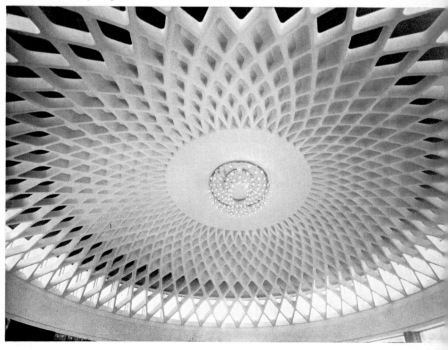

61. *Naum Gabò (born 1890): Project for the Palace of the Soviets, 1931.* Before the engineers, sculptors envisioned the new vaulting problems.

62. *Frank Lloyd Wright: Club house for Huntington Hartford, Hollywood Hills, California, 1947.* This club house of glass and concrete, whose scallop-shell form floats above the trees, was never actually built. It remains as evidence of Frank Lloyd Wright's eternal flexibility as a molder of space.

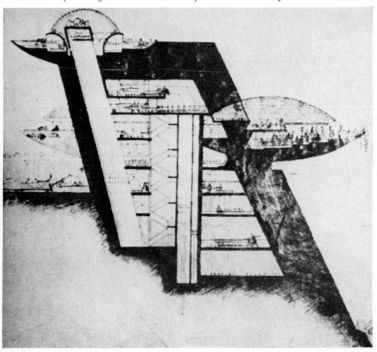

63. *Eduardo F. Catalano: Hyperparaboloid space frame.* The space frame provides a new starting point for spatial imagination.

64. *Eduardo F. Catalano: House at Raleigh, N.C., 1955.* The hyperbolic paraboloid has the same significance whether constructed of wood or as a concrete shell. Its balance is always contained within itself.

65. *Hugh Stubbins Associates, Fred Severud, engineer: Conference Hall for International Building Exhibition, 1957* (in construction). Side view from west: two bowed arches support the hanging roof. They spring from the height of the platform to 65 feet and span 260 feet. These hollow protruding arches are triangular in section. The warped planes of the sagging line of the roof is formed from straight wire cables strained between the arches.

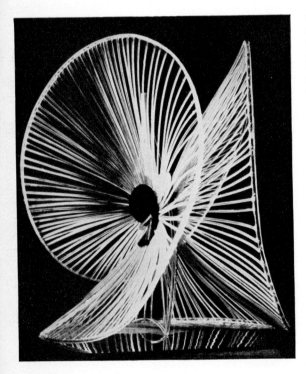

66. *Naum Gabò: Spherical construction, 1937.* The development of the structure of a space frame demands close collaboration, from the earliest stages, between the sculptor, the architect, and the engineer.

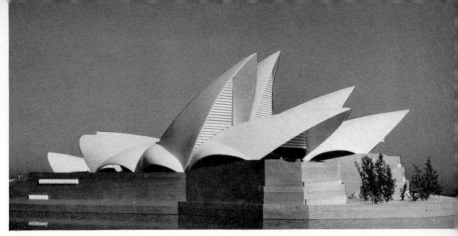

67. *Joern Utzon: Prize-winning design for Opera House, Sydney, Australia,
1957.* There is a conscious dichotomy in this building between its ground-con-
nected heavy base and its shell vaults—light as the *velum* which spanned the
amphitheaters of antiquity.

68. *Joern Utzon. Plan of Sydney Opera House.*

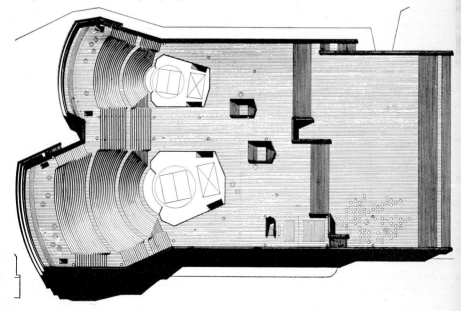

69. *Le Corbusier: Pilgrimage Chapel at Ronchamps, 1951–1955.* At the opening shown here, the Archbishop of Besançon was the first high prelate of the Church to proclaim the suitability of modern architecture for ecclesiastical buildings.

70. *Le Corbusier: Pilgrimage Chapel at Ronchamps, 1951–1955.* The interior of the church during service. The roof does not press down upon the walls but floats above them, leaving a narrow sliver of light between.

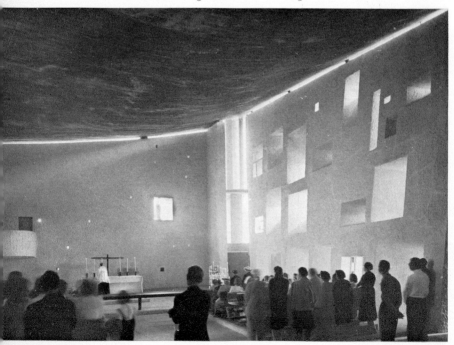

which show distinct ways of giving form to architecture in the service of the community.

The first example poses the problem of a gathering place for the people of a city destroyed in the war: Saint-Dié. The second tries to solve the question of how man, when living in a high-rise building, can recapture a balance between the spheres of private life and community life. This is the *Unité d'Habitation* at Marseilles. The third shows the spatial and social organization of a new residential area within a metropolis: Alexander Polder, Rotterdam. The fourth is a commercial and community center within a metropolis: Boston Back Bay Center. Finally, the government center for the newly founded capital city of Chandigarh, India.

Civic center for a bombed city: Saint-Dié, 1945

The civic center for the bombed city of Saint-Dié in the Vosges seems to express all that we mean today by the Core of the City (fig. 32). In a masterly way it displays a new kind of spatial relationship.

The program demanded a social center for this city of 20,000 to 30,000 inhabitants, and here theater, cinema, museum, administration buildings, hotels, shops, and restaurants are all freely disposed and yet develop a wonderful play of forces. The different buildings are designed and placed in such a way that each emanates its own spatial atmosphere and yet bears a close relationship to the whole core. The area is perforated by volumes of widely different shape that continually fill in or hollow out the space like contemporary sculptures.

People walking around or sitting in the café that forms a corner of the square would have a continuously changing spatial experience. Theater, museum, administration center—all are freely placed in space, and the eye can even glimpse the distant old cathedral and, on the opposite bank

of the river, green-girdled factories, *les usines vertes* as Le Corbusier calls them.

It is a long stride from the enclosed Renaissance piazza to the freedom of this planning, which shows in terms of a city plan what in our time until now had only been expressed in the ground plans of individual dwelling houses. However, this core does not lose contact with normal life: it is from the café in the southwest corner that the best view can be obtained of the life and the buildings of the center.

Medieval Italy knew how to place volumes in space: in the Piazza del Duomo in Pisa, the cathedral, baptistry, campanile, and camposanto give an exciting display of volumes in space. The modest unrealized scheme of Saint-Dié develops a different spatial conception. The relationship in the Gothic period was the relationship of formally closed volumes. Today we are moving toward a more dynamic conception of space, created by solids and voids.

The whole area of the core of Saint-Dié is reserved exclusively for pedestrians and this, but not only this, relates it to the Greek agora. Saint-Dié, for the first time in our period, would have presented a crystallization of community life which could have equaled the Greek meeting place.

But Saint-Dié remained a paper plan. All political parties of this small French city, including those of the extreme left, incited by the academicians, were violently against Le Corbusier's project. Instead they accepted a scheme of horrible banality, such as is, unfortunately, common among cities that have suffered war destruction. This is but one more example of the tragic gulf that still exists between creative solutions and the powers of judgment of politicians and administrators.

Architecture cannot be confined to those buildings which have been erected. Architecture is a part of life and architecture is a part of art. As a part of life it is more dependent than any other form of art upon the will of the public, upon their desire to see or not to see a scheme come into being.

In architecture the standard of values of the client is as important as the standards of the builder.

If, in the time of the Parthenon, the Pantheon, Chartres, or St. Peter's, the taste of those who had power to order the erection of public buildings had been as weak and debased as it is today, none of them would ever have been built. They are daring experiments, every one of them.

The high-rise apartment house and social imagination: Unité d'Habitation, Marseilles, 1946–1952

One of the few instances in which social imagination has been given three dimensional expression is the *Unité d'Habitation* (the residential unit), 1946–1952 on the Boulevard Michelet at the outskirts of Marseilles. The people of Marseilles call it simply "Maison Le Corbusier." That this daring building could be successfully completed during five difficult postwar years is due to the courage of Claudius-Petit, the French Minister of Reconstruction, who defended it to the very last against violent attacks. In architecture the cultural level of the client is as important as that of the designer.

The boldness of this experiment lies in bringing together accommodation for the needs of the individual and of the community. We all felt doubtful whether such an experiment could succeed in the southern city of Marseilles, whose inhabitants are famous for their independence and individuality. But it did succeed. And this is a good augury for the hope that now, everywhere in the world, there is a latent desire to break away from the isolation and loneliness of the dwelling cell in a great metropolis.

The Unité d'Habitation, and here lies the heart of its boldness in our contemporary scene, does not merely pile up dwelling units on top of one another (fig. 44). In the Unité d'Habitation the housing problem loses much of its special meaning today. The boldness of this experiment does not just consist in housing some 1600 people under one roof

or even in providing twenty-three different types for its 337 apartments, varying from one room up to dwellings for "families with eight children." Numerically there are far larger apartment houses in America, such as the so-called London Terrace in Manhattan in which 4000 apartments are stacked one upon the other.

The boldness of the Unité d'Habitation consists in its close linkage of social opportunities with the daily life of its inhabitants. The most interesting experiment in this residential unit was to take the shopping center from the ground and from the street and to place it on the central floor of the building itself. From outside, this central shopping street, *la rue marchande*, can be immediately identified by its two-story louvers. These, together with the vertical rows of square staircase windows in the middle of the block, vitalize and give scale to the whole front. The shopping street includes shops for groceries, vegetables, meat and fish, laundry and cleaning services, hairdresser and beauty shop, newspaper stand, post office, cafeteria, and hotel rooms for the guests of the inhabitants.

Unfortunately, the French government, owner of the building, demands that the shopkeepers purchase the stores outright, instead of renting them as is the usual custom. This has greatly hindered the bringing of this internal shopping street to active life, and one can understand that the shopkeepers hesitate to take the risk.

On the seventeenth floor is placed the nursery for one hundred and fifty children. A ramp leads directly to the roof terrace with its rest room raised on *pilotis*, its shallow pool (fig. 47), and some charming installations for the children, who are encouraged to decorate the walls with their own murals (fig. 45). The other part of the roof terrace 24 × 165 meters is designed for social activities of the adults. There is an area for gymnastics, partly open and partly covered, and, at the north end of the building, a large slab which acts as a protection against the strong north

wind, the mistral, and also as a background for open-air theatrical performances.

The variously formed volumes and walls and the movement of the levels on this terrace (fig. 46) play together marvelously in the sunshine, and yet it is perhaps under the light of the full moon that they reveal their secrets. This at least was our experience on the night of July 26, 1953, when CIAM celebrated its twenty-fifth anniversary on this roof terrace. About four hundred people were able to move about freely and uncrowded on the various levels. The architecture came to its full strength when animated by this vibrant throng. It was on this evening that Walter Gropius, always generous in recognizing talent in others, said: "Any architect who doesn't find this building beautiful had better lay down his pencil."

In this building it depends on the individual inhabitant whether he prefers to remain a lost number in a huge building—the normal fate of the great city dweller—or whether he will spend part of his free time together with others. It has now been shown that if the inhabitant is given the possibility of choice, as is here the case, the social opportunities are not left unused.

In the hands of Robert Maillart, the Swiss bridge-builder, reinforced concrete lost its rigidity and became almost an organic skeleton, where every particle throbbed with life. In the hands of Le Corbusier the amorphous material of crude concrete, *béton brut*, assumes the features of natural rock. He does not smooth away the marks and hazards of the form work and the defects of bad craftsmanship which, as Le Corbusier stated in his opening address, "shout at one from all parts of the structure!" The use of the natural imprints of wooden boards to vitalize a concrete surface is far from new, yet it has never been used so consistently to give ferroconcrete the properties of "a natural material of the same rank as stone, wood, or terra cotta." Le Corbusier continues: "It seems to be really possible to consider concrete

as a reconstructed stone worthy of being exposed in its natural state." [6]

The rough concrete surface is employed wherever it can strengthen plastic intentions, as in the herringbone pattern on the huge supporting pilotis which was left behind by the narrow boards that had been used for their wooden form work. On the roof the rough surfaces of the ventilator shafts and elevator tower, upon which every change of the strong Mediterranean light plays with a peculiar intensity, help to transform these utilitarian objects into exciting plastic elements.

Strong, pure colors are used in this building, but Le Corbusier, the painter, has refrained from using any colors directly upon the façade. He paints the side walls of the balconies red, green, yellow, but not the front. In this way they are made to gleam like vivid colors through gauze.

Bright colors are also used in the artificially lit *rues intérieures* and, on each floor, one color predominates, so that the different floors are now called the green, red, blue, or yellow "streets." One steps from the elevator or the naturally lit staircase into one of these "streets," where the colors glow from the light source over each front door.

Is the high-rise apartment house developing a type form? A few words are necessary on this point, as the problem of the high-rise dwelling type will remain acute as long as our civilization contains dense concentrations of population. One thing that must be avoided is the undifferentiated stacking of dwelling units, like sardine boxes, one above the other. This can be permitted in two- or three-story walk-up apartments, but not in high-rise buildings. Since 1922, when Le Corbusier presented the plans for his "villa apartments," *immeubles villas*, in the fall Salon, he continued to think over the possibilities of the two-story villa which was realized in the Unité d'Habitation. He stated that each dwelling is "in reality a two-story house, each a villa with a hanging garden, no matter at what height it

[6] Le Corbusier, *Oeuvre complète*, 1946–1952 (Zurich, 1953), p. 191.

166

is from the ground. Each has a loggia, twenty feet high, which makes the house like a gigantic sponge that soaks up the light: the house breathes." [7]

As a dwelling type, the Unité d'Habitation embodies the idea of the villa apartments that Le Corbusier first conceived in 1922, and of which he showed a single type specimen on the outskirts of the International Exhibition of Decorative Arts in Paris, 1925, in the *Pavillon de l'Esprit Nouveau*. The basic conception, then as now, consisted in the conviction that, even in a high-rise building, the individual dwelling should have ample free space in the open air, even at the expense of the size of the rooms. At the same time, the inhabitants must not lose the feeling of complete privacy within their apartment. This was one of the reasons why, from the first, Le Corbusier designed apartments on two floors, for this secured both enhanced privacy and the possibility of greater spaciousness.

That the inhabitants of a well-planned high-rise building can have more freedom, light, and contact with nature than in the finest street of four- or five-story buildings was demonstrated in vain by Walter Gropius in the second half of the twenties. None of his slab apartment blocks, interspersed with stretches of sunlit green, came into being on German soil. The first realization of this building type was in Rotterdam in 1933.[8]

Among leading spirits, the concepts that were first given birth in the Unité d'Habitation had long been discussed, but through the rise of the Swedish point houses, which appealed greatly to the laymen and to romantics among the architects, they were temporarily pushed aside. These point houses, as they have become called from their cramped ground plan, remind one on the one hand of the towers of San Gimignano, and on the other hand of the horrors of

[7] Le Corbusier, *Vers une Architecture* (2nd ed., Paris, 1924), pp. 206–212.

[8] See S. Giedion, "The Development of the Slab Apartment Block," *Walter Gropius, Work and Teamwork* (New York, 1954), p. 79.

Wall Street. In city planning, in regard to our present-day space conception, they are generally unusable. Moreover they do not permit of an expanded layout.

How does the high-rise building stand in relation to the landscape? There are two different attitudes toward the relationship of a building to nature—even to the cosmos.

One consists in the greatest possible merging with nature: Indian rock temples and the simple log hut and, in our time, some of the dwelling houses of Frank Lloyd Wright's middle period, have been deliberately fitted into folds of the earth.

The other attitude is concerned with the conscious accentuation of the contrast of an abstract man-made structure with its natural surroundings: the Pyramids, the Parthenon, and, among other examples of our own period, the high-rise building.

Both attitudes have their justification. It all depends on how they are handled. Adjacent colors of the same tone range are just as delightful as the contrast of complementary colors. The forms of the Pyramids or of the Parthenon are inferior to their opposing landscapes of surrounding desert and rocky eminence, despite their dominating position. But the contrast of their man-made form with the grandeur of undisturbed nature sets up a tension that is highly impressive.

The same is true of the high-rise building as a human habitation when it is correctly sited in the landscape.

Just as Cézanne was able to seize the soul of Provence in his paintings, so Le Corbusier has known how to capture it within an architectural frame. Each two-story apartment looks to both sides. To the east their view embraces an arena of the limestone mountains which can be found everywhere in Provence. To the west lie the blue waters of the Mediterranean: while directly below, the eye can rest on treetops interspersed with red-tiled Mediterranean roofs.

The Unité d'Habitation has shown that the human habitation (a "human" way of living) does not depend upon

its largeness or its smallness. To our eyes, the wicked devastation that is caused by building regulation which, through zoning ordinances and frontage limitations, compel the destruction of the countryside, is infinitely worse as a human habitation than high-rise buildings which fully express the needs for social and physical extensions of the individual dwelling—*le logis prolongé* as the French call it.

A second "complete habitat," the *Maison Familiale de Rezé*, was erected at Nantes between 1953 and 1955, on a more modest scale. This building, 108 × 17 meters, contains 294 dwellings of ten different types for 1400 people.

There is no doubt that the Unité d'Habitation at Marseilles will have an enormous influence in shaping the mind of the coming generation. It will help to liberate also the mind of the architect and planner from the conception of housing as a simple addition of single units and expand it to the wider frame of the human habitat. Last but not least, it shows how, in the hands of a genius, Social Imagination can find a plastic expression.

A new residential area for a metropolis: Alexander Polder, Rotterdam, 1953

Even the metropolis, the great trading or administrative center, will no longer retain the compact structure of the present-day city. Individual residential areas, with more or less predetermined numbers of inhabitants, will become separated from one another by traffic lanes and bands of greenery.

A typical example of such planning is the Dutch project for Alexander Polder prepared by J. B. Bakema and the CIAM Group called OPBOUW (figs. 52, 53). This is planned on the outskirts of Rotterdam for 30,000 inhabitants. On three sides the area, which belongs to the city of Rotterdam, is hemmed in by rental apartment houses. The architects sought to give the new settlement a different form: barrack-like apartment houses were rejected and an effort

was made to return to small differentiated housing units. Toward the center, three high-rise slabs for 1500 people stand amid greenery. Recreation areas, community centers, industry, and dwelling areas have been carefully and successfully integrated.

Their intentions may be illustrated by an abbreviation of J. B. Bakema's notes:

This new section of the city of Rotterdam is situated on an artificially built terrace (or polder) raised to the same level as the national highway.

Each residential unit contains individual houses, row houses, three- and four-story apartment houses. There are also a few ten-story high-rise apartments. Eight of these residential units are foreseen, each for 3500 people. These groups are called horizontal dwelling units.

In addition there are three *unités d'habitation* each for 1500 people. Each of these blocks is placed in greenery and contains a full complement of social needs. These are called vertical dwelling units.

The open spaces are so arranged that they form a connecting link between the industrial area—glass hothouses growing vegetables and flowers—that are within the area and the public park, individual gardens, and the sports area. There is also a small port that is used for nautical sports.

The whole development is based upon the rectangular structure of the Dutch landscape, with its small canals or ditches that drain the raised areas or polders.

The plan thus takes into account, very happily, regional characteristics. J. B. Bakema draws some conclusions:

We are approaching a period in which the integration of the four functions of the city—work, housing, traffic, recreation—becomes ever more important.

The vertical unit never excludes the horizontal unit, but in their development both become integrated into the structure of the landscape and the community.

What seems important in this study—the result of several years of research—is the differentiated handling of horizontal and vertical elements so that simultaneously uniformity has been avoided and a closer and better integration of the different functions has been achieved.

Commercial and community center for a metropolis: Boston Back Bay Center, 1953

It is new in the history of large enterprises that an undertaking of some seventy-five million dollars should be designed by a group of architects who were practically all university professors. Twenty years earlier it would have been unthinkable for a leading real-estate developer to have consulted a university professor in connection with an important building project. This reflects a far-reaching change of the businessman's attitude toward the teacher of architecture, and it cannot be denied that this change is largely due to the creative achievements of such architects as Mies van der Rohe and Walter Gropius. An even clearer example of this change of attitude appears in the acknowledgment by the *Architectural Forum*, in September 1943, that the earliest designs from the new Boston Center were made by students of the Harvard School of Architecture.

The plan for the new Boston Center (fig. 54) made use of the freight yards of the old Boston and Albany Railroad which have become unbearably costly to operate owing to the increasing tax rates on the property. So it became possible for an enterprising firm of real-estate developers to undertake the project.

The strength of the spatial planning of the first coordinated group of skyscrapers—the Rockefeller Center (fig. 27), twenty years earlier—cannot be forgotten. The Boston project is however, by comparison, a more elaborate complex and is more urbanistically varied.

A large area was consciously created for the sole use of the pedestrian, a protected zone within which he can wan-

der free from danger. At the entrance to the Forum at Pompeii stand stone bollards, blocking the entry of wheeled vehicles. In the Boston Center, three-story car-parking garages were proposed beneath the ground in which 5000 autos could be stored like garments in a closet. At last the pedestrian regains the right he had lost since antiquity, to move freely within a center of collective life. This is clearly connected with a third principle of urban planning: the reduction in importance of the street frontage and the movement of the shops to their rightful positions: within the traffic-free pedestrian area. Shopping calls for a certain degree of concentration and absence of extraneous disturbance, and here the city dweller of the West was restored something that has always continued to be enjoyed in the bazaars of Eastern cities, such as the sooks of Cairo or Bagdad.

The significance of this scheme lies in its relation to the changing structure of the city: of the great metropolis which is here with us and cannot be simply dreamed away.

It is this practical aspect that gave rise to this Boston project with its comprehensive building program, occupying a tongue of land covering some thirty acres.[9] The scheme included several office buildings, one of which, a forty-story slab, stood transversely across the project, dominating the scene. There was also a hotel, the low buildings of a motel, an exhibition hall, and, separated from these by a wide pedestrian way across the traffic stream, a large convention hall for 7500 people.

From all sides this new center was hemmed in by the dense structure of the great city, gripped as in an iron vice. It stood as an isolated phenomenon closed in upon itself. Its volumes lacked breathing space. Even so, from a sociological point of view, this center was a leap into the future,

[9] Further information on this project, including the difficulties which prevented its realization, are contained in the illustrated article "A Cavity in Boston," *Architectural Forum* (November 1953), pp. 103–115.

away from the commonplace business approach, toward the satisfaction of the human needs of twentieth-century man.

Civic center of a capital city: Chandigarh, Punjab, India, since 1951

The founding of new towns is a sign of vitality and of an enterprising courage. New towns are often related to higher living standards, or to the promise of them. This was the case during the Gothic period, when new towns suddenly sprang up in Central and Western Europe. The same phenomenon occurred during the last century in the United States, foreshadowing its industrial hegemony.

Toward the middle of the twentieth century we are witnessing the decentralization of Western culture. New energy radiates from its former fringes: Finland, Brazil, Colombia, Venezuela, Canada, the African Gold Coast, to name only some areas of the centers of a new vitality. The Middle East is now also going ahead with an astonishing speed. Countries which have long been slumbering in their own lethargy or under oppression begin to awake and to become active participants in an evolution which is encompassing the entire world. In this process spirits of East and West are meeting together.

This meeting of East and West may explain, why India—through the understanding of its leader Pandit Nehru—could choose a Western architect for the new capital city of the East Punjab, Chandigarh. Yet there is also another reason. This is an inherent trend in contemporary architecture toward satisfying cosmic and terrestrial conditions and the habits which have developed naturally out of them. This explains why contemporary architecture, when it is truly imbued with the spirit of the age, takes on so many different forms.

This aspect of architecture has long been a feature of literature, never more sublimely expressed than in the works

of James Joyce, who kept his roots firmly embedded in Ireland though he grappled with the cosmos and showed humanity unsevered by division into past, present, and future.

When the Punjab was divided in 1947 between Pakistan and India, the ancient capital of Lahore was attached to Pakistan. A new capital became necessary for the East Punjab with its twelve and one-half million inhabitants. On a sloping plateau at the foot of the Himalayas a superb site was discovered in 1950 through airplane reconnaissance by E. L. Varma, an eminent Indian government engineer.

The new capital city was called Chandigarh after a village on the site. When complete, it will house half a million people. The first section, now largely constructed, is for a population of 150,000. Neighborhood planning, housing, and schools were, for the first three years, under the direction of Pierre Jeanneret, Maxwell Fry, and Jane Drew in cooperation with an entirely Indian staff of architects and engineers. The Civic Center itself was entrusted to Le Corbusier, with the assistance of Pierre Jeanneret, and Le Corbusier has also been responsible for the master plan of the whole city.

A town planner, an architect, an artist, a sculptor, and a man with the grasp of a poet are surveying a wide empty space at the foot of the Himalayas. These five are united in one person. This is the spot where the capital of Chandigarh is to stand. There is nothing more thrilling for the truly creative mind than to turn a dream into reality here on this myth-soaked soil. To achieve this, it may be worth while to have accepted a lifetime of humiliations.

We can follow line by line in Le Corbusier's sketch book how the vision of the new Capitol crystallized, how it became a mighty monument, in which, for the first time, Eastern and Western thought merged without a break. Western calculation, shell concrete vaulting, and a butterfly roof of huge size, normally associated with locomotive sheds and station platforms, here change under our very eyes into some dream-building of the East.

The program for the Capitol (fig. 50) consists of a House of Parliament, a building for the Ministries, the Palace of the Governor, and the High Court of Justice. The most fantastic of these will probably be the Palace of the Governor,[10] designed in April 1952, with its roof terraces, the upper one concave, in shape almost like a sickle moon. The

d. *Le Corbusier: Chandigarh, Capital of Punjab, India,* 1951. Entrance to High Courts of Justice.

Pilgrimage Chapel of Ronchamps, 1951–1955, designed at the same time, also has a concave roof as its most outstanding feature.

A word is necessary regarding the High Court of Justice, which was opened in the spring of 1955. This building (figs. 48, 51) contains seven courts of law surmounted by an enormous butterfly roof, which provides shelter from the tropical sun and from the monsoon rains. The huge sloping eaves stretch far out from the building. Parabolic shell vaults stiffen the structure and span the wide-open entrance hall,

[10] Le Corbusier, *Oeuvre complète,* 1952–1957 (Zurich, 1957), pp. 102–107.

which reaches up to the full height of the building. In this strange Palace of Justice modern techniques comply with cosmic conditions, with the country, and with the habits of its people.

What astonish the European eye are the great distances between the buildings. Only time will show whether these are not too grandiose, as has happened in India with government buildings erected under British rule. But there will be no dead surfaces between them. The sculptor in Le Corbusier has taken the opportunity to mold the enormous surface by varying levels, large pools, green lawns, single trees and artificial hills made of surplus material; and also by symbolic representations of the harmonic spiral, such as the daily path of the sun. A dominant symbol, the Open Hand (fig. 49), will be seen from everywhere and will "turn on ball bearings like a weathercock." [11] The impress of the human hand placed upon the rock was the first artistic utterance of man. This symbol is still alive in India, and at the marriage feast friends leave the red stamp of their hands—red is the color of good luck—on the white walls of the bridal pair.

A monument in form of an enormous hand can be found earlier in the work of Le Corbusier. It was then an aggressive and menacing hand. Now under an Eastern sky it has quieted down like the hand of Buddha.

E. L. Varma, who discovered the site of Chandigarh, has given the Indian response to this symbol in a letter to Le Corbusier:

We have a word, *Ram Bharosa*, which indicates deep faith in the ultimate—faith born of the surrender of the will to the Ultimate Source of Knowledge, service without reward and much more. I live in that faith and feel happy in the vision of the new city which is so safe and so secure in its creation in your hands.

We are humble people. No guns to brandish, no atomic

[11] Le Corbusier, *Oeuvre complète*, 1946–1952 (Zurich, 1953), pp. 150–151.

energy to kill. Your philosophy of "Open Hand" will appeal to India in its entirety. What you are giving to India and what we are taking from your open hand, I pray, may become a source of new inspiration in our architectural and city planning. We may on our side, when you come here next, be able to show you the spiritual heights to which some of the individuals have attained. Ours is a philosophy of open hand. Maybe Chandigarh becomes the center of new thought.[12]

[12] See S. Giedion, *Space, Time and Architecture*, third edition, p. 540.

SPATIAL IMAGINATION

The need for imagination implies that there exists a need for something more than the bare interpretation of functional requirements.

Nothing is so difficult to find today as an imaginative handling of space—a Spatial Imagination. An imagination that can dispose volumes in space in such a way that new relations develop between differing structures, different edifices, so that they can merge into a new synthesis, a symbolic oneness.

Even greater hesitations arise when the building program demands that the architect create an interior space which transcends its purely technical and organizational requirements, as in great halls destined to reflect general aspirations—whether they be the nave of a Cathedral or the meeting place for a world organization.

The need for a monumental expression in art and architecture is one that has existed, and has been solved, in all civilizations. Our own cannot be an exception.

The area where the spatial imagination has always had the greatest freedom—where it could unfold with the least interference—has been the area that lies above normal utilitarian requirements. This is the space that floats over our heads, lying beyond the reach of our hands. It is here that the fullest freedom is granted to the imagination of the architect.

In two words, we are talking of the vaulting problem.

It is true that there have been vaults, even stone vaults, ever since the dawn of architecture. But their sacred connotation, and with this their major development, evolved much later.

The problem of the origin of the concept of the domed vault is frequently raised. There is no doubt that the great

vaults of late antiquity—domes, barrel vaults and cross-ribbed vaults—represent their first large-scale development. Their forerunners have recently been thought to be the Maltese rock temples of the Neolithic period which stand half free and half hollowed out of the living rock. Today it is thought that these were mortuary buildings linked to fertility rites of the Great Mother.[13] In Rome, and probably earlier in the East, the question arises of how the change was effected between the vault considered as the mother's womb and the vault as the heavenly firmament.

This is linked with the relation of the vault to the cosmos. The turning cupola (known only from coins [14]) in Nero's Golden House which depicted the movement of the stars is—except for certain oriental legends—the first example of a direct comparison between the vault and the cosmos. Here the role of the emperor was identified with that of the creator of the universe.

The complete development of the vaulting principle is evidenced in Hadrian's Pantheon at the beginning of the second century. The eternally open eye in the center of the cupola and its former covering with gold leaf point out that the universe is here symbolized, rather than the maternal womb (fig. 56).

From that time on, the conception of space was almost always identified with interior space. Since late antiquity, hollowed-out space, circumscribed interior space, has been the major problem of architecture. The greatest skill has been devoted to its modeling. And the ceiling has been the area in which the imagination has had the fullest freedom to give symbolic strength to this hollowing out of space.

Since the time of the great Roman vaults, each period has solved the vaulting problem according to its own emotional needs. Basic forms of enclosing space were developed

[13] G. von Kaschnitz-Weinberg, *Die mittelmeerischen Grundlagen der antiken Kunst* (Frankfurt, 1944).
[14] H. P. L'Orange, *Studies on the Iconography of Cosmic Kingship in the Ancient World* (Cambridge, Mass., 1953).

within the limitations of then known techniques of span-, ning, such as the barrel vault and the cupola. Already in late Roman times more complicated construction afforded possibilities of through lighting and perforation. The development of the cupola received particular attention during the Byzantine period, and the accent was laid on strengthening the spatial effect through the introduction of mosaics, rather than on elaborating the interior form of the dome. Perforation of the walls, together with their greater spatial freedom, gave the impression that the heavenly vault was suspended from above rather than supported from below: it had become a canopy.

All was now prepared for a transfer from solid construction to light rib vaulting, though, of course, this intervening period had occupied several hundred years.

A curious link leads from the domes of the Arabic world in the tenth century to our own striving for the solution of the vaulting problem. Both intend to eliminate heaviness and to reduce the amount of material as much as possible. The Arabs, maybe because of a mobile heritage, favored lightness and slim dimensions. In the vaulting of their small domes they invented reinforcing ribs, those binding arches which they made to spring so precisely from one support to another. The Mihrab, the chapel, orientated toward Mecca in the mosque of Córdoba (fig. 59), shows how the Arabs developed a forerunner of the space frame construction long before the ridge ribs of the Gothic cathedrals.

Another ancestor of the means of spatial construction of our period is the mathematician and monk, Guarino Guarini. The lantern of his cupola of San Lorenzo, Turin, 1668–1687, is placed upon the free-standing binding arches of the dome, whose intersections form a fantastic eight-pointed star (figs. 57, 58). The result is a veritable light filter, for the light penetrates through the curving triangles formed by the intersecting arches so that, when the observer looks upward, the highest, light-flooded area seems to hover in space, and this without any artificially induced per-

spective illusions. Here the principle of the mosque in Córdoba—well-known to the widely traveled monk—has been transposed into daring dimensions. Guarini's intention was to satisfy by architectonic means the Baroque feeling for mystery and infinity. The Baroque period was strongly attracted to constructions defying the force of gravity and awakening the impression of spatial infinity. Mostly this was done by painting. In San Lorenzo, purely architectonic means are used to defy gravity. No later architect dared to follow the precedent Guarini set in this church. The dome of San Lorenzo presents the case of an architectural vision that uses the structural resources of its age to the utmost limit. Today, the situation is just the reverse. The means of construction present the architects with the subtlest possibilities of development. They need but to be grasped.

The next step leads from Guarini's cupola of San Lorenzo to our own time. Today light-filters and the perforation of space, which were only achieved in the seventeenth-century church with the utmost difficulty, have become relatively simple practical problems. Today Pier Luigi Nervi [15] constructs his perforated space frames from the simplest prefabricated elements. Maybe his Festival Hall in Chianciano, Italy, cannot be compared with the finesse of Guarini's perforated space, yet the principle of composing a dome of simple prefabricated elements which can be assembled in a new and fantastic way, has been achieved by this twentieth-century engineer (fig. 60).

Industrialization and the vaulting problem of this period are inextricably interwoven. Curtain walls and eggshell skin-vaults have taken the place of the massive structures of former periods. Even in the field of engineering, there is a tendency for ever lighter structures. There is a remarkable difference between the nineteenth- and the twentieth-century approaches to the problem of wide spans. Nineteenth-century engineering found its apex in Cottancin's Hall of Machines at the International Exhibition, Paris, 1889,

[15] Pier Luigi Nervi, *Construire correttamente* (Milan, 1954).

which, by means of its three-hinged arches, achieved for the first time a free span of 115 meters.

Today, we are on the way to replace heavy trusses with small prefabricated members, each of them forming a part of a space-truss and being themselves spatial structural elements. It would have been impossible for the nineteenth century to build the enormous cantilevered hangers which Konrad Wachsmann has designed.

The tendency to achieve lightness, less weight, and greater flexibility in the forms of vaulting appears also in ferro-concrete structures. Great engineers, like Freyssinet and Maillart, built their eggshell vaults in the twenties: in Freyssinet's locomotive sheds at Bagneux, near Paris, the thin reinforced slabs can almost be bent like cardboard; in Maillart's later parabolic vault for the Cement Hall in the Swiss National Exhibition, 1939, the thickness is only two inches.

Rather further from architecture are the domes of the Zeiss Planetarium, whose space frame of wire netting was later covered by a thin skin of cement. Maybe the first realization of this idea is to be found in the Exhibition of the German Werkbund, Cologne, 1914. Here in his Crystal Pavilion, Bruno Taut developed a fantastic dome with the lightest kind of concrete construction. "The dome was built up on the principle of a wickerwork construction without the use of supports, and was the forerunner of postwar laminated wood and concrete constructions." [16]

After this, principles that formerly could only be employed for the lightest of materials could be set in a space frame that at the same time absorbed both stress and strain: hanging membranes in the form of a canopy; rope nets like a hammock; stretched skins like a drum; the principle of the soap bubble whose molecular tension holds it in shape.[17] Torrochs in Spain, Dischinger and Finsterwalder in Ger-

[16] Bruno Taut, *Die neue Baukunst* (Stuttgart, 1929), p. 28.
[17] An insight into present possibilities is given by Frei-Otto, *Das hängende Dach* (Berlin, 1954).

many have side by side developed the theoretic bases for the system.

The question at once arises: what is going to happen from the artistic point of view? Here we return to the isolation of the artist, which has still not been overcome; for we find that the greatest of the structural engineers are working with mediocre architects, and the greatest architects with mediocre structural engineers. The blending of the finest talents in both fields has as yet not been achieved, and the

e. *Eduardo F. Catalano: Rippling space frame construction.* One of the most hopeful signs of our time is the way in which mathematical and structural calculations are being given emotional expression. The Surrealists, especially Max Ernst, recognized the emotional power of models of complicated mathematical formulas and now the hyperbolic paraboloid shells of the engineer have become a starting point for this spatial imagination.

difficulties lie in the same area as those that exist between the architect, the painter, and the sculptor.

If one examines the present-day situation more closely, one finds that even without direct collaboration between engineer and architect, it seems that similar lines of direction are being followed—the evidence sometimes coming from most unexpected places.

One very early push came from the Russian sculptor, Naum Gabò. His competition scheme for the Palace of the Soviets in Moscow, 1931 (fig. 61), followed the outlook developed by the Russian "Constructivists" who led sculpture into the architectural domain as "it is the spiritual source from which the future architecture will be fed." [18] Here Naum Gabò, an artist, a sculptor, was the first, as far as we can see, to conceive two halls—an auditorium for 15,000 and a theater for 8,000—like two enormous shells

[18] "The Concepts of Russian Art," *World Review* (June 1942).

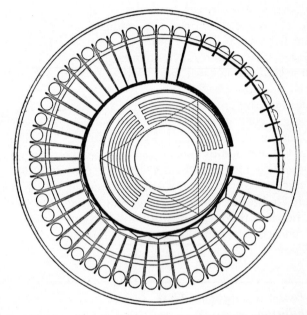

f. *Paffard Keatinge Clay: Light dome for the Carl Cherry Foundation, Carmel, California.* Ground plan and section. The structure is designed for experimental dance performances with music and changing lights.

whose ceiling and floor mirror each other and are drawn into continuous movement. Perhaps it could not have been realized in 1930, but now it could, and Catalano's stadium, 1952, taken up from the ground and floating in space, having the sky as its counterpart, could be realized immediately. Catalano the architect, Le Ricolais, the excellent mathematician-engineer, and other collaborators, have

184

proposed for this project three different kinds of space frames of prefabricated parts.

Since the project of the Russian Naum Gabò, Frank Lloyd Wright has produced a scheme for a club-house for Huntington Hartford, Hollywood Hills, California (fig. 62), based on a similar spatial conception. Is this "international style"? Certainly not. Two artists have been touched independently by the current of ideas inherent in our period.

In schemes prepared by the youngest generation, such as the light dome for a California foundation by Paffard Keatinge Clay, the same tendency toward combining an organic and geometrical, an emotional and a rational approach is again reflected.

The vaulting problem is certainly not the main factor in creating a community life. But the molded sphere above the head has always given a decisive stimulus to the places where the community has gathered for religious or political purposes, for a music festival or for theatrical performances. It is not that the creation of an all-embracing sphere immediately changes a chaotic crowd into an integrated community, but it is its foremost symbol. The Gothic candles are long burned out; but the cathedrals still remain as silent witnesses.

Berlin Conference Hall, International Building Exhibition, 1957

When the first version of this article was printed at the beginning of 1954 in the *Architectural Record*, there were still little more than paper projects to refer to as statements of possibilities—imaginative expressions of what the future might hold.

Much sooner than we had thought possible, evidence has been produced to show that our period is really on the way to solving its vaulting problem. In all corners of the world rise buildings that indicate the same direction.

Almost without exception these have incorporated the

shell vault into their architecture. Its lightness and, above all, its tremendous flexibility of form, as well as its self-supporting nature have made it a springboard for the spatial imagination.

To select but a few: Eero Saarinen's domed Kresge Auditorium for the Massachusetts Institute of Technology, 1954; Yamasaki's airport for St. Louis, Missouri, 1955; Raglan Squire's large assembly hall for the University of Rangoon, Burma, with its shell of teakwood; Hugh Stubbins' Conference Hall for the Berlin International Building Exhibition of 1957; Joern Utzon's prize-winning design for the National Opera House, Sydney, 1957; and Le Corbusier's Pilgrimage Chapel at Ronchamps, Vosges, 1955. These last three show, in their different ways, what differentiates the vaulting problem of our period from those of early times.

What is at the root of their form of expression?

It was the engineer Eiffel, in the soaring, perforated lattice of his Eiffel Tower (1889), who first achieved a pure expression of the interpenetration of inner and outer space. Anyone who has ever climbed the spiral staircase of this tower has experienced this fantastic interpenetration (fig. 19).

In a certain sense the present-day development of architecture has been attained by the use of glass walls to achieve interpenetration of inner and outer space (the Bauhaus at Dessau by Walter Gropius, 1926). This desire for transparency and interpenetration which continues unabated, can now be achieved in a more sublime manner: through a new conception of the vaulting problem.

From the Roman Pantheon to the Baroque Church of the Fourteen Saints, known as the *Vierzehnheiligen*, the vaulted ceiling has been placed like a bell over the interior space. It has assumed a wide range of forms often emphasized by marvelously contrived directional lighting. It has still much to teach us, for we are still only at the beginning of our development.

But all these vaults—from the first development of the

186

round house in northern Mesopotamia around 5000 B.C.—
have one thing in common: the enclosing of an interior
space, shaped by light.

In the buildings now to be considered—the Assembly Hall
for the Berlin Exhibition, the National Opera House, Syd-
ney, and Le Corbusier's Pilgrimage Chapel at Ronchamps—

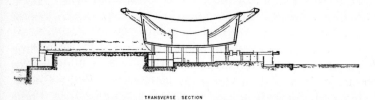

TRANSVERSE SECTION

g. *Hugh Stubbins Associates, Fred Severud, engineer: Conference Hall for
International Building Exhibition, 1957.* Transverse section: showing the
roof dipping into the Conference Hall, with the triangular sections the
arches. The walls of the hall support a compression ring.

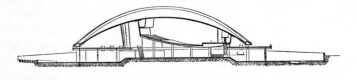

LONGITUDINAL SECTION

h. *Hugh Stubbins Associates, Fred Severud, engineer: Conference Hall for
International Building Exhibition, 1957.*

it happens that the curved ceiling is concave in form: it
sinks into the space below (fig. 69). This means that the
center of the ceiling, which up to now has been the position
of maximum height, has become its lowest point. The curve
rises toward the encompassing walls, indicating by this that
it does not terminate there, but that it extends further into
the exterior. With great insight Le Corbusier in the chapel
at Ronchamps has inserted a narrow band of light to mark
the separation of the wall from the hanging ceiling.

The curving vault opens outward like an opening eye.

187

And if one stands in front of the building one sees how this great brown-grey concrete vault raises itself up from the white walls and attracts one into the interior.

In the Berlin Assembly Hall for the Exhibition of 1957 (fig. 65), the heavy outward curving roof seems almost to hover over the platform. The engineer, Fred Severud, has here employed all the experience he acquired in his earlier building for Matthew Nowicki, who died too young. Through its concave planes a subtle play of strength has been achieved so that the vault is supported by its own internal equipoise. It is true that the eye sees none of the invisible wire cables which are concealed in the concrete, but even the least perceptive observer cannot but be aware that here is a mastery of workmanship that could never have been achieved before our period.

This Assembly Hall, which the United States has erected for the Berlin Exhibition, is intended as a permanent building for cultural interchange, to be handed over, later, to the city of Berlin. It is situated in the Tiergarten by the side of the river Spree. At its center is the auditorium for 1200 people whose curving roof can be seen from afar. Very wisely the glass walls of the entrance hall have been pushed well back. It is this that gives the building the buoyancy that seems to raise it from the ground.

To describe the way in which today's curved, creased, and crumpled planes are related to the geometry developed by Riemann and Lobatschevsky (much as the forms of former periods were with Euclidean geometry), and how molecular tension can be transformed into architectonic space is not here our task.[19]

[19] Information on such matters must be acquired elsewhere, for example, in the excellent booklet issued by the North Carolina State College (Student Publications of the School of Design, vol. 5, no. 1) prepared under the guidance of one of the leading pioneers in architecture, Eduardo F. Catalano.

Dome versus rectangle

During the first half of this century it became evident that the plane surface was one of the constituent elements of contemporary architecture, and after a struggle, started by the First Chicago School in the late 1880's, and after many aberrations, the emotional content of the high-rise building as expressed in the gigantic undisturbed surfaces of Mies van der Rohe's immaculate apartment buildings on the lake front at Chicago may stand as the supreme solution of the intermarriage of the plane surface and the latest structural techniques.

It can be easily understood why a good deal of interest has been aroused by the fact that, after having concentrated for so long upon a battle for the purity of the two dimensional plane, emphasis has shifted to the problem of the curving vault. So it is not astonishing that the magazines of architecture have been concerning themselves with the question: Is there not a contradiction between the developing space frame structure and the steel skeleton? For instance, recently the *Architectural Forum* asked several people to express their views on the form of Eero Saarinen's Kresge Auditorium under the general title of "Dome versus Rectangle." [20] I replied as follows in December 1955:

I could never agree to discuss in painting:

 Mondrian versus Kandinsky or
 Miró versus Mondrian.

Their great differences are just different threads in the intricate pattern of contemporary art. There is neither right nor wrong. Their external contradictions have in reality a complementary function. The organic conception (Miró) meets with the geometric horizontal-vertical conception (Mondrian) which has been deeply embedded in our consciousness ever since the Egyptians, 5000 years ago, made the horizontal-vertical relation supreme over all others.

[20] "Dome versus Rectangle," *Architectural Forum* (March 1956), pp. 156–157.

For Mondrian or for Mies van der Rohe, any deviation from the horizontal or vertical spoils the artistic purity, and from their point of view they have every right to believe this.

The uncompromisingly clean cut skyscrapers of Mies van der Rohe may one day stand as a testimony that our period contained some particle of the clarity of abstract strength that gave the Pyramids their eternal force.

This is one way to conceive buildings, but it is not the only one.

Eero Saarinen's shell concrete dome for the Kresge Auditorium, Massachusetts Institute of Technology, is by no means an isolated phenomenon. It is one of the steps toward the solution of the vaulting problem of our period. This solution for which architecture everywhere is craving has not yet been found, but we are on the way to it. Each civilization since interior space was first shaped has found a solution to the vaulting problem that has met its particular emotional needs. The area that lies above normal utilitarian requirements, the space that floats above our heads beyond the reach of our hands, is where the fullest freedom has been granted to the imagination of the architect.

In 1953 I hinted that the vaulting problem of our period will be derived from the possibilities offered by the structural engineer—particularly in the forms of space frame construction.

Since Davioud in 1878 designed a parabolic ceiling for the Paris Trocadero, architects have been trying to find a solution to the problem of vaulted interior space in our period.

As mentioned above, Naum Gabò made a scheme for the Palace of the Soviets in 1931 in which the ceiling and floor were curved like a shell (fig. 61). In 1947, Frank Lloyd Wright prepared designs for a club house in Hollywood on the same principles as this Russian sculptor. In the same year, Le Corbusier prepared a scheme for the great Assembly Hall of the United Nations in which floor and ceiling

flowed together in one continuous curve. If executed, this would have been one of the marvels of our period. Eduardo F. Catalano made interesting experiments in North Carolina and built his own house beneath a space frame vault (fig. 64). Stubbins has constructed the American Congress Hall in Berlin with a space frame as its outstanding feature (fig. 65).

I stood at Ronchamps while the chapel of Le Corbusier was dedicated. The Archbishop spoke of the forward-curving bows of the roof as containing within its form both the old and the new—the arch and the airplane. We are on the way. This work that brings to expression the secret boldness that dwells within our times had not to wait to find recognition.

Dome versus Rectangle
Rectangle versus Dome?

This I cannot answer with a simple yes or no. Just as I could not discuss Kandinsky versus Mondrian. Both in their own way are expressing what is inherent in our period. Kurt Schwitters, the German painter and poet, would have answered this quite simply: "Whatever an artist spits is art."

National Opera House, Sydney, 1957

It is a good omen for future development when, scarcely two years after the completion of the chapel at Ronchamps, another building again widens our vision of the vaulting problem of our period. This is the prize-winning design for the National Opera House at Sydney, Australia, won by a young Danish architect, Joern Utzon (figs. 67, 68). His project outshone all the others—as, three decades earlier, Le Corbusier's project for the Palace of the League of Nations at Geneva had done. Let us hope that Fate, in his case, will be kinder.

Le Corbusier's pioneering project was intended for an international center in the very heart of Europe. There has been a change since that time; now the most courageous buildings are erected on the fringes of our Western civiliza-

tion. This one brings Australia into the world-wide development which already embraces Brazil, India, and Japan.

A second surprise is the country in which the project originated. Danish architecture, until now, has been overlaid by a delicate mist of classicism which has given rise to an atmosphere of fatigue, similar to that breathed by the novels of Jens Peter Jacobsen. Joern Utzon, the architect of the Sydney Opera House, is known for his sound and origi-

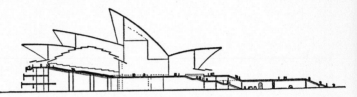

i. *Joern Utzen: Prize-winning design for Opera House, Sydney, 1957.* Longitudinal section.

nal designs for housing developments and private houses. But this sudden stroke of genius was quite unexpected.

The theater with its two auditoriums stands upon a promontory overlooking the harbor of Sydney: Bennelong Point, a highly exposed position. "We have been impressed," comments the jury, "by the beauty and the exceptional possibilities of the site in relation to the Harbour . . . We feel strongly that a large and massive building, however practical, would be entirely unsuitable on this particular site."

The marvel that this project was ever selected can only be explained by the fact that the jury included Professor J. Leslie Martin, designer of the Festival Concert Hall, London, 1951, and Eero Saarinen, architect of Kresge Auditorium, Massachusetts Institute of Technology, 1955, both of whom were among the first architects to use shell concrete vaults over places of public gathering.

One of the features of the new regionalism is its recovery of an inner relationship between a structure and its surroundings.

This can be attained by stressing the differences between

192

the man-made artifact and nature: by contrasts which complement and complete one another, as day and night, male and female. Among the highest expressions of this principle is the Acropolis—with its conscious juxtaposition of the formed and unformed—of temple and rock; or the bridges of Robert Maillart in their high mountain settings.

Another principle is the amalgamation of the structure with nature. This, too, the Greeks accomplished superbly: the steps of their semicircular theaters bite into the hillside; they are cut out from the rock, and become one with it.

The new and, certainly for many people, strange aspect of the Sydney Opera House is that it makes use of both principles—contrast and amalgamation.

The principle of contrast is found in the upper part of the structure: the thin concrete shells, used with great courage and freedom, have become sails billowing with dramatic expectancy. They prepare one for what will take place within. They seek to divorce the audience from the routine of their daily lives. At one blow, the banal stage tower is also destroyed. The jury commented:

The great merit of this building is the unity of its structural expression. One of the most difficult problems of opera house design is to relate the stage tower to the separate and surrounding buildings and this becomes of particular importance on this exceptional site. The solution suggested in this scheme is that the two auditoria should be roofed by a series of interlocking shell vaults in which the high stage is only one of a series of separate shells. This creates a striking architectural composition admirably suited to Bennelong Point. The white sail-like forms of the shell vaults relate as naturally to the Harbour as the sails of its yachts. It is difficult to think of a better silhouette for this peninsula. The dynamic form of this vaulted shape contrasts with buildings which form its background and gives a special significance to the project in the total landscape of the Harbour . . . The use of this form of construction seems to us to be particularly appropriate.[21]

[21] Assessors' Report, "Sydney Opera House Competition," *The Architect and Building News* 211 (28 February 1957), 275.

The principle of amalgamation is also found. The heavy, massive base stands in complete contrast to the upper part. This lower area forms a contrasting extension of the rock upon which it stands. "The auditoria are arranged like Greek theatres in this rising base externally and are approached either underground from cars or externally along a magnificent ceremonial approach. This conception solves by elimination, all the complex needs of escape which form so much dead space in a multi-storeyed building."

The project consciously brings into play both principles —amalgamation and contrast—within one building. This is the exciting novelty of this scheme, and here is one more quotation from the jury's verdict: "We are convinced that the concept of the Opera House is capable of becoming one of the great buildings of the world."

In certain places, such as the entries to the auditorium, one might perhaps prefer a certain moderation in the vaulting. And the lower walls have not yet the great lines of the vaulting concept. But this Opera House design contains all the elements of a masterpiece and will give Australia its first great forward-looking building. One can but hope that the authorities in whose hands Fate has placed this gift are able so to comprehend its intention that they will neither prevent its realization, on pretexts of one kind or another, nor change it unrecognizably.

Pilgrimage Chapel at Ronchamps, June 25, 1955

On a wooded hill above the town of Ronchamps, about thirty kilometers west of Belfort, rises the Pilgrimage Chapel of Sainte-Marie-du-Haut. Grey-brown like the wings of a moth, the curved roof rests on curving chalk-white walls. The space outside this pilgrims' chapel is more important than the interior, which hardly has room for two hundred people. Twice a year about 10,000 pilgrims used to visit the chapel, which was destroyed in the last war. The venerated

statue of the Virgin Mary is now so built into the structure that it can be seen from both inside and outside the church.

Dedication (fig. 69): The boys' choir, clad in red, sings from a gallery set in the concave back wall. The dedication takes place in the open air, under the protection of

j. *Le Corbusier: Pilgrimage Chapel at Ronchamps.* Silhouette seen from the valley—the architect's sketch.

the curving concrete roof, like under the overhanging crag of one of the prehistoric Magdalenian shrines.

Le Corbusier, the architect, hands over the keys of the church to Archbishop Dubois of Besançon. From the pulpit the prelate in his violet-colored cassock addresses Le Corbusier and the sun-drenched throng:

You said once that a style took form in the century of the cathedrals that led to devotion to art, to forgetfulness of self and to joy in life. You must have felt something of this inward elevation when you cast these walls up in space. This "skyscraper of the Virgin Mary" that dominates the landscape far and wide, was for you, as you have said of the architects of the thirteenth century, an act of optimism.

195

Something more rang through this address by the Archbishop: It was one of the first recognitions from such a quarter that contemporary architecture is a symbol of the inner strivings of our period—a courageous recognition of the present. He spoke of the forward-curving bow of the roof, which the walls cut at an angle like the bow of a ship,

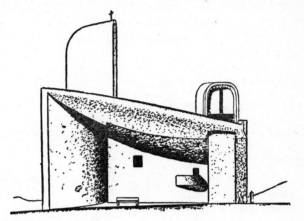

Façade est

k. *Le Corbusier: Pilgrimage Chapel at Ronchamps.* The eastern side of the church, designed for open-air services—the architect's sketch.

and of *arche et avion,* arch and airplane, the oldest and the newest, as being borne within it.

Does this signify a radical change on the part of those authorities who hold power in their hands? It is a fact that, upon this dedication day, this little chapel immediately became world famous. It appeared at once in the newspapers and magazines on both sides of the ocean. It became the symbol of a concept more quickly than any other building of our times, unaccompanied by the usual attacks and denunciations.

Does it deserve this?

Ronchamps is a building in which all the parts are plastically interdependent. What happens here is what Naum Gabò and others have proclaimed: the principles of modern

196

art have passed over into architecture and have coalesced with it. The white walls, especially in their most prominent position where the pilgrim, coming up from the vale, first catches sight of the building, raise up the roof, whose concavebearing surface is made of a double shell of reinforced concrete. This concrete is left rough. The roof swings like a canopy into the half-darkened interior of the chapel.

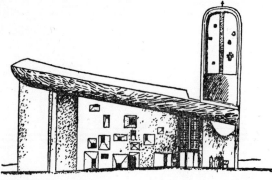

Coupe longitudinale

1. *Le Corbusier: Pilgrimage Chapel at Ronchamps.* Elevation with bell tower and light turrets.

The walls are as flexibly modeled as the roof. The bell-tower juts upward alongside the chapel in a completely unprecedented manner, and, like a conch shell, sends the sound of the bells out over the plain. (Le Corbusier has talked of acoustic architecture.) There are two low, similarly formed structures which through their slits give indirect light to the two side chapels that appear as tongue-like projections of the walls.

The nave proper of the chapel is in twilight. Light sources are variously distributed. The south wall lets light in through small scattered square holes (fig. 70). On their glass, the architect has written in his own handwriting passages from the service of the Mass, or has painted symbols.

Le Corbusier accepted this commission because he was "intrigued by the prospect of going deeply into problems

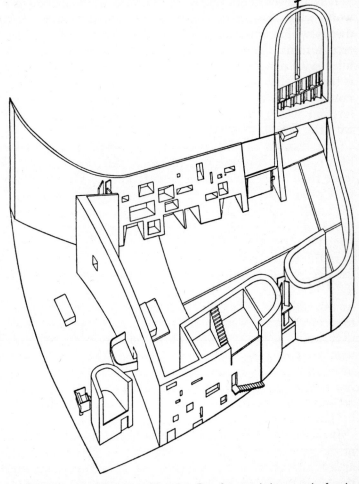

m. *Le Corbusier: Pilgrimage Chapel at Ronchamps.* Axionometric drawing from the south. This drawing gives an excellent insight into the relationship of organization of space, especially of inner and outer space and the volumes of the high side chapels.

198

where no utilitarian purposes were to be served." No self-important persons interfered; free scope was generously given to him.

It is an event that cannot be brushed aside: that such a work, which brings to expression the secret boldness that dwells within our times, has not had to wait to achieve recognition. There are many fine churches in existence filled with a worthy contemporary spirit. But Ronchamps is the one that has particularly aroused enthusiasm. It has raised the problem of the vaulted interior space to a new level in which, despite meditative seclusion, the contact with the exterior may still be felt.

The transfer of the chapel to the public was followed by a banquet. A corrugated sheet-iron hall was set up and more than five hundred were served. The Archbishop, with Le Corbusier at his side, sat among the crowd on one of the crude benches arranged in rows. Opposite was the fine profile of Claudius-Petit, some military men, a priest or two. Then the workers who had taken part in the construction, the Resistance fighters who had fought here, and gendarmes. At our table sat the Ronchamps building contractor. "Well, how do the people feel about this building?" we asked him. "At first they were 90 per cent against it, now they are 90 per cent in favor."

It is not the people who are holding things up. It is those who think they can obtain power by catering to the lowest instincts. As a Swiss architect once said, "Generally it is not the people who are against us but those who are unwilling to risk anything."

Have we reached a moment of change?

Is the ruling taste, that has befuddled the innate strength of the general public for a century and a half, disappearing at last, and, with it, the tragic conflict between feeling and thinking? From now on will those few great spirits who have the gift of spatial imagination be able to concentrate upon real achievements rather than upon clever imitations?

It almost seems so.

FINALE

FINALE

Slowly, but uninterruptedly, the conviction becomes accepted that housing projects composed solely of dwelling units are no longer sufficient.

What is needed are extensions to the dwellings—*le logis prolongé*—where contacts between neighbors can occur as a matter of course. Already in remote areas—such as a new built Arabian housing project in Morocco—in schemes intended for the poorest sections of the community, small community centers have been incorporated from the very start of the project. These additional elements, essential for community life, must be made a necessary condition everywhere. Their promotion is nothing new. Such places have existed ever since man first began to establish a differentiated society. They began to develop as soon as a freer society took the place of the constitutionally and mystically attached clans of prehistory. They are bound up with the consciousness of being a member of a *polis*, of a city. But today, particularly in highly industrialized countries, our way of life has become more similar to that of primitive nomads.

The thing that is demanded today is an almost completely neutral contact between person and person—no intimate relationship. No matter how much man may change his residence, he needs some wider relationships in his private life—apart from the family circle. The life of a number of people in the same place only acquires meaning when some care is taken for their spiritual stimulation outside the family household. These neutral relationships outside the dwelling have become as necessary today as the sanitary fixtures within it, which were first introduced only two generations ago. An opportunity is needed for the expression of casual remarks and observations every day, not only on the occasion of some extraordinary event.

In order to realize this relationship, a demand has arisen to reëstablish the eternal claim of the human scale in all urban planning.

Closely linked with the demand for the human scale is another demand that is now widely accepted—at least in theory: this is the right of the pedestrian, which under the influence of unbridled traffic has become neglected.

Added to this is a human "birthright": that a relationship with nature must also be reëstablished. Due to the destruction of the human scale, the working people of all large cities are now often obliged to spend two or more hours a day in transportation—penned barbarously together —if they wish to avoid living in the midst of an asphalt jungle. Everywhere, though maybe less grotesque, a similar situation exists.

The four main functions of urban planning: living, working, recreation, and communication, as they were stated by CIAM in 1933,[1] have lost their balance and their interrelationship. This too must be reëstablished.

The demand for the reëstablishment of the relation between "you" and "me" leads to radical changes in the structure of the city.

Great states and highly developed industries require within their ever greater agglomerations, administration and government centers, certain places where face to face discussions can take place without the use of technical intermediaries. Monster urban agglomerations of eight millions and more with no clear internal structure must, at least for the working population, result in an inhuman way of life. These conditions will not vanish in a day, but there are already hopeful indications, and these will become more evident as the revolt against the inhuman habitat spreads through the general public.

On a smaller scale, the same phenomenon can be observed at work everywhere. The large cities devour dispro-

[1] CIAM (France), *La Charte D'Athènes* (Paris, 1943).

portionately large numbers of people in relation to the total population of the country, and this seriously affects the general pattern of land settlement. This is a miserable continuation of one of the evils of the nineteenth century. When the disproportionate enlargement of the big city first set in, there were none of the highly developed transport systems that we now possess.

If a reëstablishment of the human scale is desired, if a spontaneous relationship between inhabitants is again to come about, the dense masses of urban development must be smashed. Instead of one large solid body of masonry with an inextricable chaos of functions, there must be a number of smaller units whose size is foreseen and planned in relation to the human scale.

Such units must be redivided into smaller neighborhoods dimensioned to make possible easy contacts between the inhabitants. As an integral part of this scale pattern a greater differentiation is demanded of housing types, to meet the needs of the different age groups: single men and women, and families which are small, are growing, and have again shrunk to smaller size.

The many-sided nature of these requirements, with their varied needs for distance and for nearness, give rise to new possibilities of shaping the environment. To meet these, the architect and planner must draw upon the means of expression that have been developed by contemporary art. These alone can show the possibilities by which these varied requirements can be visually expressed. It may be here repeated that the architect-planner who has not passed through the needle's eye of modern art betrays himself immediately. He can be seen to be without the necessary tools of his trade.

The clearest insight into the way in which units of this new environment can develop can be found in a country which is able to look back upon the longest development of urbanism and the closest settlement of cities: Holland.

J. M. Bakema and OPBOUW, in their project for the

Prince Alexander Polder, 1953, have shown the way in which a unit limited to 30,000 people can be planned and built in the neighborhood of Rotterdam (fig. 52).

This urban element can be linked to other similar units and all connected to a mutual administrative and cultural center.

How much of this wider vision will materialize?

Recently, I visited Henry van de Velde. This ninety-three-year-old man stood on the terrace of his charming wooden house and looked out over the landscape.[2] For seven years he has been writing his memoirs by the side of the Aegeri Lake in the Swiss mountain region of the Zug canton. These will give us an insight into the most important cultural developments in Germany since 1914. He stood there in unimpaired elegance, wearing a stone grey suit he had himself designed, which made one conscious of the ridiculousness of our ready-made clothes. His conversation, as always, turned upon practical matters; how much can in fact be brought to realization?

In 1897 when Henry van de Velde showed his interior designs at the Dresden Exhibition, he released the latent stream of the modern movement in Germany.

Now he struck the balance between the nineties and to-day: "At first, in the revolution against the falsification of architectural forms, every inch had to be redesigned by the architect himself, down to the door latches and tableware. Then came the period in which he could rely upon the good designs of certain individuals. Now we are already sufficiently far along the way that an assembly can be made of articles that are themselves anonymous. This is certainly something!"

Henry van de Velde had to wait nearly six decades before this development penetrated into industrial production and to the general mass of the people—until it became "anonymous."

To change the structure of the city is an infinitely more

[2] Still full of plans, Henry van de Velde died 25 October, 1957.

complicated and entangled process, but if we look at it from the point of view of this old master of architecture, and take note of the present position of the contemporary development, it would appear that the changed structure of the city may be achieved more rapidly.

All that is necessary is the will to bring it about.

S.G. 1955

DEVELOPMENTS IN URBAN DESIGN
SINCE 1850

It is difficult to pin down with actual dates anything as nebulous as social consciousness in urban planning. Nevertheless, certain pioneer ventures of the last hundred years can be designated. This list owes much to the traveling exhibition on Urban Design prepared by the Graduate School of Design at Harvard University, 1956–1957.

Changes in the city structure have often been preceded by changes in landscape design. The garden landscape of Versailles was the forerunner of the great city plans of the Baroque period, and much the same occurred in the nineteenth century.

1856–1867 THE PUBLIC SQUARES OF PARIS *Alphonse Alphand*

In the decade between 1856 and 1867 the landscape architect Alphonse Alphand created over twenty new public squares in the heart of Paris. For one of the last he took an old quarry in a working class district—Buttes Chaumont, 1856–1860—and transformed it into a place for active enjoyment of the populace instead of merely another pleasant public garden.

1857–1860 CENTRAL PARK, NEW YORK *Frederick Law Olmsted*

In America, Frederick Law Olmsted was superseding the artificially romantic garden with a development of the inherent qualities of the natural landscape. In Central Park, by judicious use of the natural topography, he succeeded in achieving, for the first time, one of the canons of future urban planning: the separation of pedestrian and vehicular traffic.

1882 THE LINEAR CITY *Arturo Soria y Mata*

In isolation and without creating much interest at the time, the Spaniard Soria y Mata worked out a new type of city which later exerted great influence. In this the different functions of living,

207

working, and circulation were allowed to develop continuously along parallel bands.

1889 THE ART OF BUILDING CITIES *Camillo Sitte*

The Viennese city planner, Camillo Sitte, essayed to set down the principles underlying the placing of statuary and monuments in early city squares, and to inveigh against the space-destroying crossroad "squares" of the nineteenth century.

1898 GARDEN CITIES OF TOMORROW *Ebenezer Howard*

The British parliamentary shorthand writer, Ebenezer Howard, wished to break up the congestion of the great metropolis of London by the creation of a number of small self-contained garden cities, each designed for living and working. His ideas achieved great success, especially in the Anglo-Saxon world, but in most of the settlements of the Garden City Movement industry was omitted, and the journey to work thereby greatly lengthened.

1901 THE INDUSTRIAL CITY *Tony Garnier*

Tony Garnier, a French architect from Lyons, when working on a scholarship in the French School at Rome, produced a series of plans for an industrial city to be sited on the banks of the Rhone. This was published in 1917 and was the first fully worked out plan for the organization of the urban structure of a twentieth-century city.

HOUSING LEGISLATION IN HOLLAND

This year also saw the first systematic legislation for the national organization of urban settlement. Holland required a revised general plan to be prepared every ten years for all cities over 10,000 inhabitants. In the early part of the century Holland became preëminent in housing developments. H. P. Berlage's plan for middle-class housing in Amsterdam South, 1902, and J. J. P. Oud's first really human working-class apartment blocks at Tusschindeyken in Rotterdam, 1919, were pioneer achievements in urban design.

208

1915 CITIES IN EVOLUTION *Patrick Geddes*

The Scottish Professor of Botany, Patrick Geddes, one of the pioneers of diagnostic planning, strove to bring about an integration of urban planning with sociology and economics ("place, folk, work") and to move from a mere collection of statistics to an interpretation of the living reality in time.

1920 WELWYN GARDEN CITY, ENGLAND *Raymond Unwin*

This new town for 20,000 people placed twenty miles north of London followed closely the principles laid down by Ebenezer Howard. Its new contribution to urban planning was its systematic development of the short cul-de-sac which provided for greater safety and privacy for its residents and broke up the old *rue corridor*.

1922 PLAN VOISIN, PARIS *Le Corbusier*

This was a proposal for a new organization of the metropolitan city which contained many new ideas.

1927 WEISSENHOF HOUSING PROJECT, STUTTGART, GERMANY

The late twenties saw many very hopeful developments in Germany, which were brought to an abrupt end in 1933. In 1927, under the direction of Mies van der Rohe, young architects from all over Europe were invited to erect experimental buildings at Weissenhof.

ROEMERSTADT, FRANKFORT, GERMANY *Ernst May*

Ernst May, the chief architect and city planner of Frankfort am Main, built many new suburbs around the outskirts of this city in which new designs for mass-produced low-cost row housing were tried out on a large scale, and the separation of pedestrian walks and traffic roads was developed.

1928 DAMMERSTOCK HOUSING PROJECT, KARLSRUHE, GERMANY
Walter Gropius

An attempt at giving a number of different architects responsibility for single elements in a unified project under the general direction of Walter Gropius.

209

1929 SIEMENSTADT, BERLIN, GERMANY *Walter Gropius*

This working-class housing project on the outskirts of Berlin was the most congenial of many such projects built at this period by reason of its clear lines and open layout with wide swathes of greenery.

RADBURN, NEW JERSEY *Henry Wright and Clarence Stein*

For this garden suburb of the automobile age, the cul-de-sacs of Welwyn Garden City have become garage courts and the houses are turned around to face upon a footpath entrance. A ribbon park runs through the traffic-free "super-blocks" and pedestrians cross the encircling roads through underpasses.

THE NEIGHBORHOOD UNIT *Clarence Perry*

In the Regional Plan for New York, prepared under the direction of Thomas Adams, Clarence Perry outlined his concept of dividing up New York into traffic-bounded residential districts, each centered around an elementary school.

1933 THE "CHARTE D'ATHENES" CIAM 4

The Fourth Congress of Modern Architecture was held in Athens. It established the four main functions for which a city plan must provide: living, working, recreation of mind and body, circulation.

1934 BROADACRE CITY *Frank Lloyd Wright*

On the basis of universal ownership of automobiles and the tremendous spaces of western America, Frank Lloyd Wright developed his wide-flung "city" of self-sufficient homesteads and dispersed centers of activity.

1935 LA VILLE RADIEUSE *Le Corbusier*

In this volume Le Corbusier proposed the reshaping of the metropolis by the creation of large pedestrian open spaces, free from all traffic circulation, through the concentration of residences in high-rise apartments.

1938 CULTURE OF CITIES *Lewis Mumford*

Lewis Mumford, an avowed disciple of Patrick Geddes, through this book aroused the interest of the American public in the problems of urban decentralization and the planning of garden cities on the lines advocated by Ebenezer Howard.

1944 THE GREATER LONDON PLAN *Patrick Abercrombie*

This was the first large-scale working out of a permanently green belt around a large metropolis coupled with the establishment of a number of new satellite cities (new towns) beyond it.

1945 SAINT-DIÉ, VOSGES, FRANCE *Le Corbusier*

The first truly contemporary design for a community center (see pp. 165–166).

1948 HARLOW NEW TOWN, ENGLAND *Frederick Gibberd*

The British New Towns' Act after the Second World War endeavored to return to the original principles of the Garden City, and eight satellite towns were established around London where men could both live and work. Their architectural development is not always entirely satisfying.

 CHIMBOTE, PERU *P. L. Wiener and J. L. Sert*

The first large-scale use in modern times of the patio house to provide good living conditions in single-story buildings at high density.

1951 CHANDIGARH, PUNJAB, INDIA *Le Corbusier*

The plan for the new capital city of the Punjab is the first major example of the combination of radically progressive city planning with age-old habits of life. The gridiron is used as a major traffic net, enclosing large sectors (each approximately one-half by three-quarters of a mile). These dimensions are large enough to enable each sector to be developed as an element with a life of its own, while still remaining part of an over-all organism. Here also the separation and differentiation of fast and slow traffic routes and pedestrian paths was first put into operation on a city-wide scale.

At the Eighth Congress CIAM discussed the physical expression
of "recreation of mind and body" and came to the conclusion
that the time was ripe for a concentrated endeavor to re-create
urban centers of social activity.

1952 VALLINGBY, SWEDEN *Sven Markelius*

In this, the most elaborately planned of many recent suburbs of
Stockholm, the relation of high and low buildings and the pro-
vision of a wide range of dwelling types was most carefully
studied.

1953 BACK BAY CENTER, BOSTON, MASSACHUSETTS
 Walter Gropius and others

In this unrealized project the core of the city first found its
American form.

1956 ALEXANDER POLDER, HOLLAND
 R. Bakema and Group OPBOUW

Ever since 1948 this CIAM group had been working on the
problem of the contemporary form of an urban settlement
which could provide for all the needs of a varied population
(see pp. 173–175).

 SOUTHDALE SHOPPING CENTER, MINNEAPOLIS, MINNESOTA
 Victor Gruen

The out-of-town shopping center, developed for purely com-
mercial reasons, here begins to take on some attributes of a
center of social activity.

 LAFAYETTE PARK, DETROIT, MICHIGAN *Mies van der Rohe*

The rebuilding of a complete downtown section of Detroit
combines high-rise buildings in a parklike setting with patio-
type row houses and a neighborhood core.

1957 BRAZILIA, BRAZIL *Lucio Costa*

This prize-winning project for a new Brazilian capital gives a
twentieth-century twist to some early ideas of the linear city.

ACKNOWLEDGMENTS

Much of the content of this book first appeared in the form of lectures or papers by the author; a partial list of these follows: "Brauchen wir noch kuenstler?" in *Plastique*, edited by Sophie Tauber-Arp, No. 1 (Paris, 1937); "Art as a Key for Reality," foreword for the painter Ben Nicholson (London, 1937); "The Tragic Conflict," unpublished papers on the Ruling Taste (Paris, 1936–1955); "The New Monumentality," in *New Architecture and City Planning*, edited by Paul Zucker (New York, 1944), *Revista de Occidente Argentina*, 1949, and *Architectural Review*, September 1948; "Nine Points on Monumentality," unpublished symposium prepared with J. L. Sert and Fernand Léger, 1943; "Fernand Léger," in *Der Neue Zuercher Zeitung*, August 1955; a radio dialogue with Antoine Pevsner, Zurich, October 1949; "On the Force of Aesthetic Values" and "On the Education of the Architect," in *Building for Modern Man*, edited by Tom Creighton (Princeton, 1949); "Architect, Painter, and Sculptor," in A *Decade of Contemporary Architecture*, by Sigfried Giedion (Zurich, 1954); "Architects and Politics" and "Aesthetics and the Human Habitat," unpublished material from the 7th and 9th Congresses for Modern Architecture (CIAM), 1949 and 1953; "The Humanization of Urban Life," in *The Heart of the City*, edited by J. Tyrwhitt, J. L. Sert, and E. N. Rogers (London and New York, 1951), *Architectural Record*, April 1952, and *Das Werk*, November 1952; "The State of Contemporary Architecture," "The New Regionalism," "Social Imagination," and "Spatial Imagination," in *Architectural Record*, 1952, 1954, and 1956.

Credits for illustrations used in the German edition are as follows: 1–6, 16–19, 38, 47, 69, photo Giedion; 21, 23, 25, 27, 57–59, Giedion, *Space, Time and Architecture*; 32, 44–46, 48–49, *d*, Le Corbusier, *Oeuvres*, IV, V; 7–9, municipal government, Oslo; *f, g, h*, architects' drawings; *b, c*, O. Lancaster, *From Pillar to Post*; 61, 66, Museum of Modern Art, from publication of Naum Gabò; 12, Jacques de la Prade, *Seurat*; 13, Cousturier, *Seurat*; 14, photo Galerie Valentin, New York; 15, photo Bran-

cusi; 20, photo Delaunay; 33, *Architecture d'aujourd'hui*; 34, photo Shulman; 36, Fimmen, *Die kretische-mykenische Kultur*; 37, pub. Edgar Kaufmann, Jr.; 40, Pendelbury, *Tell-El-Amarna*; 41, photo Sert; 52, Giedion, A *Decade of Contemporary Architecture*; 56, photo Lozzi; 70, photo Perusset; *a*, Durand, *Cours d'architecture*.

Credits for illustrations new in this edition are as follows: 28, 42, courtesy J. L. Sert; 30, 31, seminar, Harvard University; 32a, photo Walter Dräyer; 39, *Architectural Forum*; 51, photo Dolf Schnebli; 53, photo Vrijhof; 54, photo Robert D. Harvey; 55, photo G. E. Kidder-Smith; 63, courtesy E. F. Catalano; 64, photo Ezra Stoller; 65, photo René Burri-Magnum; 67, photo Carl E. Rosenberg, courtesy Joern Utzon; 68, *Progressive Architecture*; *e*, Student Publications of the School of Design, North Carolina State College, vol. 5, no. 1, copyright 1955, reproduced by permission of the publisher and E. F. Catalano.

INDEX OF NAMES

Aalto, Alvar, 64
Abercrombie, Patrick, 210
Acosta, Lucio, 81
Acropolis, 25, 193
Africa, 97, 140, 149, 173
Akhnaton (Pharaoh), 132
Alberti, Leon Battista, 143
Alberto, 81
Alexander the Great, 133
Alexander Polder (Rotterdam), 161, 169–71, 204–05, 212, figs. 52, 53
Alphand, Alphonse, 207
America, 54, 123, 127, 131, 156, 173
American Abstract Artists, 22
Ames, Adelbert, 64
Amsterdam, 130, 208
Apollinaire, Guillaume, 147
Arab world, 180
Arc de Triomphe, 35
Arp, Hans, 24, 35, 56, 60, 71
Arup, Ove, 111
Athens, 133
Audincourt, stained glass, 53, figs. 17, 18
Australia, 193. See also Sydney Opera House

Babylon, 142
Baghdad, 142, 172
Bagneux, 182
Bakema, J. B., 169–71, 204–05, 212, figs. 52, 53
Bathers, The, fig. 28
Baudelaire, Charles, 12, 15, 16, 18, 19, 154
Bauhaus, 87, 144, 186
Belfort. See Audincourt
Bergamo. See CIAM
Berlage, 208
Berlin, 210
Berlin Conference Hall, 185–88, figs. g, h, 65

Berne, 68, 135
Bill, Max, 80
Bird in Space, fig. 15
Borromini, Francesco, fig. 55
Boston Back Bay Center, 161, 171–73, 212, fig. 54
Bouguereau, Adolphe, fig. 5
Brancusi, Constantin, 24, 56, 77, fig. 15
Braque, Georges, 32, 143, figs. 21, 26
Brazil, 173
Brazilia, 212
Bridgwater (England). See CIAM
Broadacre City. See Wright, F. L.
Burckhardt, Jacob, 109
Buttes, Chaumont, 207
Byzantium, 180

Caesar, Julius, 134
Cairo, 172
Calder, Alexander, 53, 60, 81
California, 125
Canada, 148, 173
Candilis, Georges, 149
Capitol (Rome), 136
Caracas, 60
Catalano, Eduardo, 183, 184, 188n., 191, figs. 3, 63, 64
Cézanne, Paul, 18, 32, 168
Chandigarh, 148–49, 155, 161, 173–77, 211, figs. d, 48–51. See also Corbusier
Charte d'Athenes. See CIAM
Chartres Cathedral, 163
Chevreuse Valley, 53
Chianciano Hall, fig. 60
Chicago, 189
Chimbote, Peru, 211
China, 140
CIAM (Congrès International d'Architecture Moderne), 65, 87, 90, 91, 101, 125n., 131, 165, 169,

CIAM (Congrès International d'Architecture Moderne) (*cont.*) 203–04; MARS Group, 70; Bridgwater Congress 1947, 70–71, 72–78; Bergamo Congress 1949, 79–80; Aix-en-Provence Congress 1953, 91–98; Hoddesdon Congress 1951, 127, 128; OPBOUW Group, 169, 204, 212, figs. 52, 53; Charte d'Athenes, 210

Cigale, La, fig. 3
Clarinet, The, fig. 21
Clay, Paffard, 184, 185, fig. f
Colombia, 127, 173
Colonne Développable de la Victoire, 56, fig. 16
Composition, 1930, fig. 22
Corbusier, Le, 58, 75–76, 77, 80, 84–85, 86, 101, 125, 126, 147, 149, 161–69, 174–76, 186, 194–99, 210, 211, figs. d, j, k, l, m, 25, 32, 32a, 44–51, 69, 70
Córdoba, 180, 181
Costa, Lucio, 23, 212
Cottancin, 181
Creighton, Thomas, 64
Crete, 150; oval house, fig. 36
Cuba, 149. *See also* Sert

Dammerstock, 209
Dante, 15
Daumier, 18
Davioud, 190
de Groot, Hofstede. *See* Groot, Hofstede de
Delacroix, 15, 17, 18
Delaunay, 41, 147
Descartes, 72, 77
Dewey, John, 104
Dischinger, 182
Divers, 54
Doesburg, Theo van, 144, 145, 146, fig. 24
Domino House, 147, fig. 25
Drew, Jane, 149, 174
Dubois, Archbishop of Besançon, 195, 199
Durand, Jean N. L., 29, fig. a

Ecochard, Michel, 149
Eesteren, C. van, 80, 85–86, 144, 146
Egypt, 113, 114, 132, 189
Eiffel Tower, 27, 44, 148, 186, fig. 19
Eiffel Tower (painting), fig. 20
Eliot, T. S., 13, 36, 68
Ellesmere, Earl of, 16
Eyck, Aldo van, 76–78, 130

Faust and Marguerite, fig. 6
Femme en Bleu, 41
Finland, 158, 173
Finsterwalder, 182
Fletcher, Bannister, 108
Flight of the Bird. See Colonne Développable de la Victoire
Florence, 136
Forum Romanum, 133
Fould, Achille, 15
Frankfort am Main, 209
Freysinnet, 182
Frogner Park Sculpture Group, figs. 7, 8, 9
Fry, Maxwell, 101, 149, 174
Fuller, Buckminster, 150

Gabò, Naum, 24, 57, 183, 190, 196–97, figs. 61, 66
Galerie Drouin, 57
Galileo, 68
Garden City movement. *See* Howard, Ebenezer
Garnier, Tony, 147, 208
Gautier, Théophile, 17
Geddes, Patrick, 209, 211
General Motors Technical Center, 56, 60
Géricault, 15
Giacometti, Alberto, 24, 56
Gibberd, Frederick, 211
Goethe, 13, 15, 17
Gonzales, 81
Goya, 87, 88
Greece, 27, 69, 82, 113, 114, 131, 132–33, 193
Groningen, University of, 17
Groot, Hofstede de, 17

Gropius, Walter, 23, 64, 101, 111, 144, 165, 167, 171, 186, 210, 211, fig. 54
Gruen, Victor, 212
Guarini, Guarino, 180–81, figs. 57, 58
Guérin, 15
Guernica, 32, 81, 85. *See also* Picasso

Hadrian, Emperor, 179
Hall of German Art (Munich), 29, fig. 10
Halle des Machines (Paris), 147, 181
Hamilton, Gavin. See *Innocentia*
Hamlin, Talbot, 64
Harlow New Town, 211
Heine, Heinrich, 11
Hepworth, Barbara, 73–74
Himalayas, 174
Hippodamus, 132
Hitchcock, Henry-Russell, 23
Holford, Sir William, 23
Holland, 208. *See also* Bakema
Hooch, Pieter de, 146
Howard, Ebenezer, 122, 208
Huxley, Julian, 100–101, 105
Hyperparaboloid space frame, fig. 63. *See also* Catalano

Illustrated London News, 16
Illustration (Periodical), 16
Imperial Hotel (Tokyo), 147. *See* Wright, F. L.
India, 80, 127, 148, 156, 173
Ingrès, 17, 18
Innocentia, fig. 1

Jammer, Max, 116–117
Japan, 142, 156, 192
Jeanneret, Pierre, 149, 174
Joyce, James, 174

Kandinsky, 189, 191
Karlsruhe, 209
Kaschnitz-Weinberg, G. von, 179n.
Keynes, John Maynard, 38
Klee, Paul, 110

Krasinski, Count, 17
Kresge Auditorium (Cambridge, Mass.). *See* Saarinen

Lafayette Park, 212
La Guardia Airport, 54
Lahore, 174
Lancaster, Osbert, figs. b, c
Latin America. *See* South America
Le Corbusier. *See* Corbusier, Le
Lefèvre, Jules, fig. 3
Léger, Fernand, 22, 32, 35, 48–51, 52–55, 60, figs. 17, 18, 28
Le Ricolais, 184
Lines in Motion. See Colonne Développable de la Victoire
London, 80, 118, 209, 210
L'Orange, H. P., 179n.
Louis Phillippe, 15
Louvre Museum, 15, 17

Magasin Pittoresque, 16
Maillart, Robert, 67–68, 160, 182, fig. 23
Maison Familiale de Rezé, 169
Malevitch, 143
Malta, 179
Manet, Édouard, 12, 18, 33
Manhattan. *See* New York
Markelius, Sven, 212
MARS. *See* CIAM
Marseilles. *See* Unité d'Habitation, Corbusier
Maunier, René, 158
May, Ernst, 209
Mayer, Julius, 17n., 19n.
Mellon Institute, 29, fig. 11
Mesopotamia, 187
Michelangelo, 35, 68, 136–37
Mignon, 17, fig. 2
Mihrab (Córdoba), 180, fig. 59
Miletus, figs. 30, 31
Mirò, Joan, 32, 35, 81, 90, 189
Moholy-Nagy, 54
Mondrian, Piet, 77, 143, 144, 145, 189, 190, 191, fig. 22
Montparnasse, 43
Monument in Wood, 34, fig. 14

217

Morocco, 149, 202. *See also* Eco-
 chard
Morris, William, 125
Mumford, Lewis, 22, 23, 211
Museum of Modern Art (New
 York), 57

Nantes, 169
Napoleon, 29
National Opera House (Sydney).
 See Utzon
Nero, 134, 179
Nervi, Pier Luigi, 181, fig. 60
Neutra, Richard, 64, 101, 148, fig.
 34
New York, 53, 54, 82, 164, 207,
 210
Niemeyer, Oscar, 148, fig. 33
Noguchi, Isamu, 80
Nowicki, Matthew, 188

Ohio Valley, 140
Olmsted, Frederick Law, 207
OPBOUW. *See* CIAM
Open Hand, 176–177, fig. 49. *See
 also* Chandigarh
Orleans, duc d', 15
Ostia, 134
Oud, J. J. P., 126, 144, 208

Pakistan, 174
Palace of the League of Nations
 (Geneva), 30, 191
Palace of Soviets, 191, fig. 61. *See
 also* Gabò
Palazzo Vecchio (Bergamo), 79
Pantheon, 113, 114, 163, 186, fig.
 56
Parthenon, 163, 168
Paulsson, Gregor, 23
Penrose, Roland, 79, 80, 85
Perret, 147
Perry, Clarence, 210
Peru, 127
Petit, Claudius, 163, 199
Pevsner, Antoine, 24, 56, 57–59,
 60, 61, fig. 16
Picasso, Pablo, 24, 32, 34, 35, 81,
 85, 87, 90, 113, fig. 14
Pisa, 162

Plan Voisin (Paris), 209
Planche, Gustave, 16
Pompeii, 134, 135, 172
Priene, 133
Princeton University Conference,
 64, 65, 100, 101
Provence, 168

Radburn (New Jersey), 210
Rangoon, University of, 186
Raphael, 16, 17
Read, Sir Herbert, 72
Renan, Ernest, 17
Revue de Deux Mondes, 16
Rhone River, 208
Richard, J. M., 70, 71
Riegl, Alois, 112
Rietveld, 144, 146
Rockefeller Center, 126, 171, fig. 27
Roemerstadt (Frankfort), 209
Rogers, Ernesto, 80, 88
Roh, Franz, 13
Rohe, Mies van der, 64, 101, 125,
 146, 171, 189, 190, 212
Rome, 133–34, 136–37, 179, 180,
 208
Ronchamps Pilgrimage Chapel, 175,
 186, 187, 191, 194–99, figs. j,
 k, l, m, 69, 70
Roth, Alfred, 23, 79
Rothschild, Madame de, 15
Rotterdam, 44, 126, 208. *See also*
 Alexander Polder
Rouses Point, 54–55

Saarinen, Eero, 56, 60, 186, 189,
 190
*Saint Augustine and His Mother
 Monica*, 16, fig. 4
Saint-Dié, 10, 161–62, 211, figs. 32,
 32a
St. Louis airport, 186
St. Paul's Cathedral, 10
St. Peter's, 163
Sainte-Marie-du-Haut. *See* Ron-
 champs
San Carlo alle Quattro Fontane, fig.
 55
San Gimignano, 167

San Lorenzo, 180–81, figs. 57, 58.
See also Guarini
Sartre, J. P., 128
Scamozzi, Vincenzo, 79, 87
Scheffer, Ary, 15, 16, 17, 18, 19,
figs. 2, 4, 6
Schmarsow, August, 112
Schwitters, 86, 191
Sert, José Luis, 22, 48–51, 53, 64,
79, 80–84, 85, 149, 211, figs. 41,
42
Seurat, Georges, figs. 12, 13
Severud, Frederick, 64, 187, 188,
figs. g, h
Shakespeare, William, 13, 154
Siemenstadt, 210
Siena, Piazza del Campo, fig. 24
Sitte, Camillo, 207
Somme, 140
Sophocles, 13
Soria y Mata, Arturo, 207
South America, 148, 149, 158
Southdale Shopping Center, 212
Space Study, 1920, fig. 24. *See also*
Doesburg
Spherical Construction, fig. 66. *See*
also Gabò
Squire, Raglan, 186
Stalingrad, 10
Stein, Clarence, 210
Stubbins, Hugh, 186, 187, 191,
figs. g, h, 65
Studer, André, 149, fig. 43
Stuttgart, 209
Sullivan, Louis, 157
Sumer, 113, 114
*Sunday Afternoon on the Grande
Jatte*, figs. 12, 13
Sweden, 125, 167
Sweeney, J. J., 80, 88–89
Sydney Opera House, figs. 1, 67, 68.
See also Utzon, Joern
Syria, 142
Syrkus, Helena, 80, 86–87, 88, 89

Tange, Kenzo, fig. 35
Taut, Bruno, 182
Tel el Amarna, fig. 40
Torrochs, 182
Trajan, 134

Tremaine House, fig. 34
Trotsky, Leon, 42
Truman, Harry S., 88
Turin, 180
Tusschindeyken, 208

UNESCO, 65, 100, 101, 102
Unité d'Habitation, 126, 161, 163–
69, figs. 44–47. *See also* Cor-
busier
United Nations Building, 55; As-
sembly Hall, 190–91
United States. *See* America
Unwin, Raymond, 209
Uruk-Warka, fig. 38
Utzon, Joern, 186, 191–94, figs. 1,
67, 68

Vallingby, Sweden, 212
van de Velde, Henry. *See* Velde,
Henry van de
van der Rohe, Mies. *See* Rohe, Mies
van der
van Doesburg, Theo. *See* Doesburg,
Theo van
van Eesteren, C. *See* Eesteren, C.
van
van Eyck, Aldo. *See* Eyck, Aldo van
Varma, E. L., 174, 176–77
Velde, Henry van de, 125, 205
Venezuela, 173
Versailles, 82, 139
Victoria, Queen, 15, 17
Vierzenheiligen, 186
Vigeland, Gustav. *See* Frogner Park
Sculpture Group
Ville, La, 41, 52
Ville Radieuse, La, 210
Villenueva, 60
Violin, The, fig. 26
Virgin with Angels, fig. 5
Vitet, L., 15

Wachsmann, Konrad, 182
Wall Street, 167
Warsaw, 87
Weissenhof, 209
Welwyn Garden City (England),
209

219

Whitehead, Alfred North, 72
Wiener, Paul L., 149, 211, figs. 41, 42
Williamson, G. Scott, 128
Wölfflin, Heinrich, 112
Woods, S., 149
Wright, Frank Lloyd, 64, 122, 125, 147, 149, 150, 185, 190, 210, figs. 37, 39, 62

Yamasaki, 186
Young, Edward, 154

Zeiss Planetarium, 182
Zola, Émile, 17, 18
Zucker, Paul, 22n.
Zürich, 56, 64, 105, 129

SUBJECT INDEX

Architect, as coordinator, 102–03
Architecture, nineteenth-century, 19, 68, 103, 107
Architecture and town planning, 49
Art as luxury, 2, 32–33, 50

Béton brut, 165
Blut und Boden advocates, 140
Butterfly roof, 174, 175

Cathedral as symbol, 37
Children's playgrounds, 130
City, as age-old symbol of social life, 124, 158
City center. *See* Core
City planning and community life, 122–24, 125–37
City planning: Greek, 131–33; Medieval, 134; Roman, 133–34
City-state, medieval, 136
Civic center. *See* Core
Community centers, 161–63, 171–73, 202. *See also* Core
Core, 126–37, 212

Dome, 179, 180–81, 182, 184, 185, 189–91

Eclecticism, 12, 18, 25, 29–30

Gridiron plan, 132

Health Center, Peckham, 128
High-rise apartment house, 163–69
Housing, differentiated, 123, 159, 160, 204
Human Scale, 27, 93–95, 159, 204

Individual, rights of, 123, 158, 159, 203
Industrial buildings, 26, 181, 208
International style, 140, 185

Landscape architecture, 207
Legislation, Holland, 208
Logis prolongé, 202

Market places, medieval, 135

Napoleon, prototype of self-made man, 29
Neighborhood unit, 27, 49, 202

Pedestrians, rights of, 94, 128, 162, 171–72, 203
Plane surfaces, 143, 189
Pseudomonumentality, 25, 28–31
Pseudo-symbolism, 3
Public art, 4, 7

Regional planning, 148–49, 192
Round house, 150, 185

Row housing, 149
Ruling taste, 10, 14

Shell vaults, 192–94
Shopping centers, 212
Skyscrapers, 125, 171
Space conception, 112–15, 116, 143
Space-time, 143
Stijl movement, 125, 144–46

Subtropical, 148–49
Symbol, 23, 35, 49

Teamwork, 32, 49, 65–66

Vision, pyramid of, 143
Vaulting problem, 178–82, 185, 186–88